NEW JERSEY

A 25-Year Photographic Retrospective

Dedicated, with love, to
Susan & Joe
and to the memory of
"Beans"

NEW JERSEY

A 25-Year Photographic Retrospective

WALTER CHOROSZEWSKI

Introduction by

JOHN T. CUNNINGHAM

Published by

AESTHETIC PRESS, INC.

Somerville, New Jersey

NEW JERSEY, A 25-Year Photographic Retrospective

ISBN 1-932803-28-9
Library of Congress Control Number: 2005907669

www.aestheticpress.com
email: info@aestheticpress.com
Telephone: 908 369-3777

AESTHETIC PRESS, INC.
PO Box 5306
Somerville, NJ 08876-1303

John T. Cunningham

I met Walter Choroszewski 25 years ago.

A New England book publisher had hired Walter, a New York photographer, to capture the best of New Jersey on film. Prior to that book's publication, it was suggested to this publisher that I be engaged to write an essay to introduce both the book and Walter to a New Jersey audience.

I agreed, and Walter and I were introduced by telephone. Soon afterwards he sent me his slide portfolio of New Jersey images. Those "early" Choroszewski images showed both camera skills and his fine artistic sense. I reviewed them and recognized that New Jersey had another devotee. The result was: **NEW JERSEY, A Scenic Discovery.**

In all candor, the "discovery" was Walter's, as I had already known the wonders of New Jersey for years before he was even born. By 1980, more than 25 books of mine on the state had been published, and by this publication—nearly 50!

His first book was handsome, easily the best book of its type ever done on the state. The press fell in love with it. Shirley Horner wrote in The New York Times, "...Choroszewski's *photographs rival the landscape paintings of Cézanne in their capacity to set the senses afire.*" **Popular Photography** magazine raved, "*...this collection of superb photographs celebrates the existence of their subject matter.*" Celebrate indeed! With photos as proof, Choroszewski had underscored the seldom acknowledged fact that New Jersey contained assets beyond the fabled Turnpike.

After meeting Walter, I knew that I had found someone who shared a similar deep appreciation for this state. We immediately became lifelong friends and collaborators in many ventures. Since *Scenic Discovery*, Walter and I have been paired in numerous projects, about half inspired by him, the rest stemming from publications of mine, including magazine articles, pamphlets, books and textbooks.

The name "Choroszewski" soon became an important and very common New Jersey byline as he continued to share evidence of the visual beauty of this neglected state which has enamored him even to this day.

New Jersey's tourism industry was by far the greatest beneficiary of Choroszewski's vision. Who could resist his inviting images of dawn on the dunes near Old Barney or the lush and colorful perennial gardens at Skylands? Ad agency Bozell & Jacobs recognized the value of Walter's photos and used them in their pitch for New Jersey Travel and Tourism. **"New Jersey & You"** was born—*perfectly* blending Choroszewski's images with Governor Tom Kean's now iconic signature phrasing of *"Perfect Together!"*

Choroszewski continued to be the primary supplier of photography for New Jersey's tourism campaigns for many years—even through changes in administration. Walter made the state look great no matter what your political persuasion! The State honored him in 1989 with a special Photo Journalism Award: *"For Enhancing New Jersey's Positive Image through Photo Creativity."*

New Jersey-based companies sought Walter's photographs for use in their corporate annual reports. Together, Walter and I collaborated on a multi-year series of publications sponsored by my friend and New Jersey supporter, Thomas J. Stanton of First Jersey

National Bank. These special supplements were widely distributed with First Jersey's Annual Reports and also to schools and libraries across the state. They quickly became collector's items.

You may have a hard time spelling his name, but looking it up in the phone book was easy. The "Choroszewski" byline was regularly found on the cover of the Bell Atlantic telephone directories and also peppered extensively throughout their Community Showcase pages through the early 1990s.

From the welcome banners at Newark Airport to giant wall murals at some of New Jersey's leading corporations, Choroszewski's images of New Jersey graced board rooms, executive offices and lobbies at Kodak, Merck, Johnson & Johnson, Anheuser-Bush and numerous other companies. One print was never enough! You can find "suites" of Walter's New Jersey images in law firms, hospitals and offices statewide.

By 1987 it was time to share some new views; Walter delivered the award-winning book **NEW JERSEY, A Photographic Journey**. His second production, which was reprinted numerous times, continued where *Scenic Discovery* ended offering an even more personal and acute vision of the state.

His career blossomed yet he increasingly became his own worst critic. He never settled for "good enough." Walter Choroszewski is, above all else, an artist; a maestro orchestrating every nuance of what he is seeking. He is a poet laureate with a camera.

Not content with *just* producing books, Walter introduced a scenic wall calendar of his New Jersey images; and not content with just "one" New Jersey calendar, Choroszewski soon added a New Jersey *gardens* calendar. With each subsequent year he continued to expand his territory to include neighboring states, cities, lighthouses, gardens, bridges and coastal scenes from Maine to Virginia. By 2004, Walter was producing 12 annual wall calendars of his photos. Oh, there have been many imitators as bookstore shelves have become inundated with a plethora of other New Jersey calendars. But for me and many of his fans, the "Choroszewski" version is "THE" New Jersey calendar. We just wouldn't settle for less!

An artist's brain doesn't work like everyone else's and Walter is typical of the breed. Light and composition are more important to him than mundane things like where he parks his car or leaves his keys. One afternoon I received a phone call from Walter who happened to be in my neighborhood. Walter had finished photographing at the Ford Mansion in Morristown and discovered that he needed some assistance. He knocked on the door of a nearby residence (long before cell phones) to call me to ask if I could come by to help him. *"Bring some fishing tackle,"* he added. Within minutes, I arrived in Morristown and Walter and I were soon sitting on the curb, dropping a line, with my biggest treble-hooked lure attached, down the storm drain to retrieve his car keys.

I believe that Walter came as close to perfection as an artist can get in **THE GARDEN STATE In Bloom** which brightened bookstores in 1993. That book won Gold and Silver medals from the Art Directors Club of New Jersey and, like his previous efforts, was showered with accolades from the press and grateful Garden State aficionados alike. No publication has ever honored New Jersey's beauty more.

Sadly this exquisite book, like many other of Choroszewski titles, is "sold out." Thankfully you now have another chance to see and cherish some of his best photographs no longer available in their original editions. Walter has capsulated his great success in catching his adoptive state's charm in this reprise of 25 years of making New Jerseyans—and hopefully, some of our sneering critics—astonished at how truly beautiful is the State of New Jersey.

Take the road Choroszewski has followed—the path less traveled. His way leads into villages replete with country stores, into and beyond cities with their own kind of beauty, along the beaches of Cape May and over the rock-strewn trails leading to High Point.

Let Walter show you clear vistas from atop Sunrise Mountain or Mount Tammany. Experience the thrill of boardwalk amusement rides, the blur of bicycles whizzing past in the Tour of Somerville, or surfing the perfect waves that break at Manasquan. Travel with him down the tea-colored Oswego River, or fly with him above the new "Gold Coast" of

Jersey City for a face to face meeting with New Jersey's Statue of Liberty. Meet the fishermen, artists and "Norman Rockwell-esque" characters that have posed for his cameras over the past quarter century. Walter Choroszewski is proud of his Polish and Slovak heritage (his paternal grandparents emigrated to Perth Amboy). Join him as he finds rainbows of color at the varied ethnic festivals throughout this melting pot called New Jersey.

No Choroszewski photo of any New Jersey town or city, turnpike or rural road, was new to me; they all remain evergreen in my memory after more than 60 years of writing about this state. However, through these photographs of New Jersey you, too, can share what Walter and I already know—that New Jersey is the very essence of America.

Viewing the state as Walter has done, then freezing that view into perfection, causes one to wonder why anyone would want to live anywhere *but* New Jersey. Walter Choroszewski makes it easy. Pick up this volume, settle back in an easy chair, and be glad that he has found a New Jersey that few people ever recognize or acknowledge.

John T. Cunningham is "Mr. New Jersey". He has long been recognized as the state's foremost writer of New Jersey history. His first book, THIS IS NEW JERSEY, first published in 1953, has been revised five times and has never gone out of print. The latest two editions feature a portfolio of full color and black & white photos by Walter Choroszewski. Cunningham has also written more than 2,000 magazine articles and has written or been associated with more than 30 documentary films. He was one of the founders of the New Jersey Historical Commission and was its chairman for six years. Nine universities have awarded him honorary degrees.

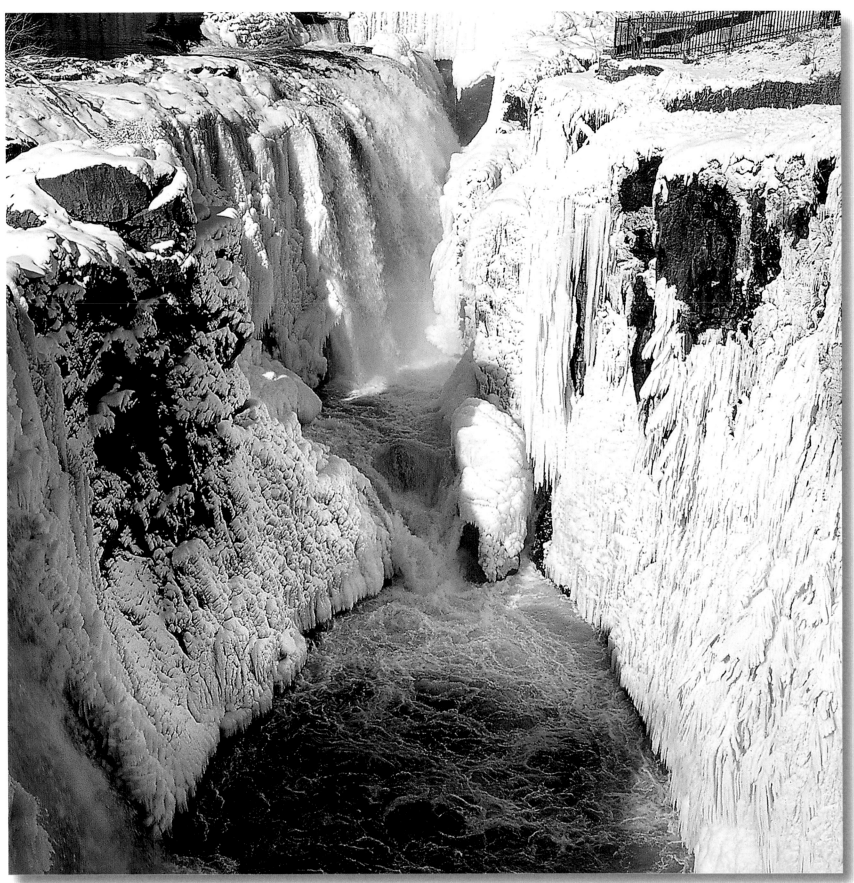

▲ Great Falls, Paterson

PREFACE

My first photo assignment of 25 years ago strangely has never ended. Unlike my peers, some of whom "moved on" to photograph the grand vistas of America's national parks, or pursued wildlife images on exotic safaris in Africa or the Galapagos, I "moved in" and accepted an unexplained calling to myopically photograph my adopted state New Jersey *ad infinitum*, almost to *ad nauseam!*

In the spring of 1980, I began photographing the state for my first book, **NEW JERSEY, A Scenic Discovery,** which was published by Foremost Publishers and released in the spring of 1981. This project launched my career as a photographer, publisher, speaker and *cheerleader* for New Jersey.

Today a visit to superstores like Borders and Barnes & Noble, or to the almost extinct neighborhood bookstore, one would find a burgeoning New Jersey section with numerous photography books and titles covering every conceivable aspect of the Garden State. Twenty-five years ago my photo book was the only one available in most bookstores. To paraphrase the popular country song by Barbara Mandrell and George Jones: *I was "Jersey" ...when photographing "Jersey" wasn't cool!*

Compared to the longstanding career of my good friend John Cunningham (*who is as productive and prolific as ever!*) my 25 years pale as a mere blip in New Jersey's timeline. But these New Jersey years have been very good to me! And this anniversary gave me reason to reflect on my time spent searching for (*and finding*) a positive perspective on New Jersey, as well as a chance to share some of my most popular images in a virtual "greatest hits album."

Since 1981, I have photographed 12 books and over 30 calendars featuring New Jersey. The task of selecting memorable images from each title was more challenging than I anticipated. In addition to photos from prior publications, I also included some recent photography and never published personal favorites. Some images were selected for their common subject matter. Others were matched for artistic reasons—similar color, composition or lighting. Designing a new book is almost as much fun as photographing for it. It is always a thrill to find photos that seamlessly juxtapose with another as if they were *meant to be together*, sharing the page.

To complement some of the photographs I included personal anecdotes and random musings—stories of the interesting people I've met over the years, my favorite locations, tales of my *sometimes unusual* experiences, and a bit of facts and Jerseyana.

The New Jersey landscape has changed greatly during the last 25 years, but still entwined within those changes lies a beautiful land rich with natural treasures, history and charm that I value and enjoy. As I continue to photograph my home state of New Jersey, I find new challenges—but also *new discoveries*!

Walter Choroszewski

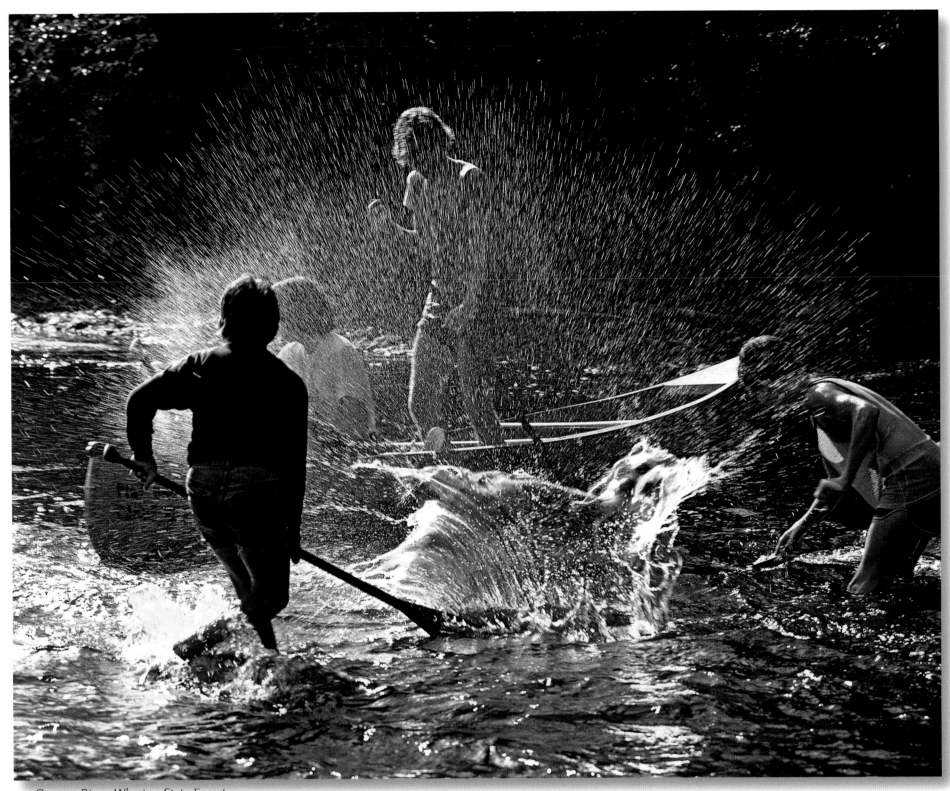

▲ Oswego River, Wharton State Forest

New Jersey Botanical Garden at Skylands, Ringwood ▶

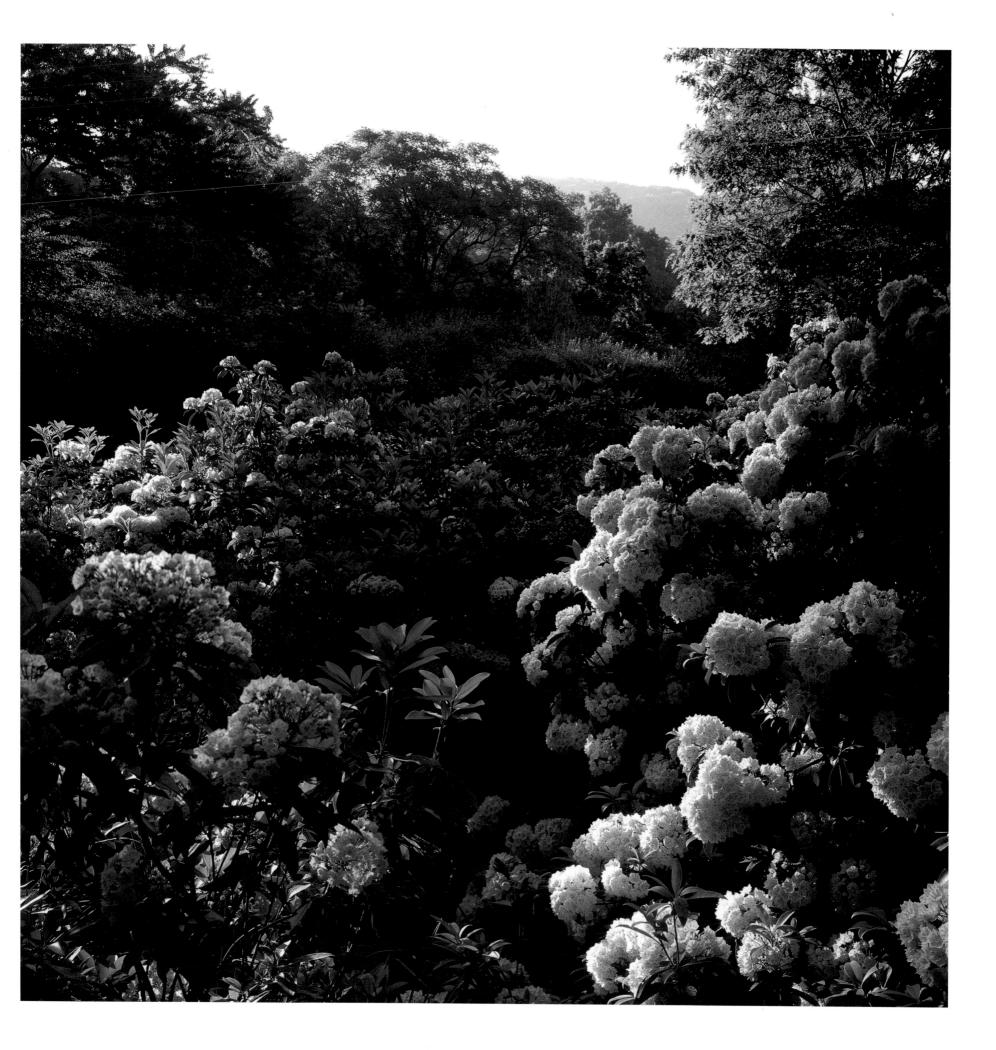

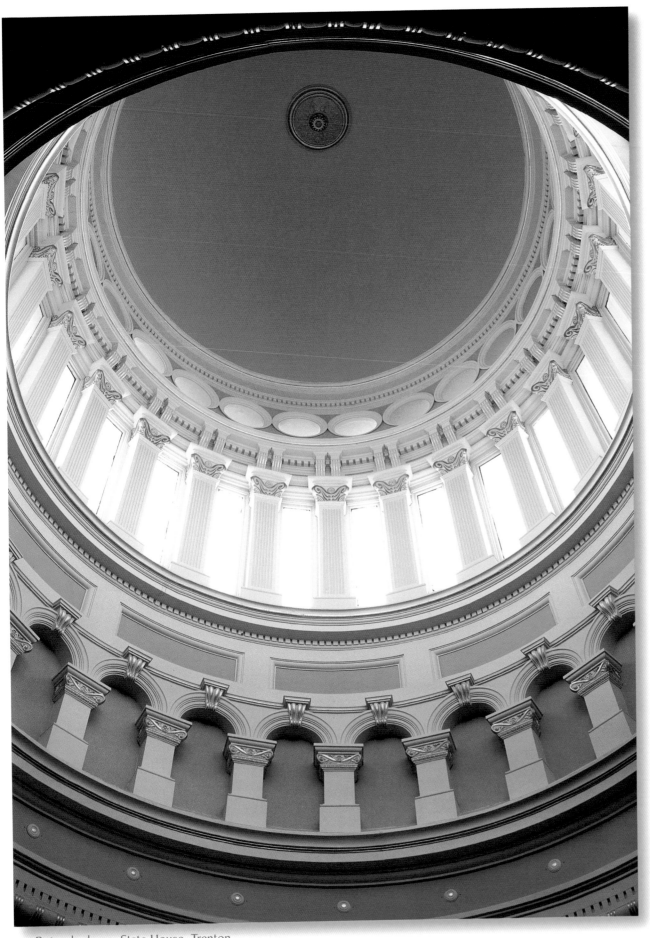

▲ Rotunda dome, State House, Trenton

New Jersey State Seal,
State House, Trenton ▶

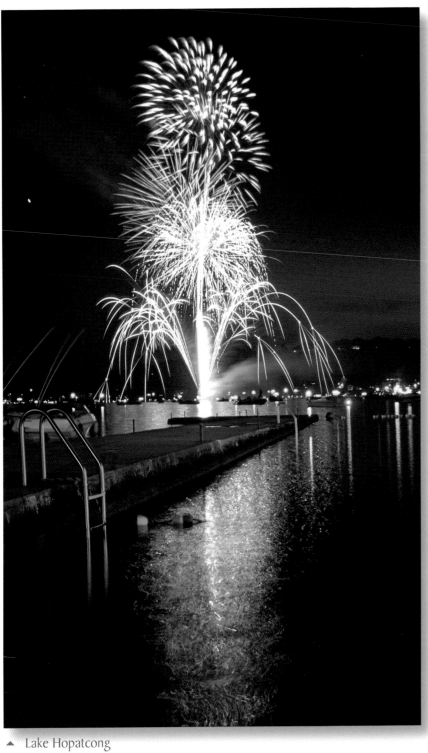

▲ Lake Hopatcong

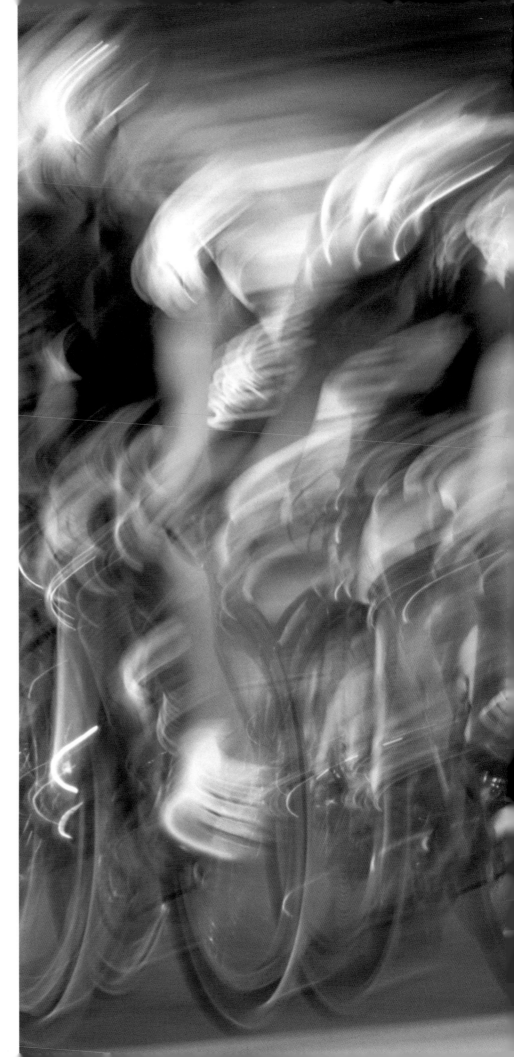

Tour of Somerville, Somerville ▶

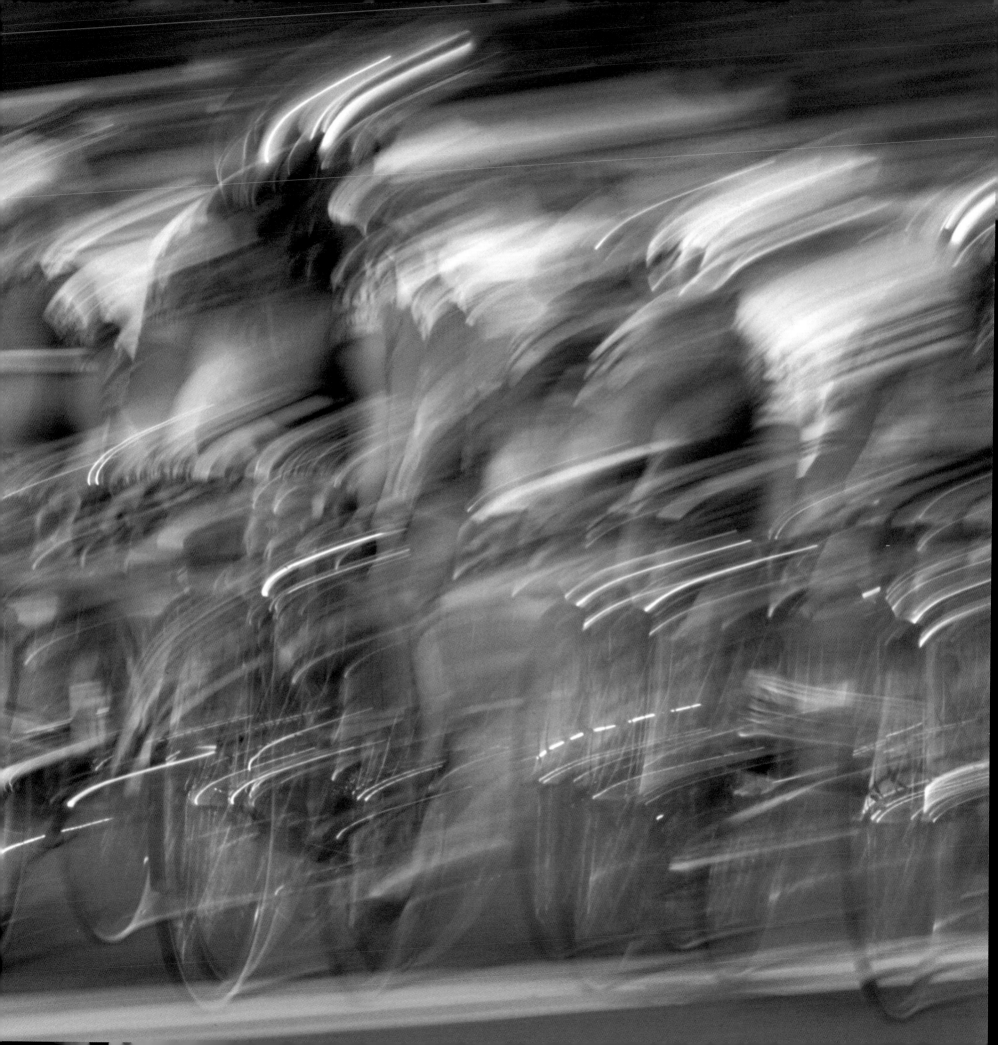

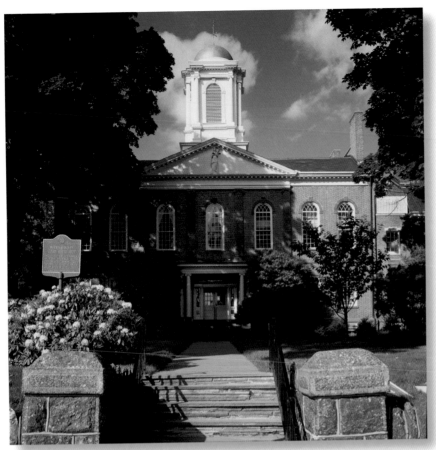

▲ Morris County Court House, Morristown

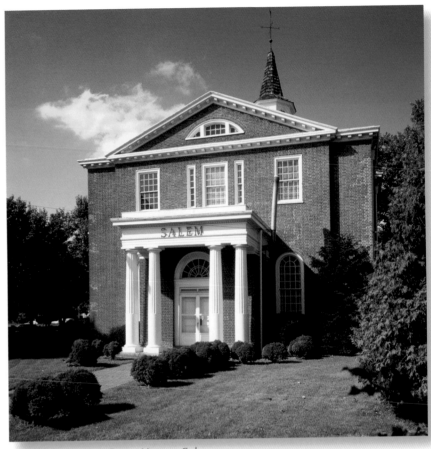

▲ Salem County Court House, Salem

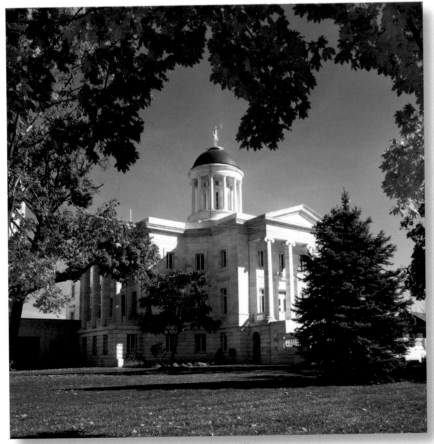

▲ Somerset County Court House, Somerville

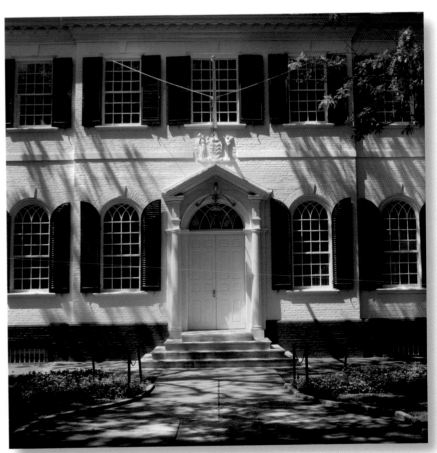

▲ Burlington County Court House, Mount Holly

Bergen County Court House, Hackensack ▶
Cape May Point ▶▶

16

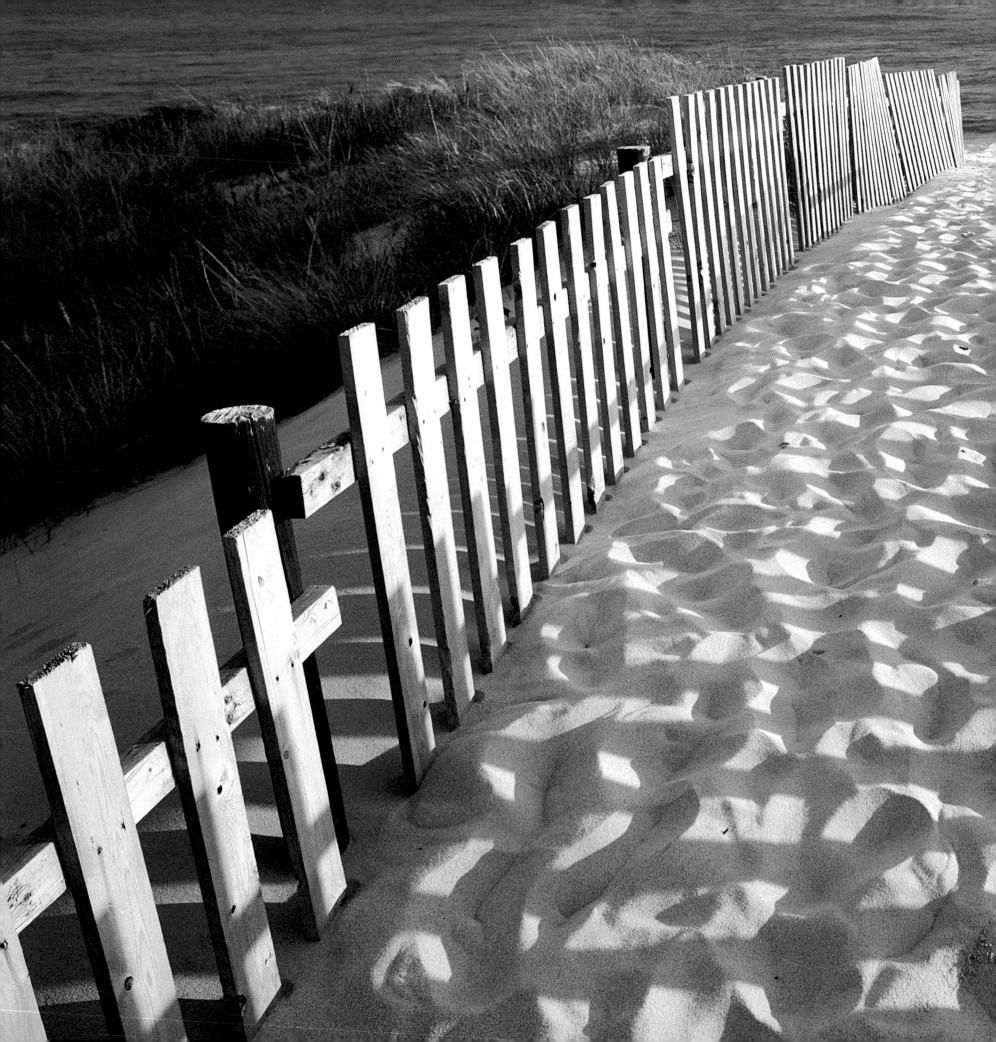

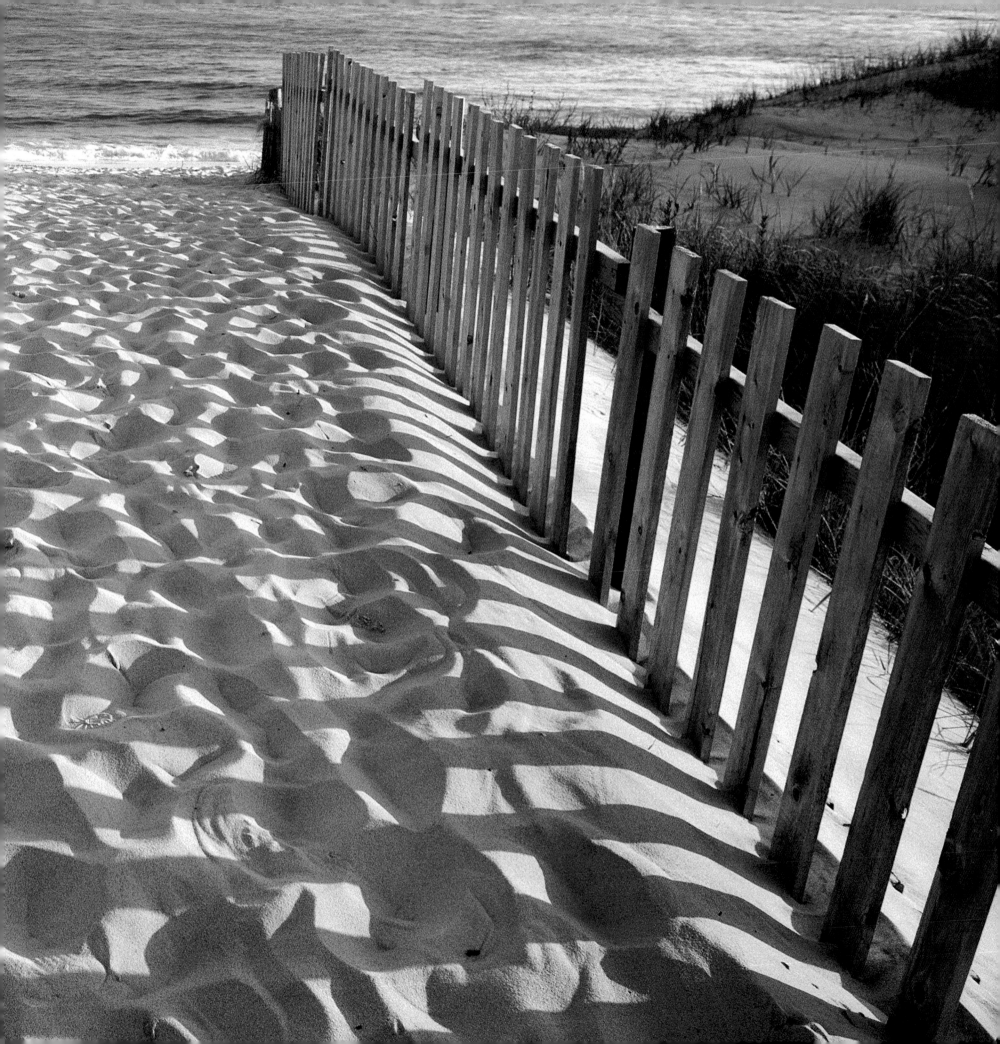

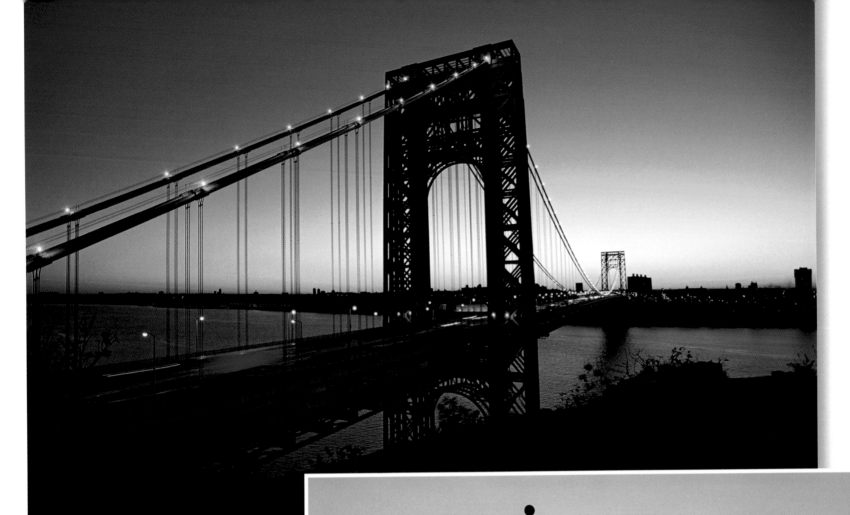

▲ George Washington Bridge, Fort Lee

Dawn is a great time of day for photography. I would awaken at 4 AM (more common earlier in my career) and I would drive in the dark to be on location and ready for the first light of morning. The black sky of night initially takes on a purple hue as pinks and yellows illuminate the horizon, followed by some rapid color changes just prior to sunrise. This technicolor show is over in a matter of minutes, but definitely worth the effort to see it.

▲ Wesley Lake, Asbury Park & Ocean Grove

Lido Diner, Springfield ▶

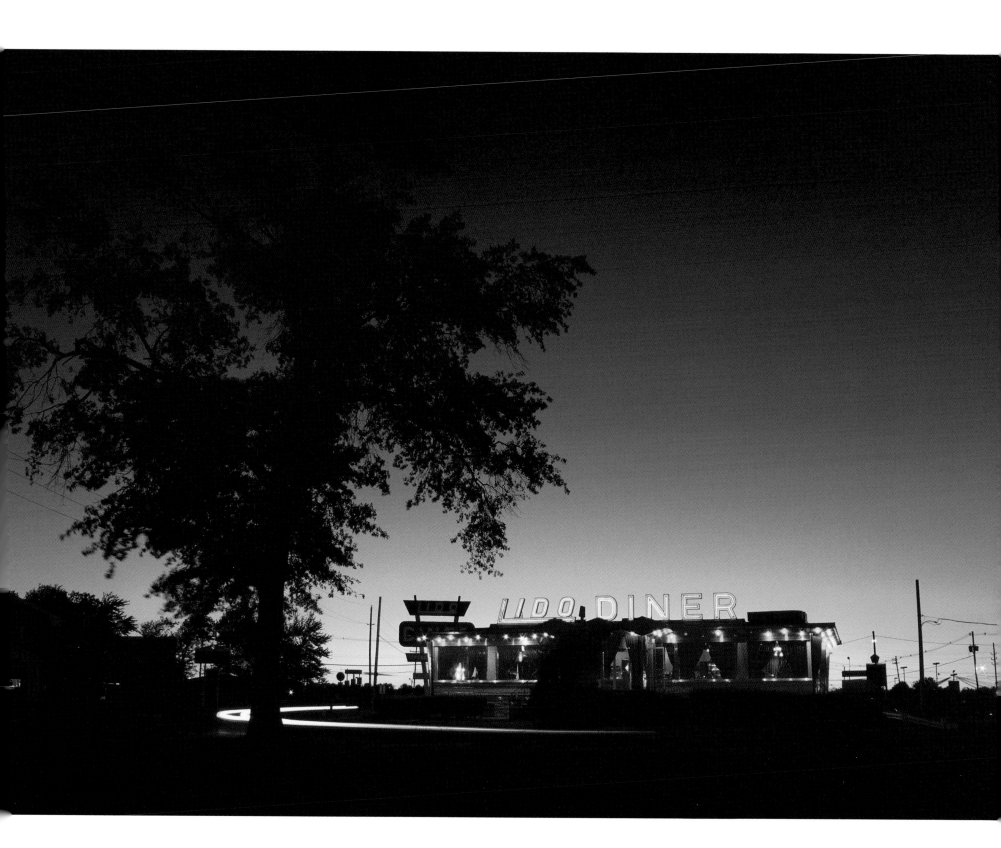

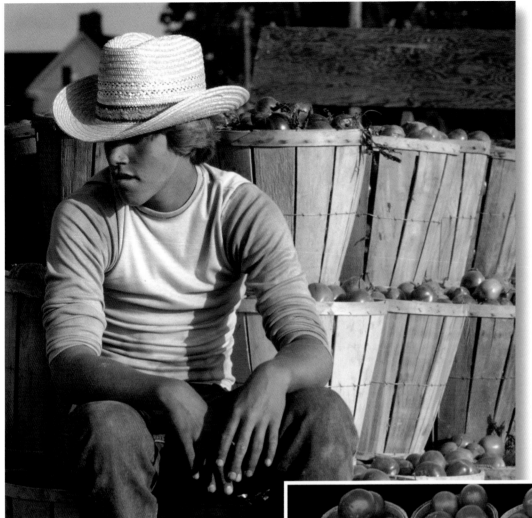

▲ Culver Lake

▲ Daretown

JERSEY TOMATOES

▲ Columbus Farmers Market, Columbus

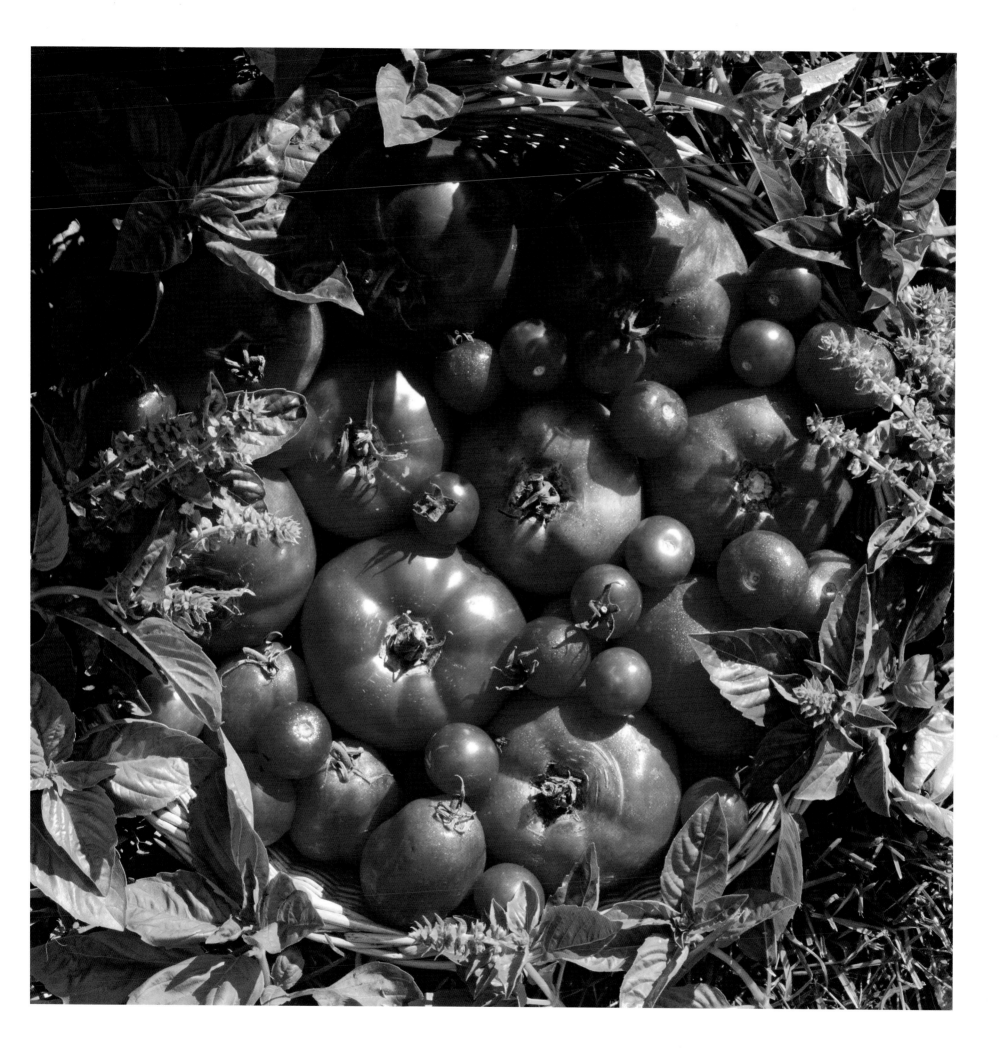

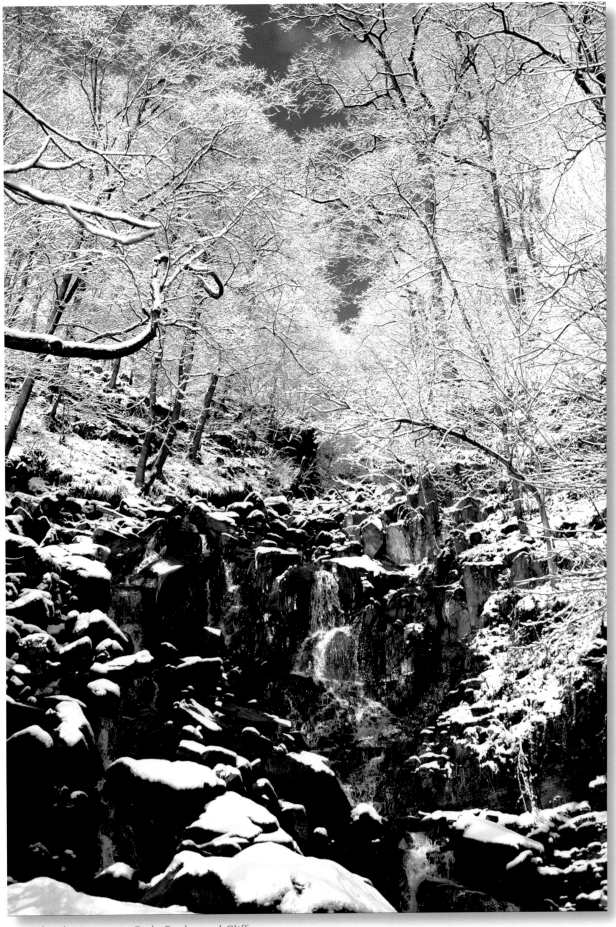

▲ Palisades Interstate Park, Englewood Cliffs

Green Sergeant's Covered Bridge,
Wickecheoke Creek, Delaware Township ▶

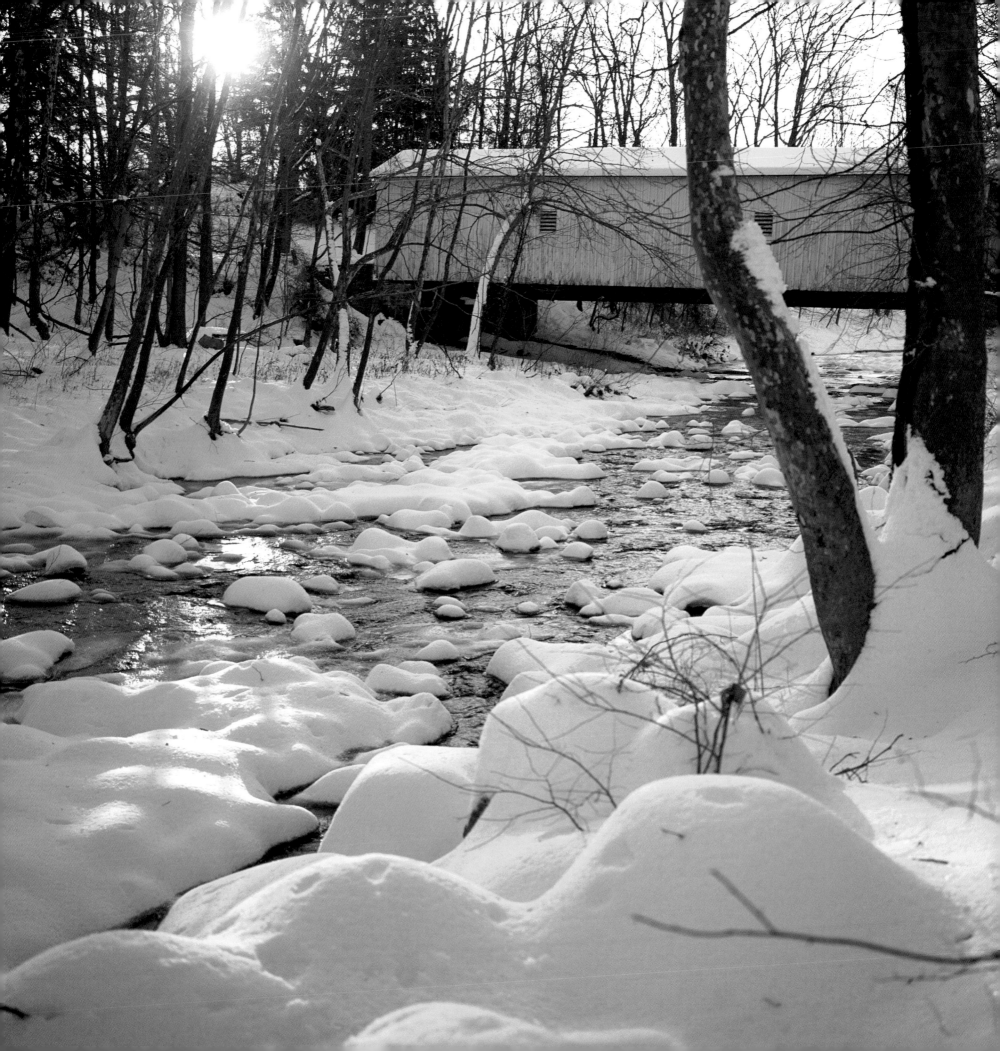

▲ Hoboken

▲ Military Park, Newark

▲ Bayonne

Earth Day, Ironbound Section, Newark ▶

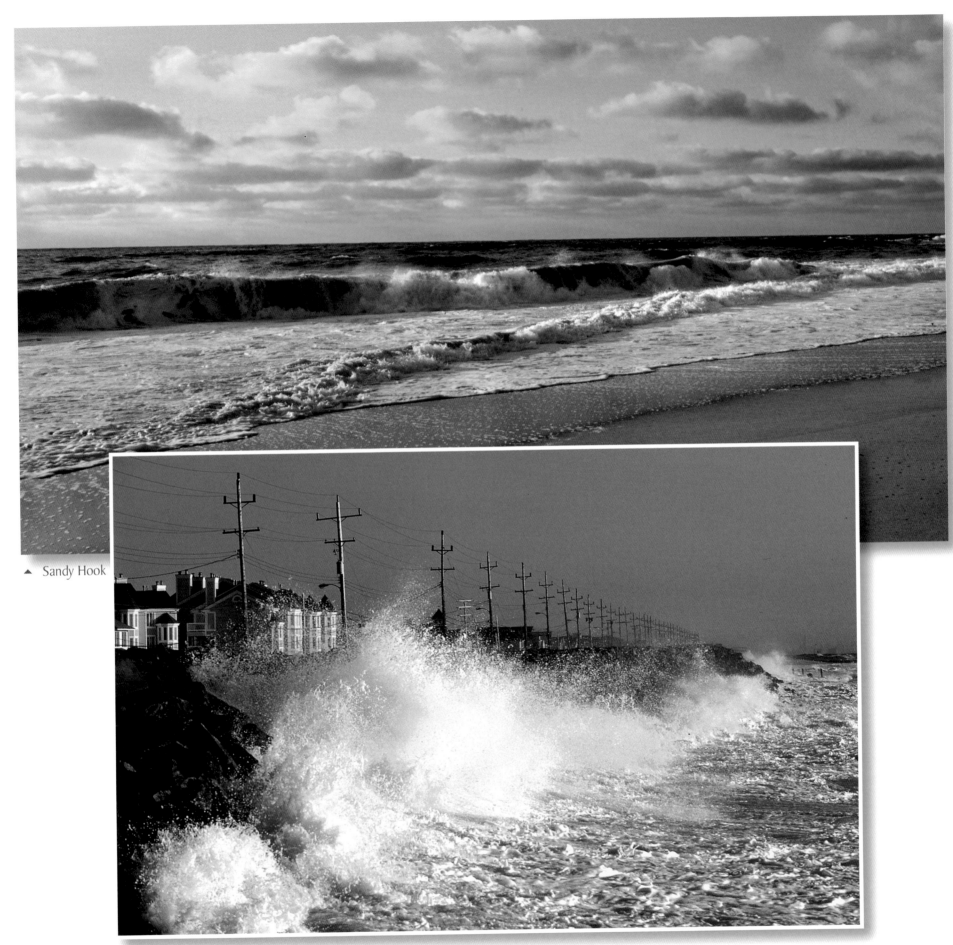

▲ Sandy Hook

▲ Sea Bright

Cape May Point State Park ▶

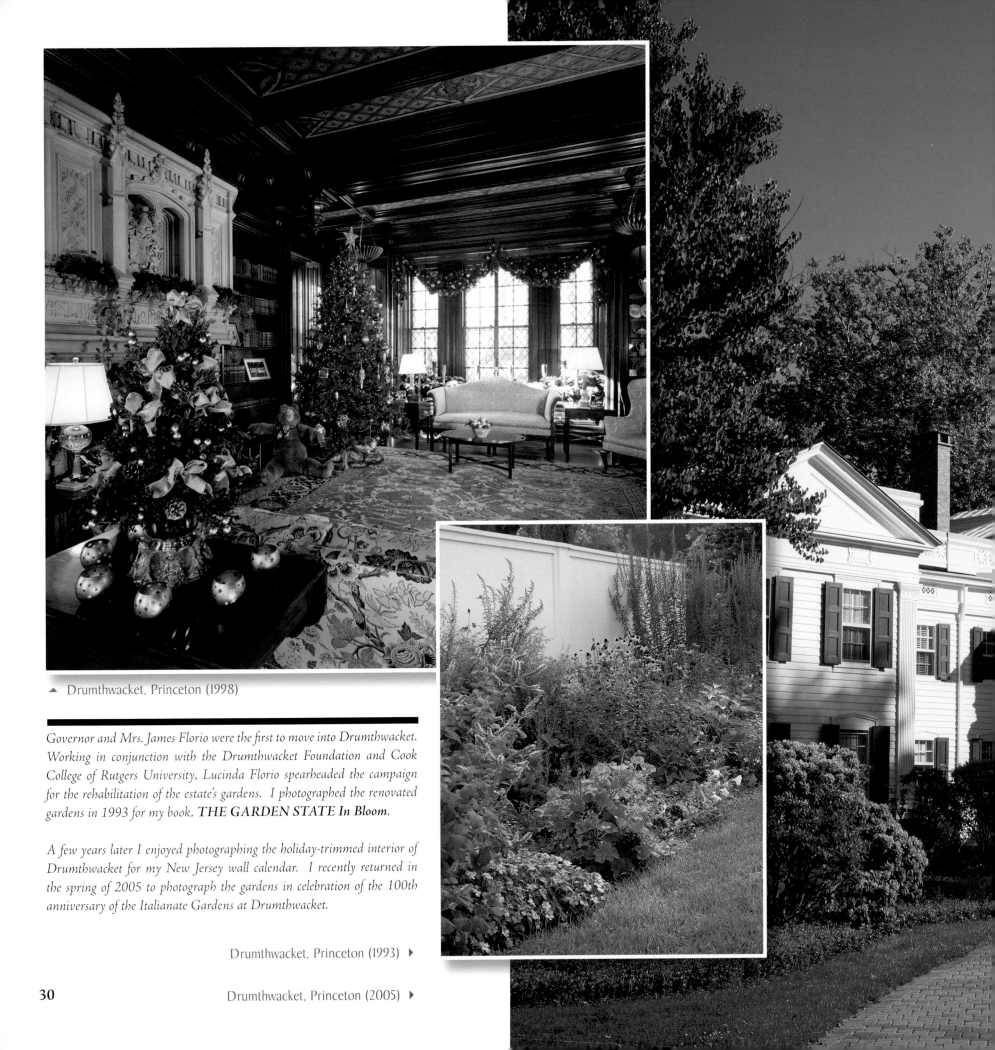

▲ Drumthwacket, Princeton (1998)

Governor and Mrs. James Florio were the first to move into Drumthwacket. Working in conjunction with the Drumthwacket Foundation and Cook College of Rutgers University, Lucinda Florio spearheaded the campaign for the rehabilitation of the estate's gardens. I photographed the renovated gardens in 1993 for my book, **THE GARDEN STATE In Bloom**.

A few years later I enjoyed photographing the holiday-trimmed interior of Drumthwacket for my New Jersey wall calendar. I recently returned in the spring of 2005 to photograph the gardens in celebration of the 100th anniversary of the Italianate Gardens at Drumthwacket.

Drumthwacket, Princeton (1993) ▶

Drumthwacket, Princeton (2005) ▶

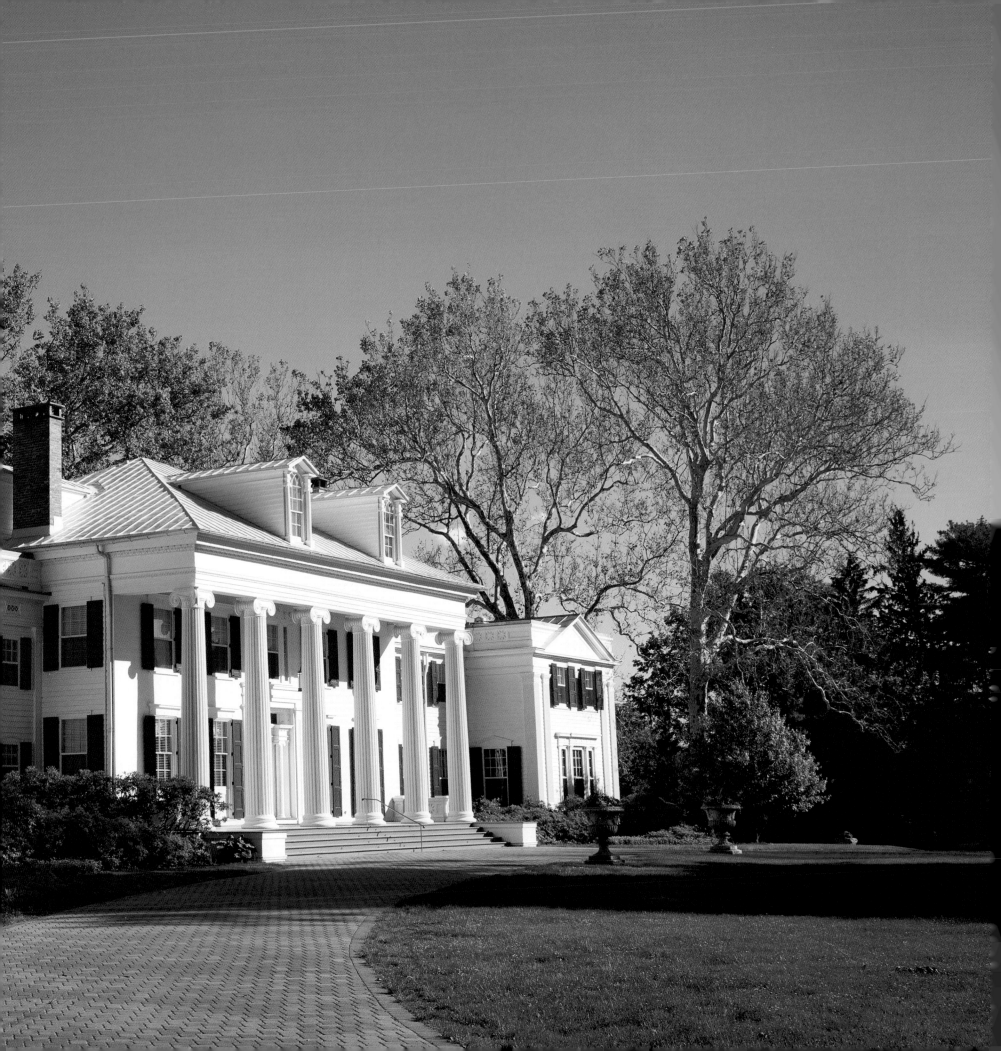

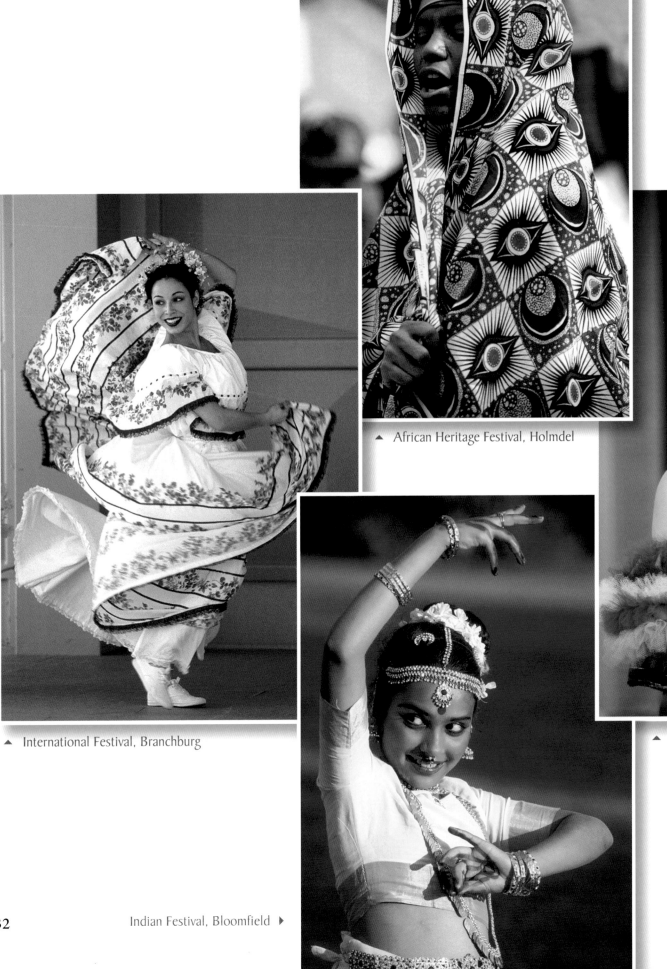

▲ African Heritage Festival, Holmdel

▲ International Festival, Branchburg

▲ Portugese Festival, Newark

32 Indian Festival, Bloomfield ▶ Hungarian Festival, New Brunswick ▶

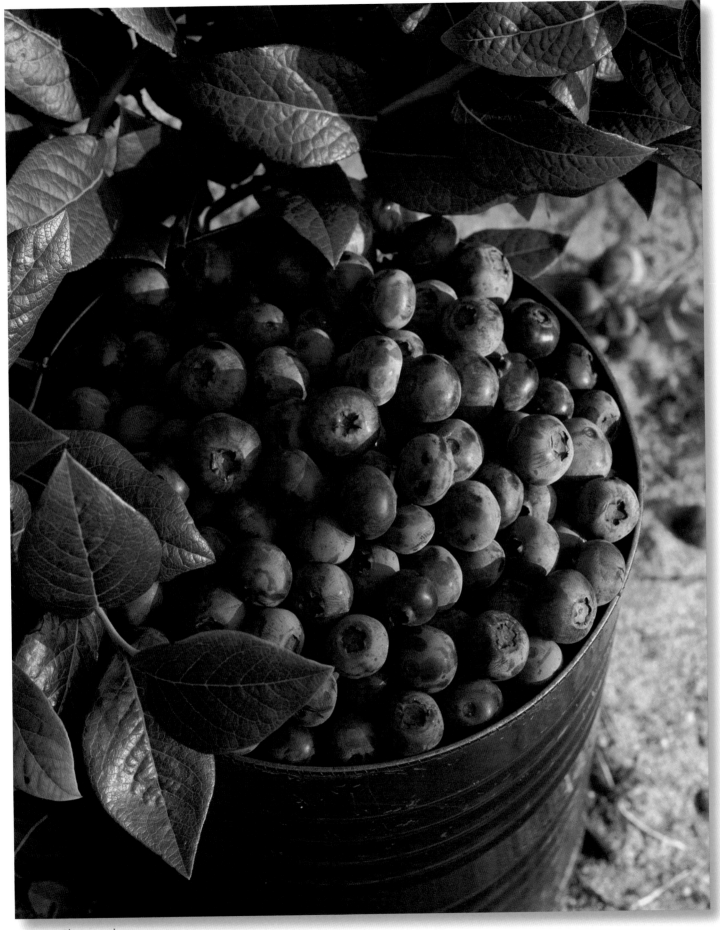

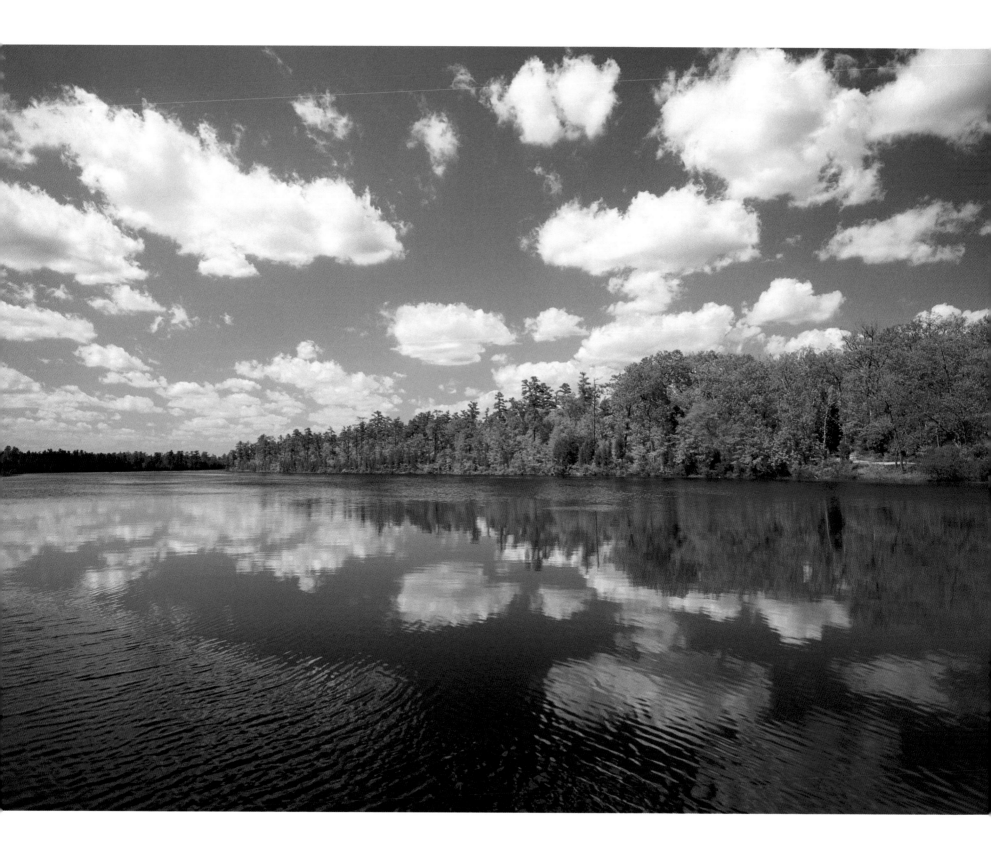

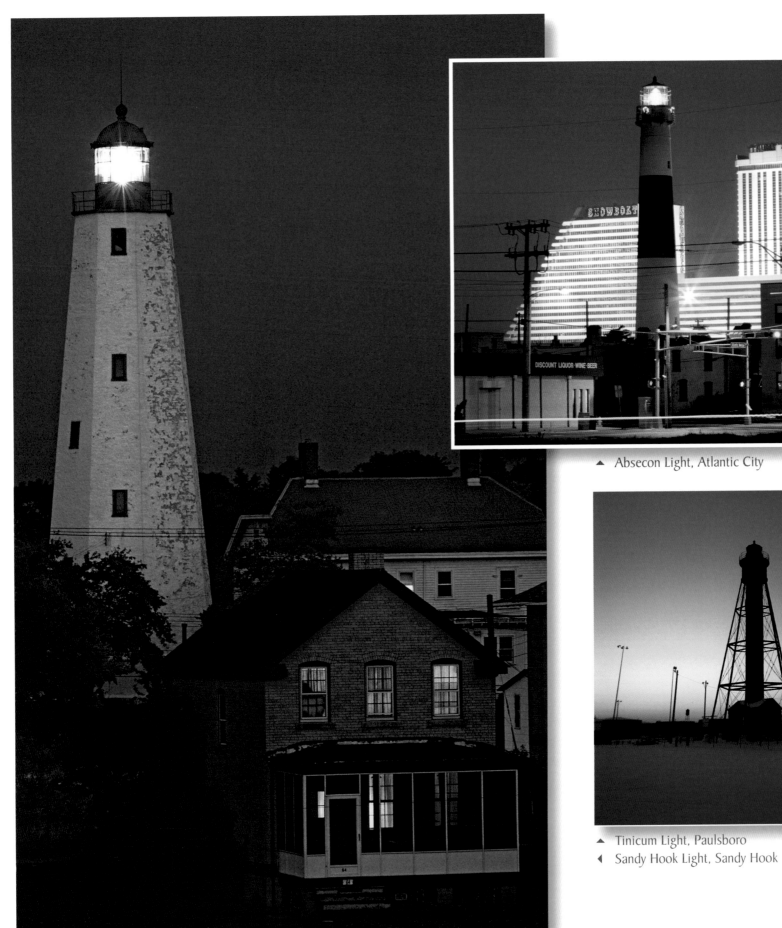

▲ Absecon Light, Atlantic City

▲ Tinicum Light, Paulsboro
◀ Sandy Hook Light, Sandy Hook

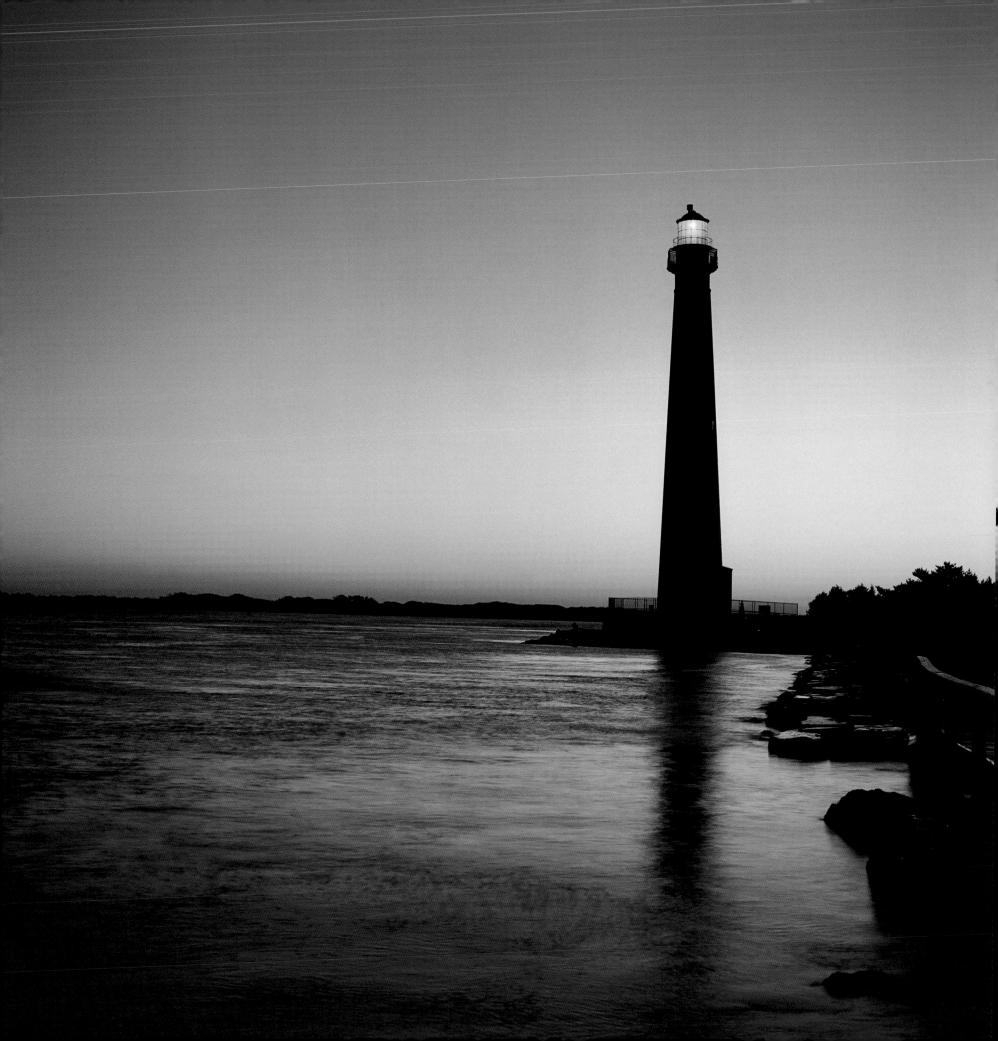

by Land, Sea and Air

▲ 4th of July Parade, Lebanon
◀ Miss Allonia, Memorial Day, Lambertville

VFW Post 2290, Manville ▶

▲ Holland Township

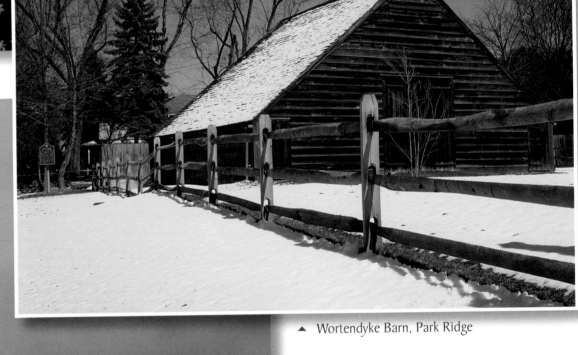
▲ Wortendyke Barn, Park Ridge

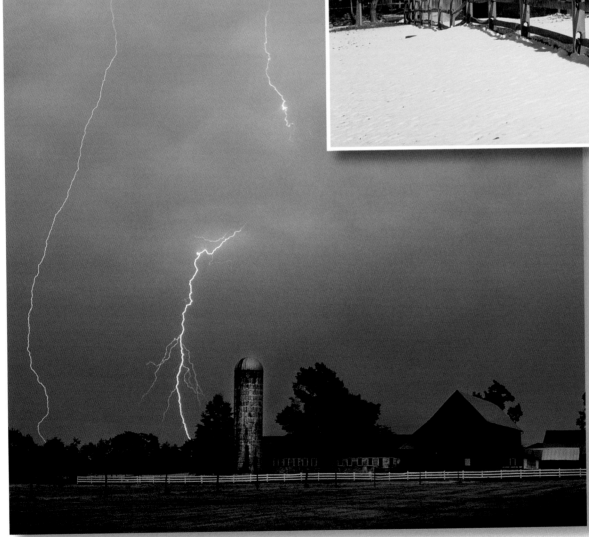
▲ Westampton Township

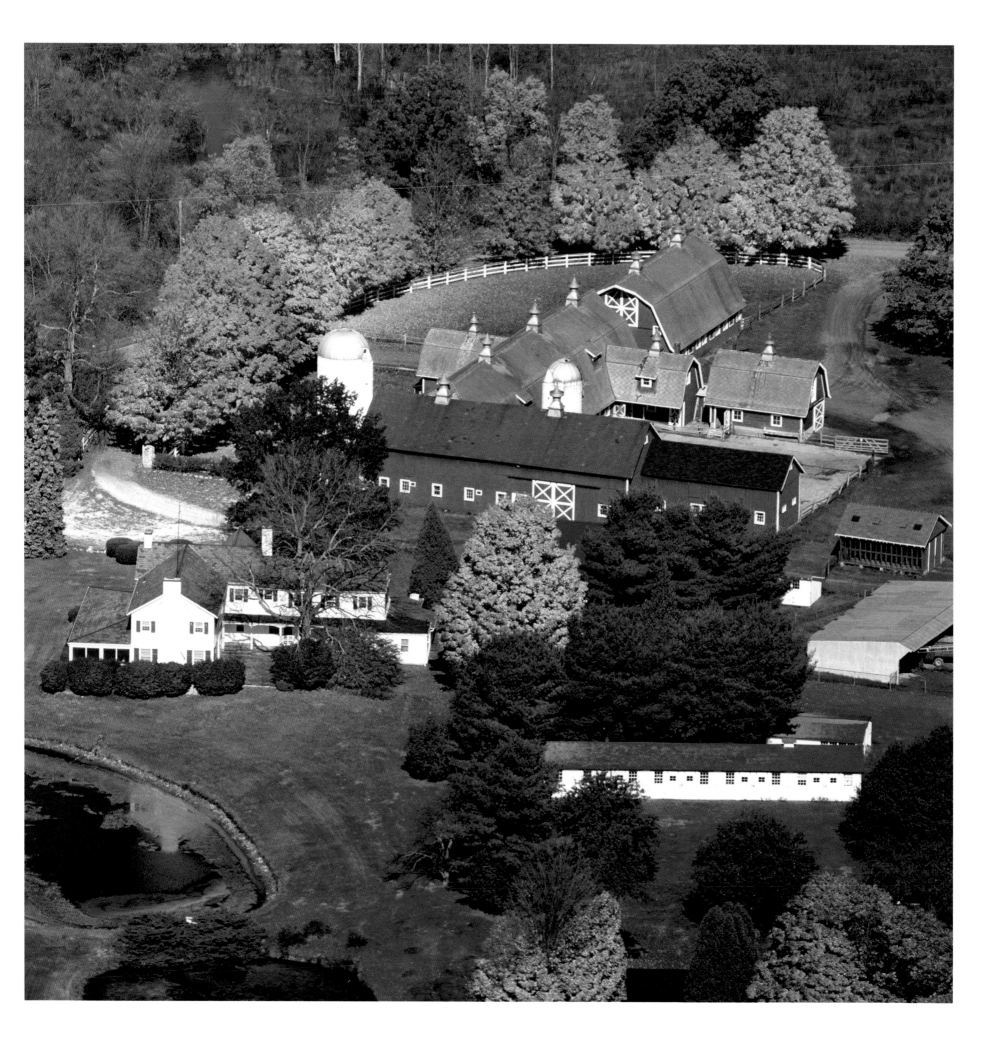

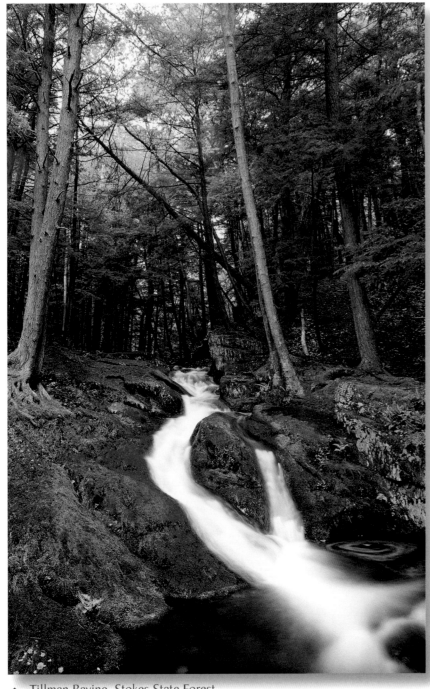

▲ Tillman Ravine, Stokes State Forest

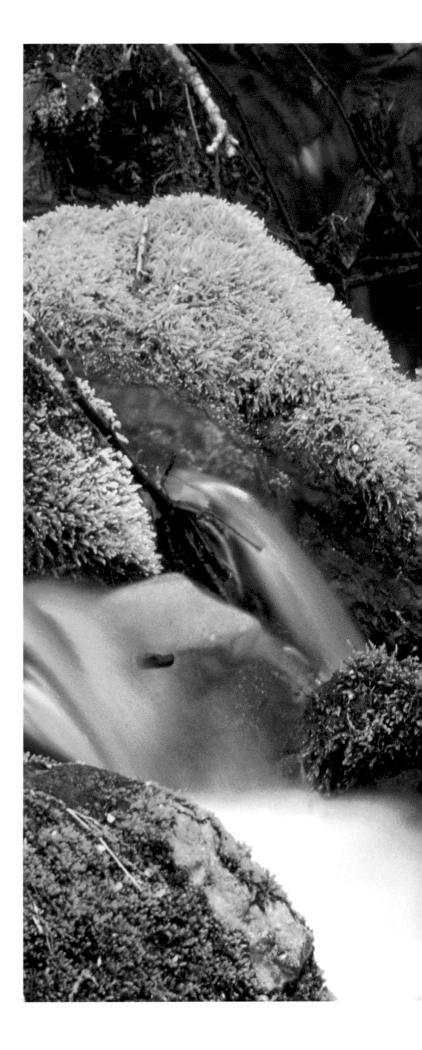

Worthington State Forest ▶

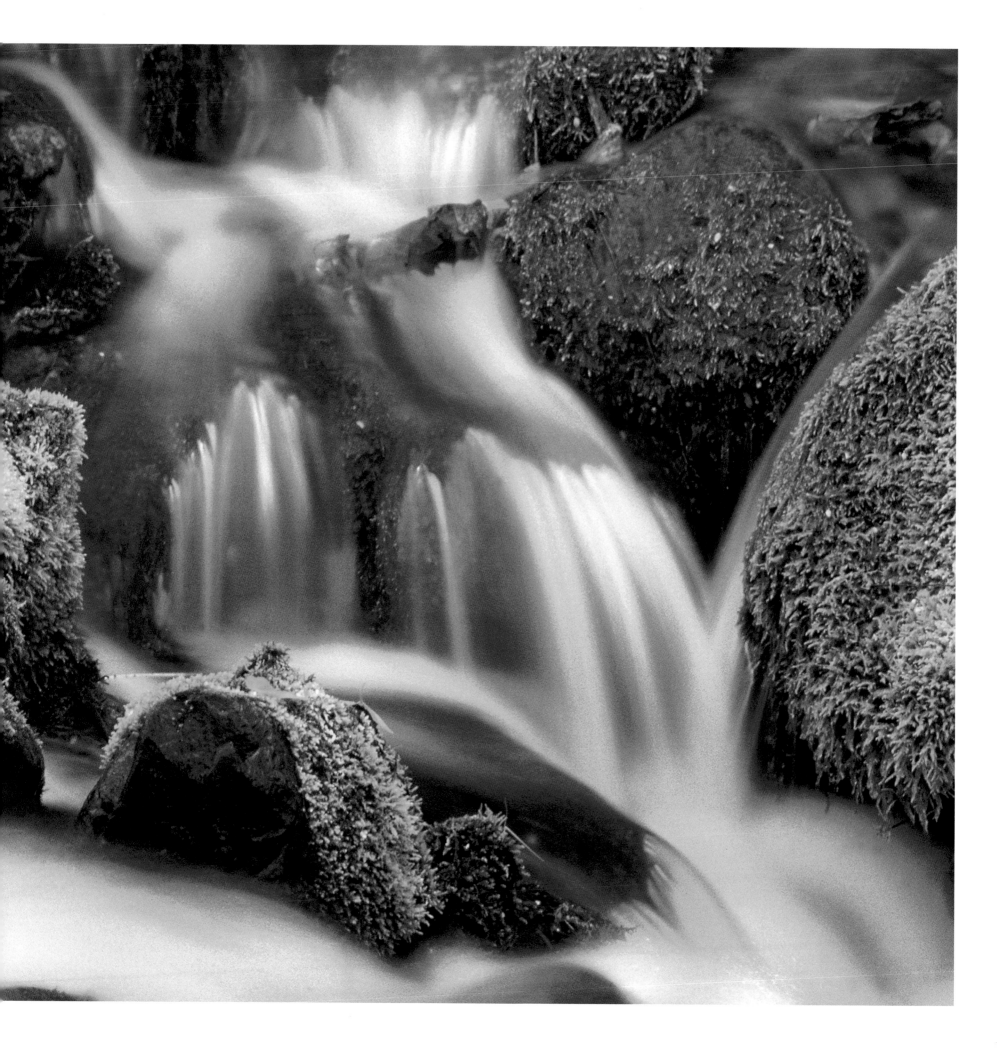

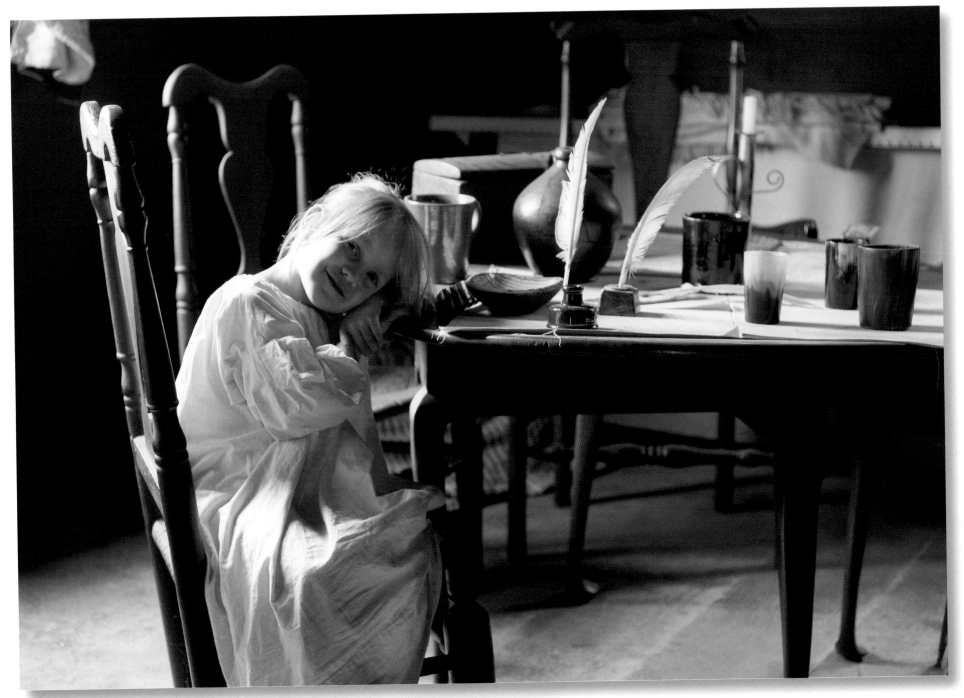

▲ Tempe Wick Farm, Morristown

I truly appreciate the passion and commitment that reenactors bring to many of New Jersey's historic sites. While photographing at the Tempe Wick Farm in Jockey Hollow in the summer of 1985, I noticed that one of the docents brought her daughter to work. She was a wispy-haired child in period dress who was playing outside the Wick House. I asked for permission to photograph her and soon afterwards this photo (above) was featured nationally in **New Jersey & You** tourism ads encouraging children to visit the historic sites of New Jersey.

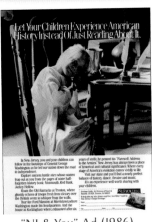

"NJ & You" Ad (1986)

Through the years I have befriended many New Jersey patriots. James Kurzenberger, curator of Wallace House and Old Dutch Parsonage, is one of those special friends who has been around for as long as I can remember. Jim (fiddle player on the far right) has been lovingly renovating these two historic sites for over 20 years. He is not only a talented craftsman, but he is also a scholar on George Washington and an entertaining reenactor who was always willing to help me whenever I needed a special photograph to celebrate New Jersey's revolutionary past.

Wallace House, Somerville ▶

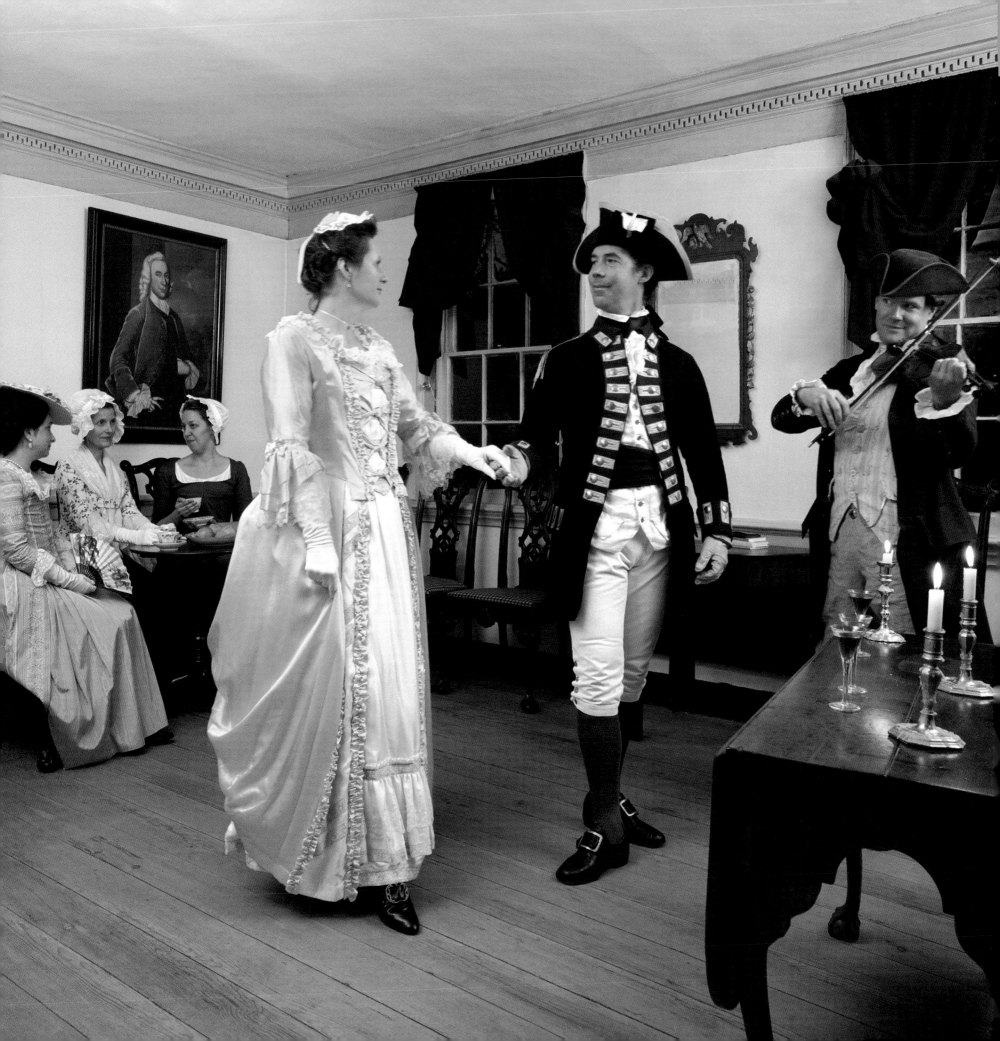

▲ Pine Barrens Gentian, Penn State Forest

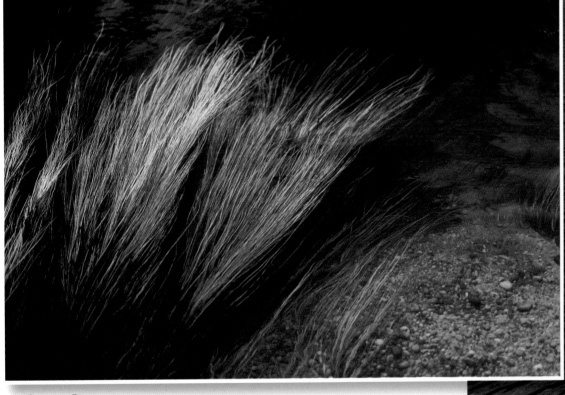

▲ Oswego River

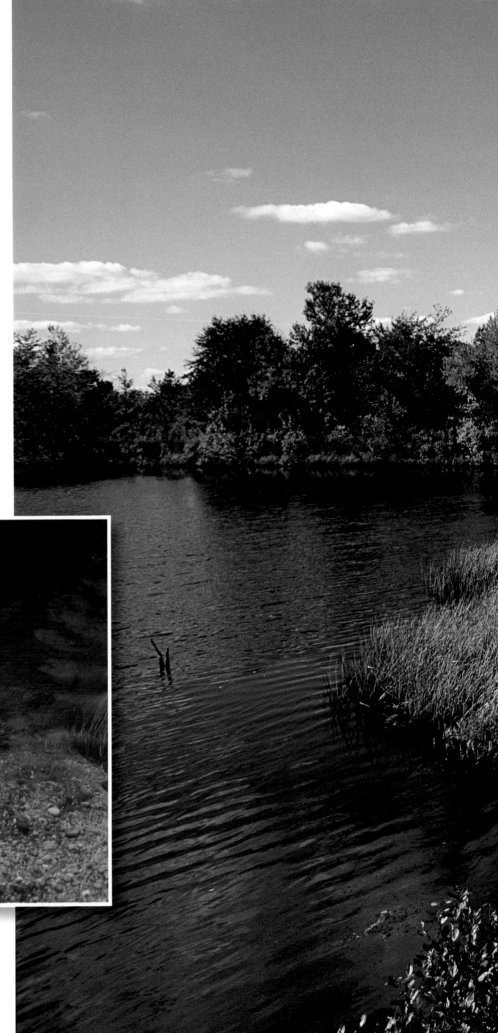

Whitesbog, Brendan T. Byrne State Forest ▶

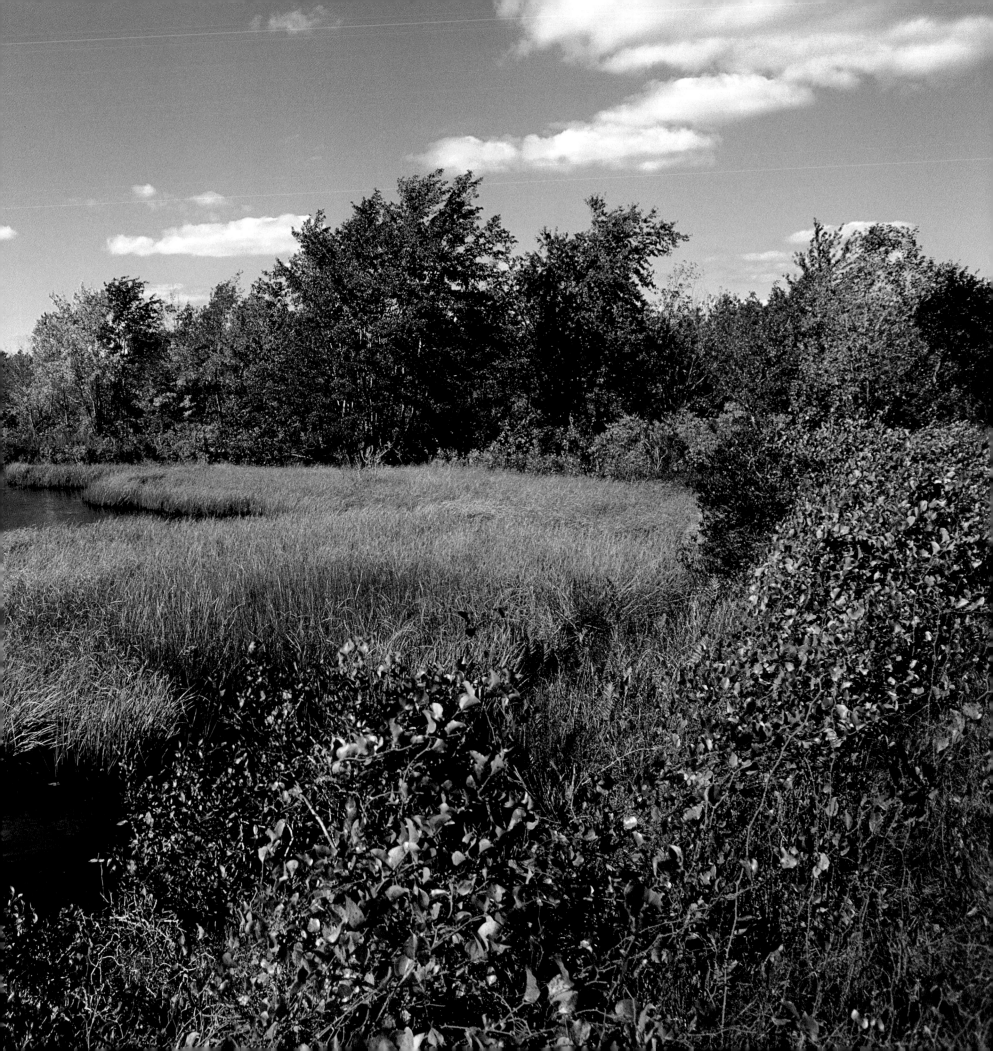

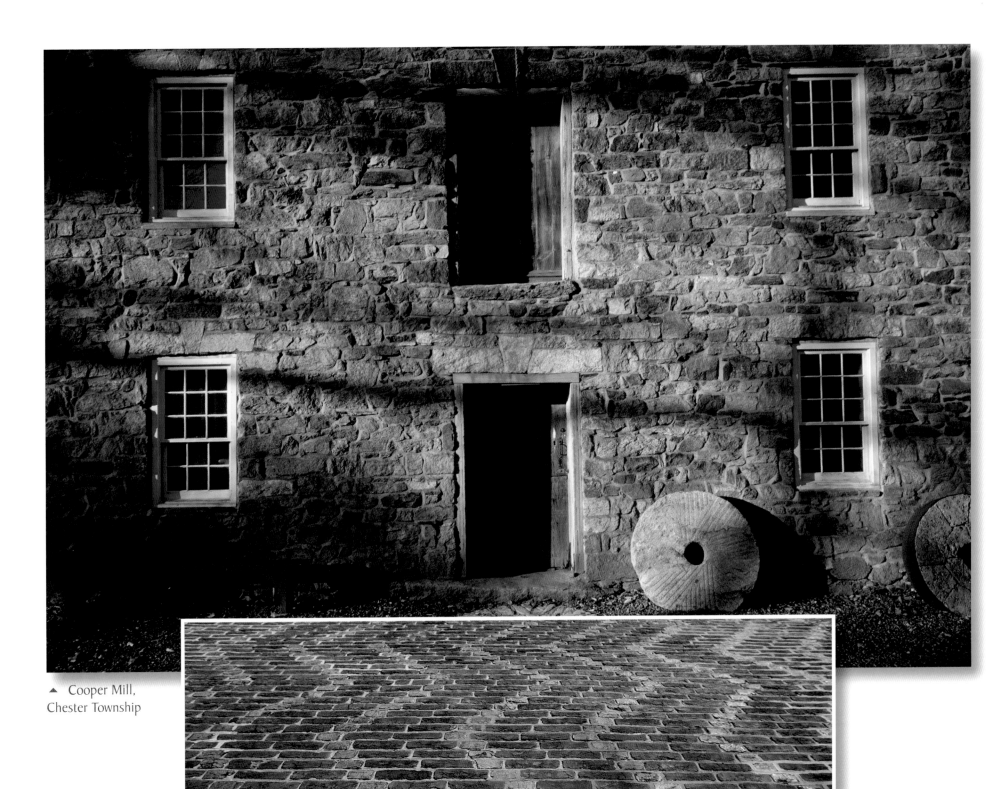

▲ Cooper Mill,
Chester Township

Allaire Village ▶

▲ Hancock House, Hancock's Bridge

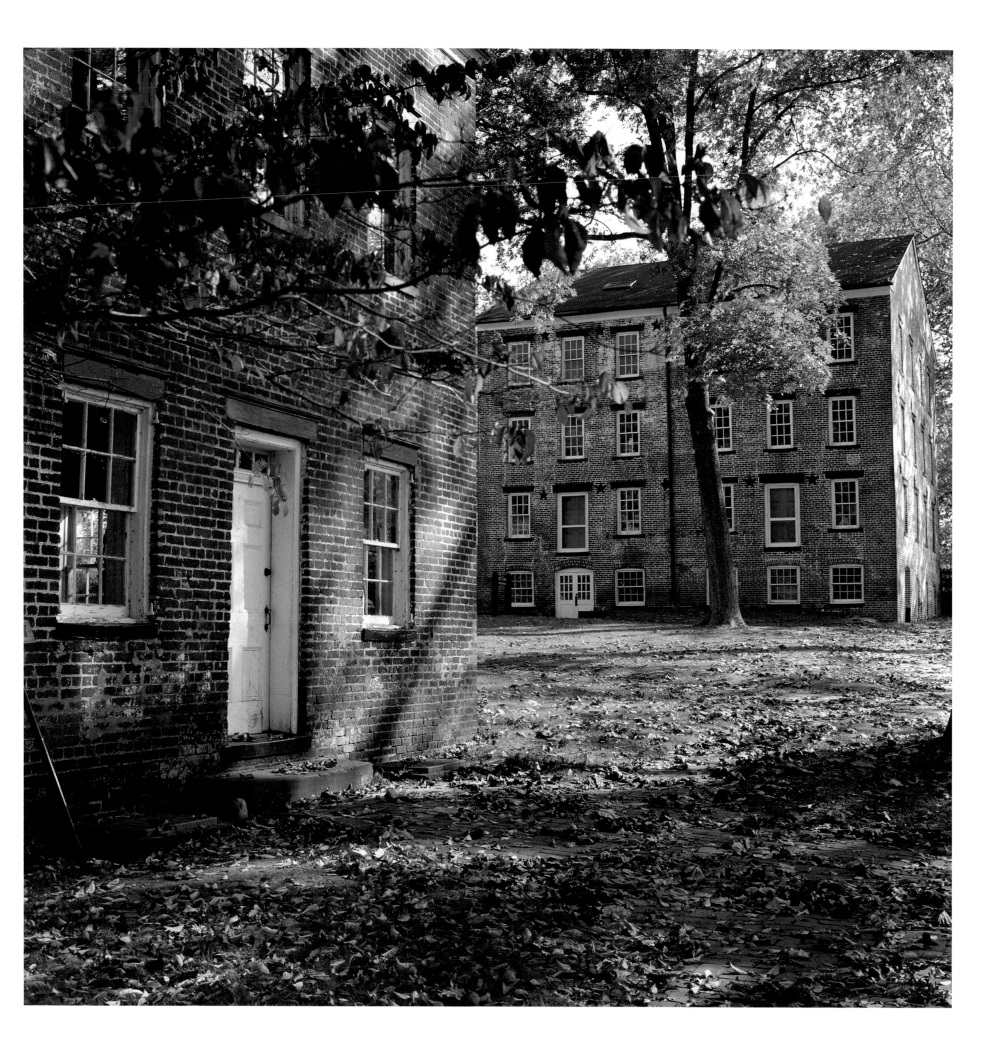

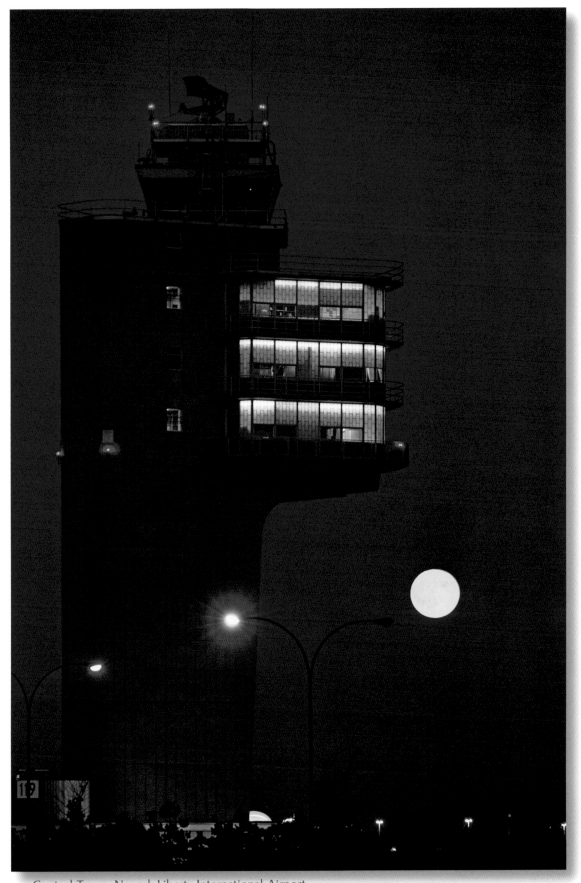

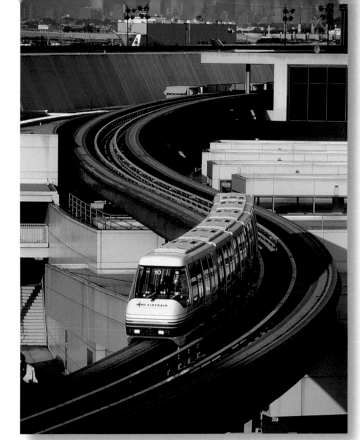

▲ Airtrain, Newark Liberty International Airport

Newark Liberty International Airport is one of the fastest growing airports in the nation. The first air traffic control tower in America was built at Newark Airport in 1935. The 1960 tower (left) was replaced in 2003 with a modern 325-foot tower (right).

Security measures have increased dramatically since 9/11/2001. After a recent flight in 2004, as I was returning to my car, I stopped to take a photo of the Airtrain (above) from the elevated parking deck near Terminal C in the beautiful late afternoon sunlight. Within minutes, an "undercover" Homeland Security agent was dispatched to investigate my actions. He approached me and asked what I was doing. "I'm taking pictures," I replied. "But, why?" he prodded. I was shocked by his lack of appreciation for the beautiful light and said, "Look at it! It's gorgeous!" He then revealed his identity and said, "We watched you take the first photo near the elevator; it was when you moved to the corner for more shots that we decided to check you out." I thanked him for his service!

The overleaf photograph features my popular image of jets on their final approach to the airport, circling above the night skyline of Newark. This photo was taken from the overlook at Eagle Rock Reservation—about 10 miles west of the city.

▲ Control Tower, Newark Liberty International Airport

Newark Liberty International Airport, Newark ▶

Jets on their approach to Newark Liberty International Airport, Newark ▶▶

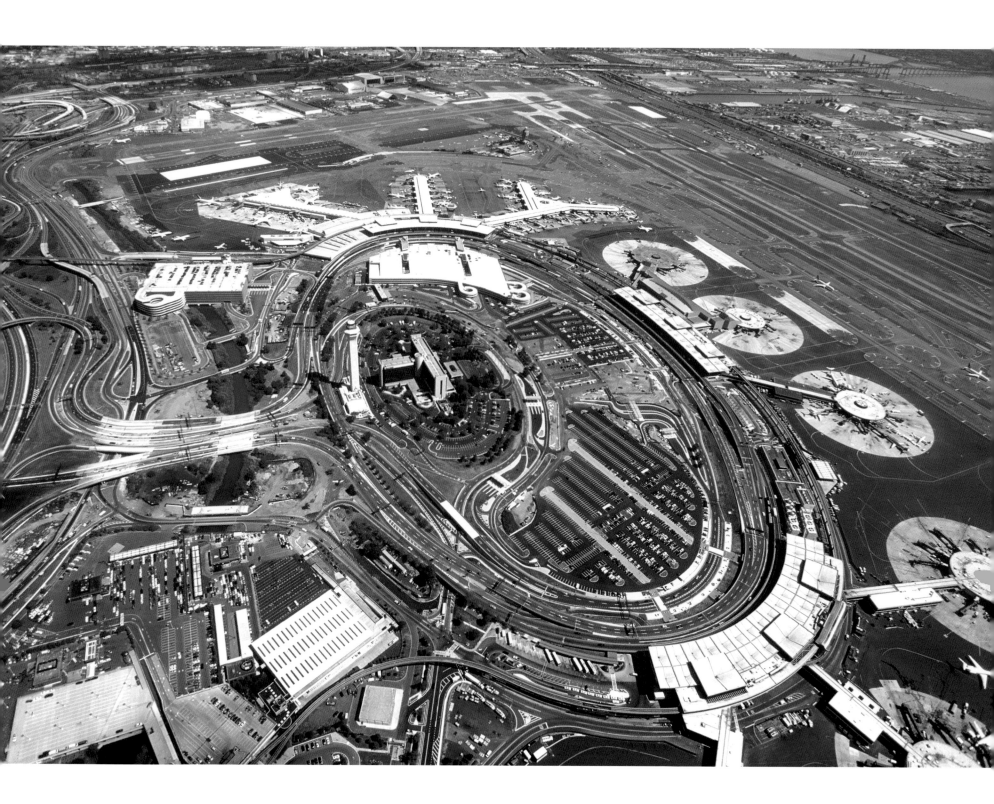

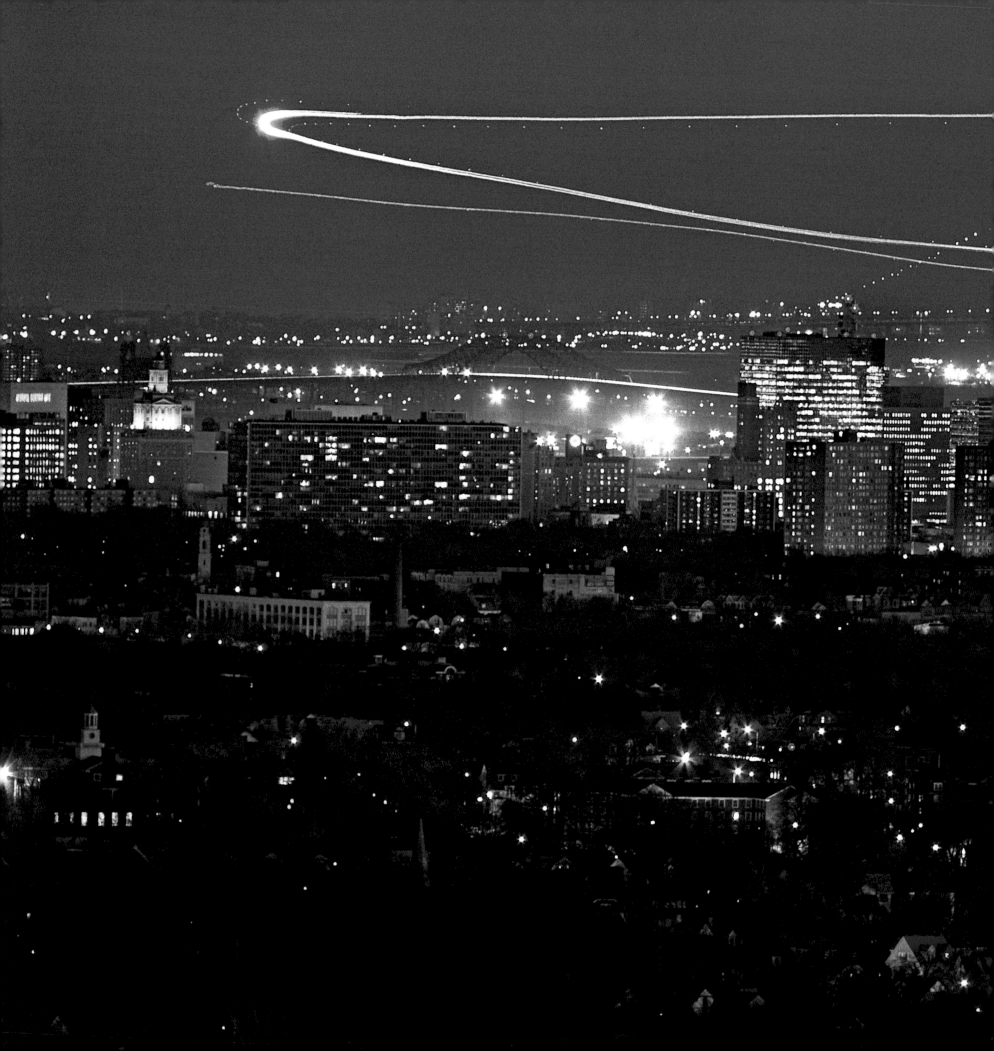

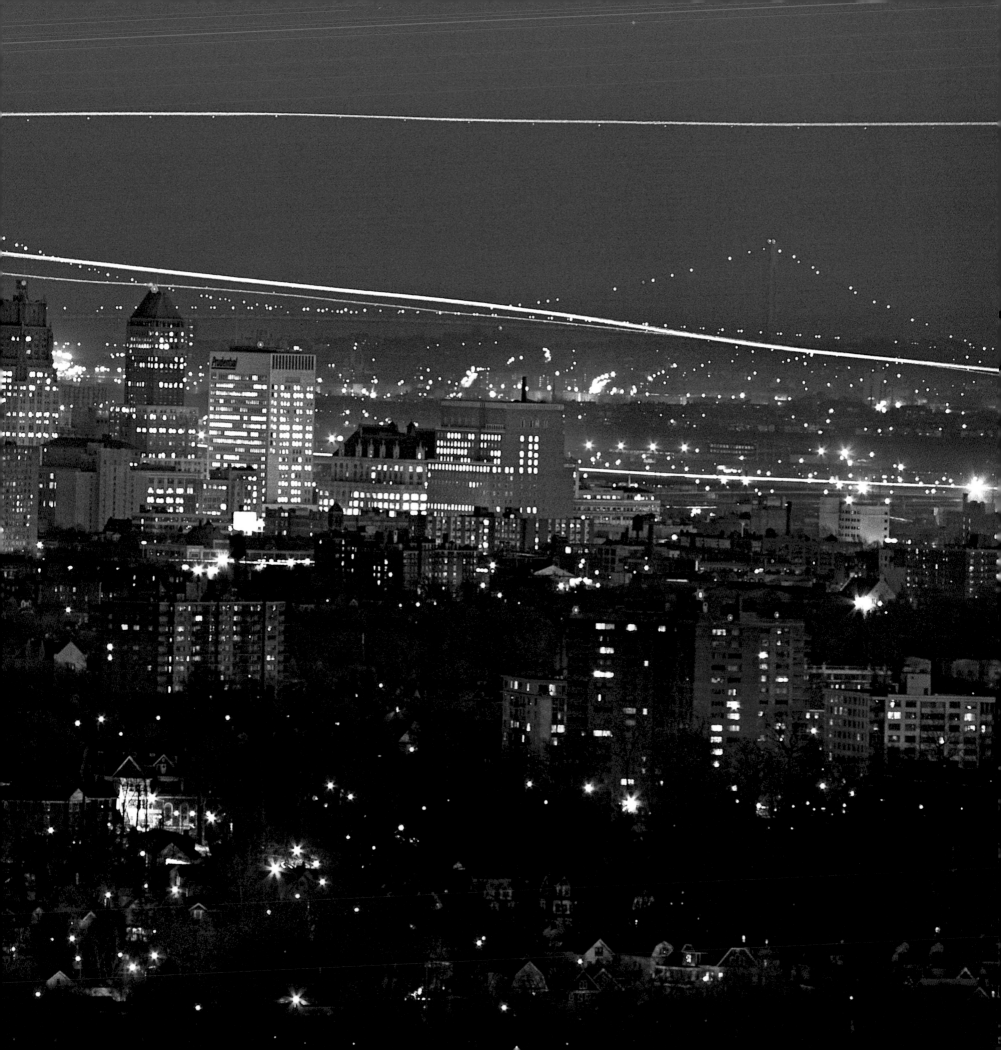

▲ Delaware River, Milford

▲ Hackensack River, New Bridge Landing

Pine Barrens bog, Chatsworth ▶

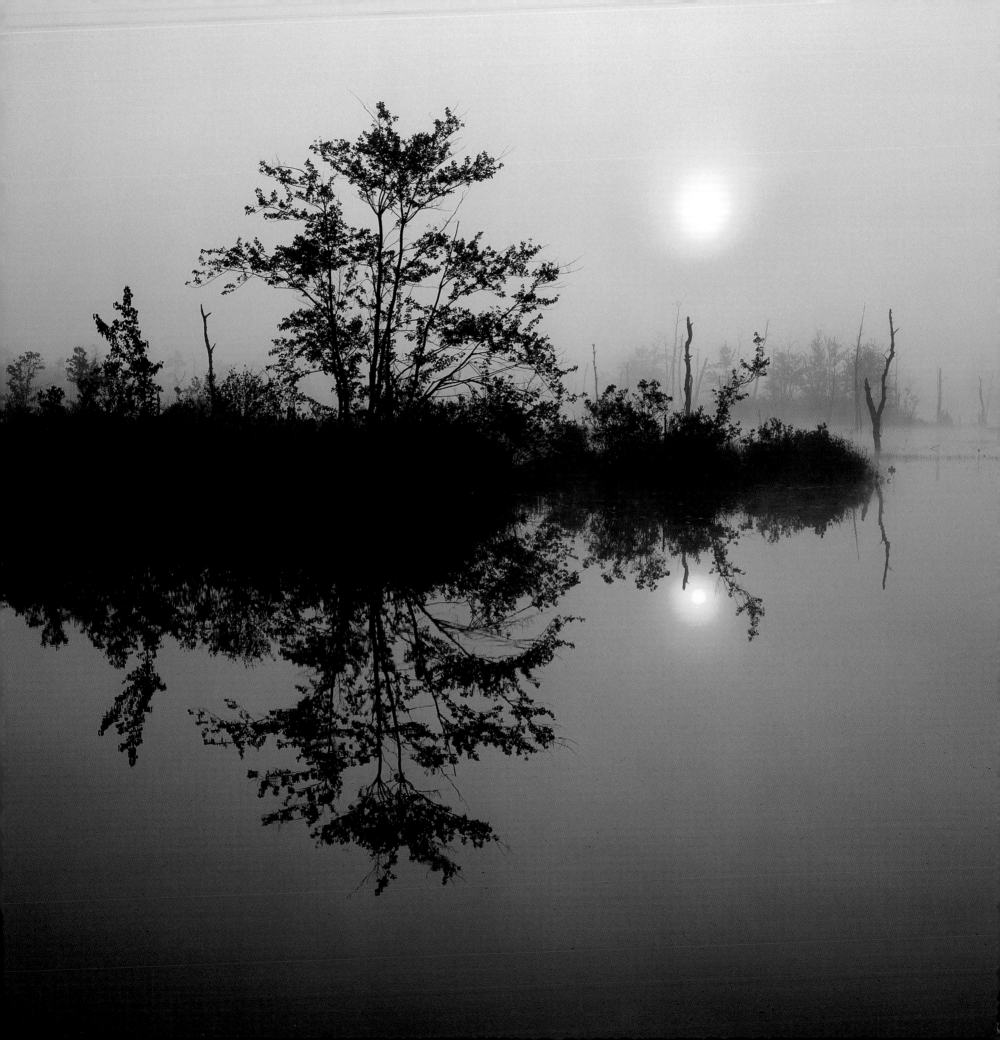

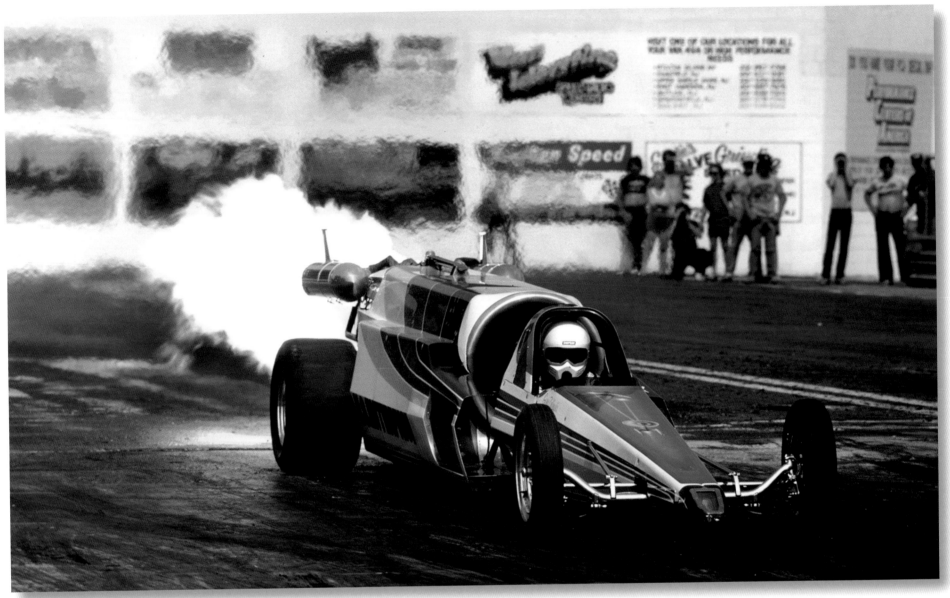

▲ Raceway Park, Englishtown

My first visit to Raceway Park was an electrifying experience. I obtained press credentials and was granted access to the track where I stood with a few other photographers near the starting line.

As the first "Jet" dragsters approached the line, the sound of their engines was crackling and thunderously loud. With one eye glued to the camera I was totally engrossed with the excitement of the moment, shooting all the fantastic color around me. As I pivoted and turned to face the track, I never noticed that everyone else, including the other photographers, had stopped to put on headsets prior to the approach of these special dragsters.

I focused on the starting lights for the first race—amber, amber, amber, GREEN!
The deafening roar that immediately followed was so intense that my hands dropped the camera (thankfully still hanging from my neck) and I covered my ears as my knees buckled and I crumbled to the ground in the wake of that awesome sound. There was nowhere to run as cars for the second race were quickly approaching the line. In a panic I quickly searched my pockets and camera bag for makeshift ear protection, finally stuffing my ears with wads and wads of "lens tissue." It wasn't ideal, but it somehow worked and I was able to enjoy photographing the races that followed.

▲ Raceway Park, Englishtown

Aggi Hendriks, Raceway Park, Englishtown ▶

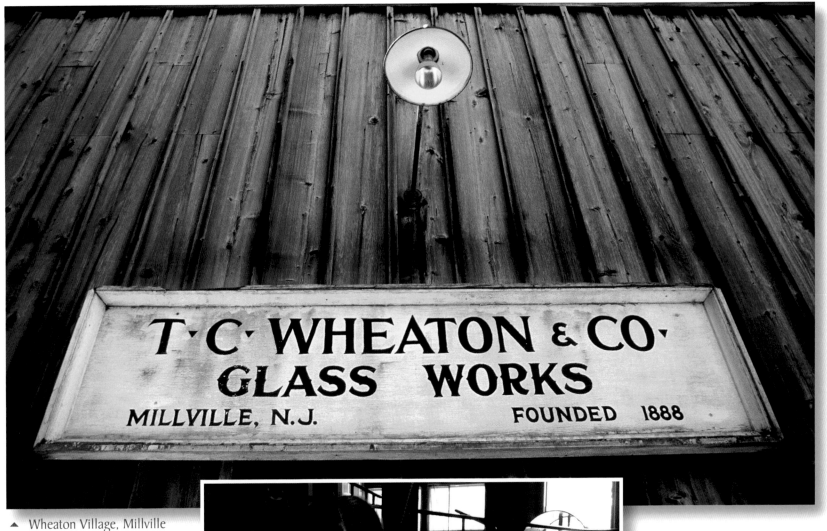

▲ Wheaton Village, Millville

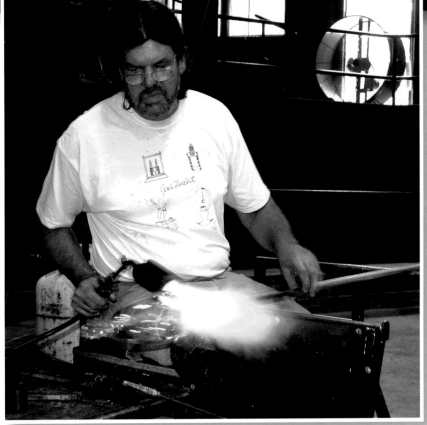

▲ Glass artist and Head Gaffer, Don Friel, Wheaton Village, Millville

Presby Memorial Iris Gardens,
Upper Montclair ▶

60

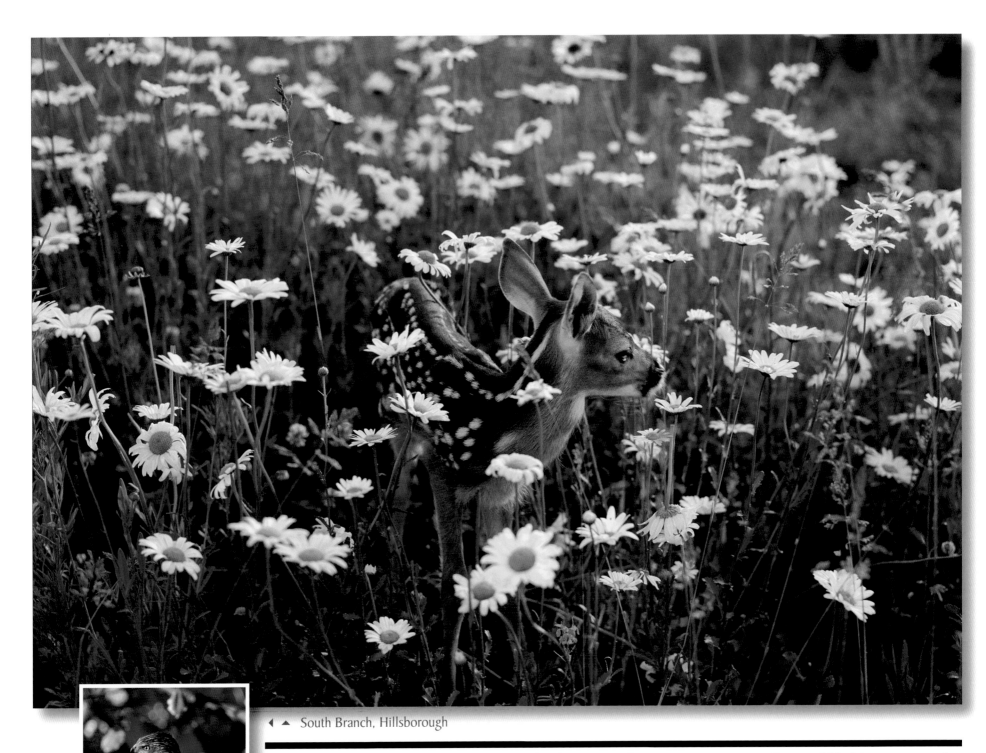

◀ ▲ South Branch, Hillsborough

There's no place like home! Truth is I've taken some of my best images at home on our own property. Susan and I both love nature, so when we moved to South Branch we decided to let half of our property remain "natural" as a preserve for the birds and wildlife.

The bunnies (right) were born atop a mulch pile in our driveway. I was too busy photographing New Jersey to have time to spread the mulch, so a mother rabbit claimed it! We helped care for her clutch sometimes providing an umbrella to protect them from the hot sun and spring rains. The fawn (above) came visiting one day after the adjacent farm fields were disturbed by haying. We gave him some goat's milk and he was then a cooperative model posing for me in our wildflower field. Later that evening I returned him to his field to be reunited with his mother. The hawk (left) was discovered just outside my bathroom window one morning. He patiently waited for me as I went downstairs for my camera and returned to the bathroom window to photograph him sunning in our pear tree.

South Branch, Hillsborough ▶

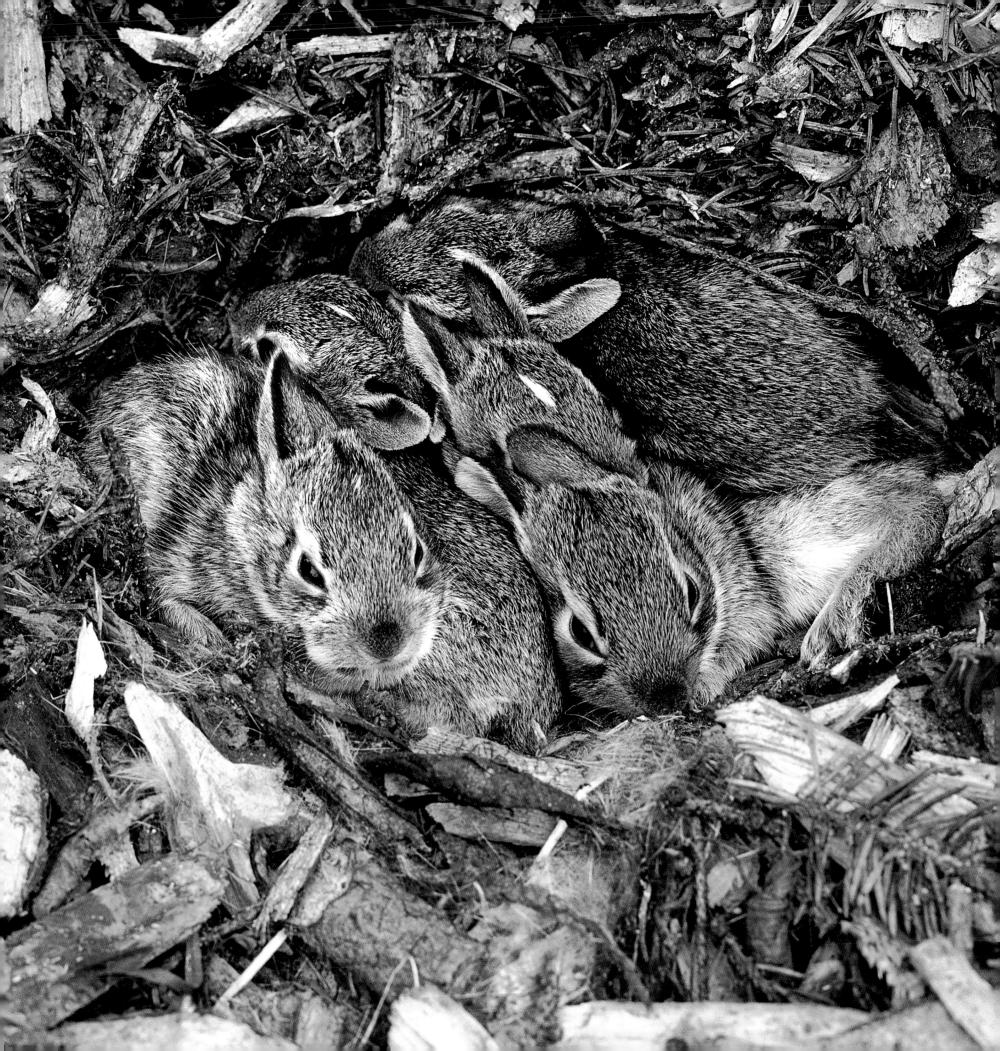

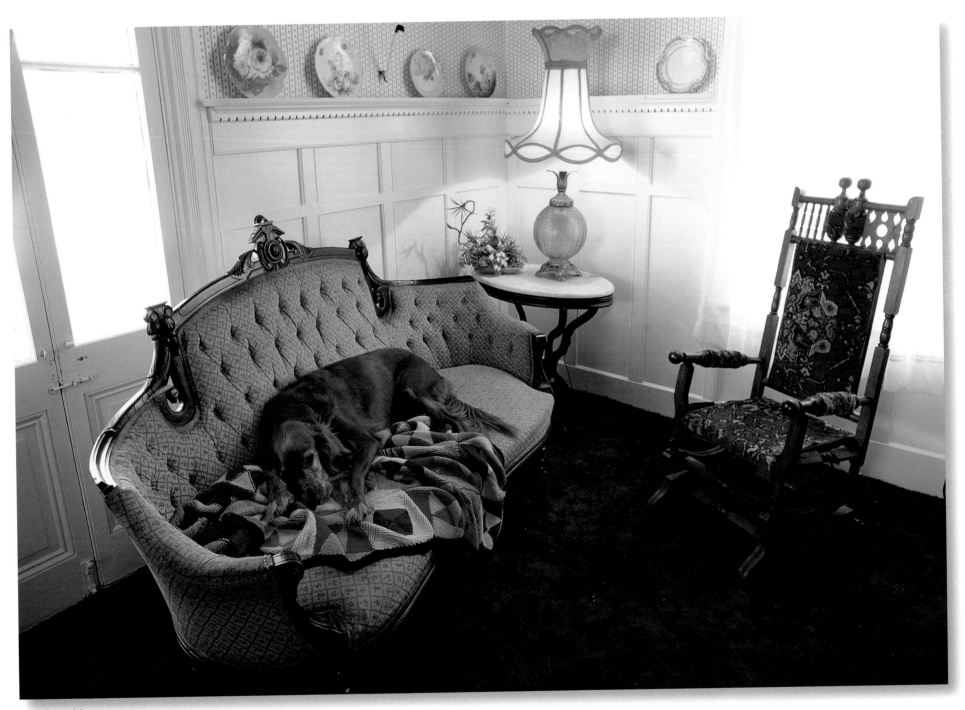

▲ Cape May

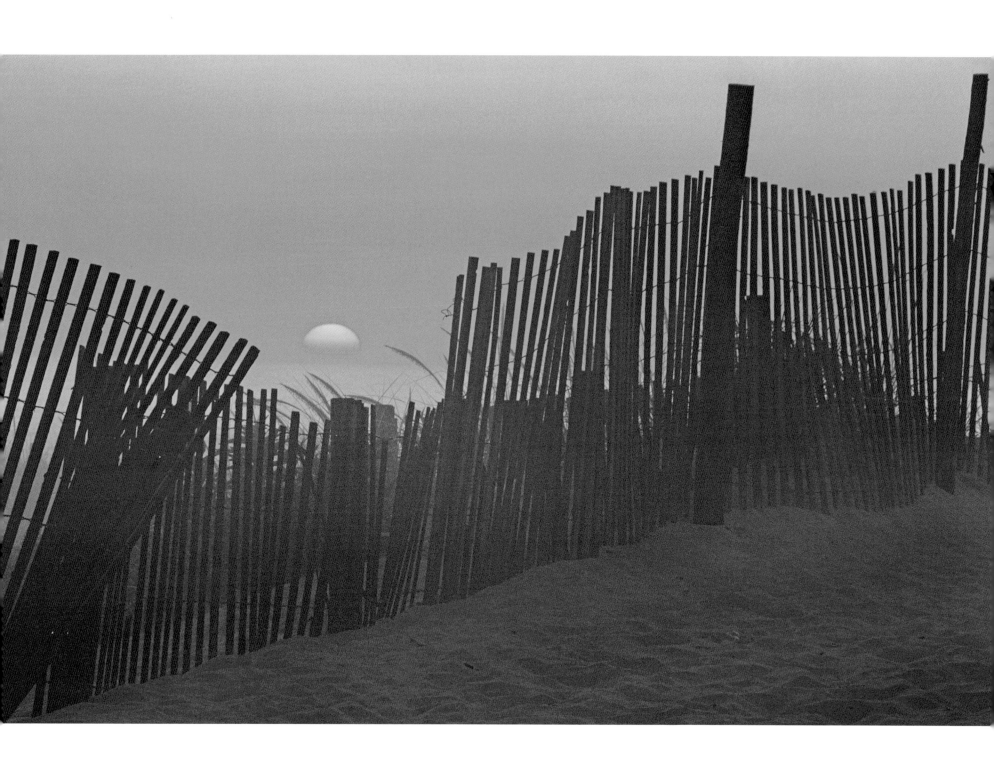

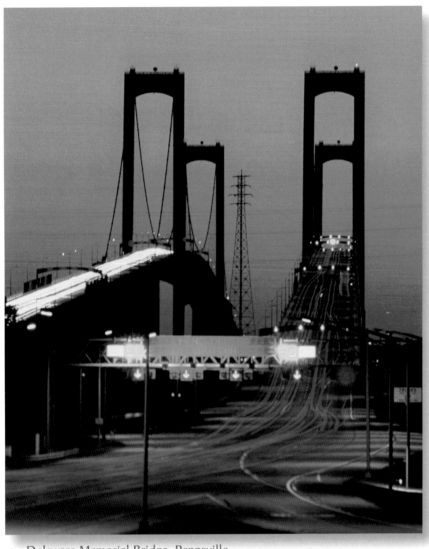

▲ Delaware Memorial Bridge, Pennsville

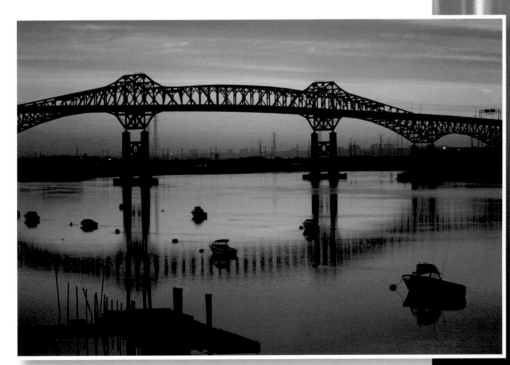

▲ General Pulaski Skyway, Kearney

Bayonne Bridge, Bayonne ▶

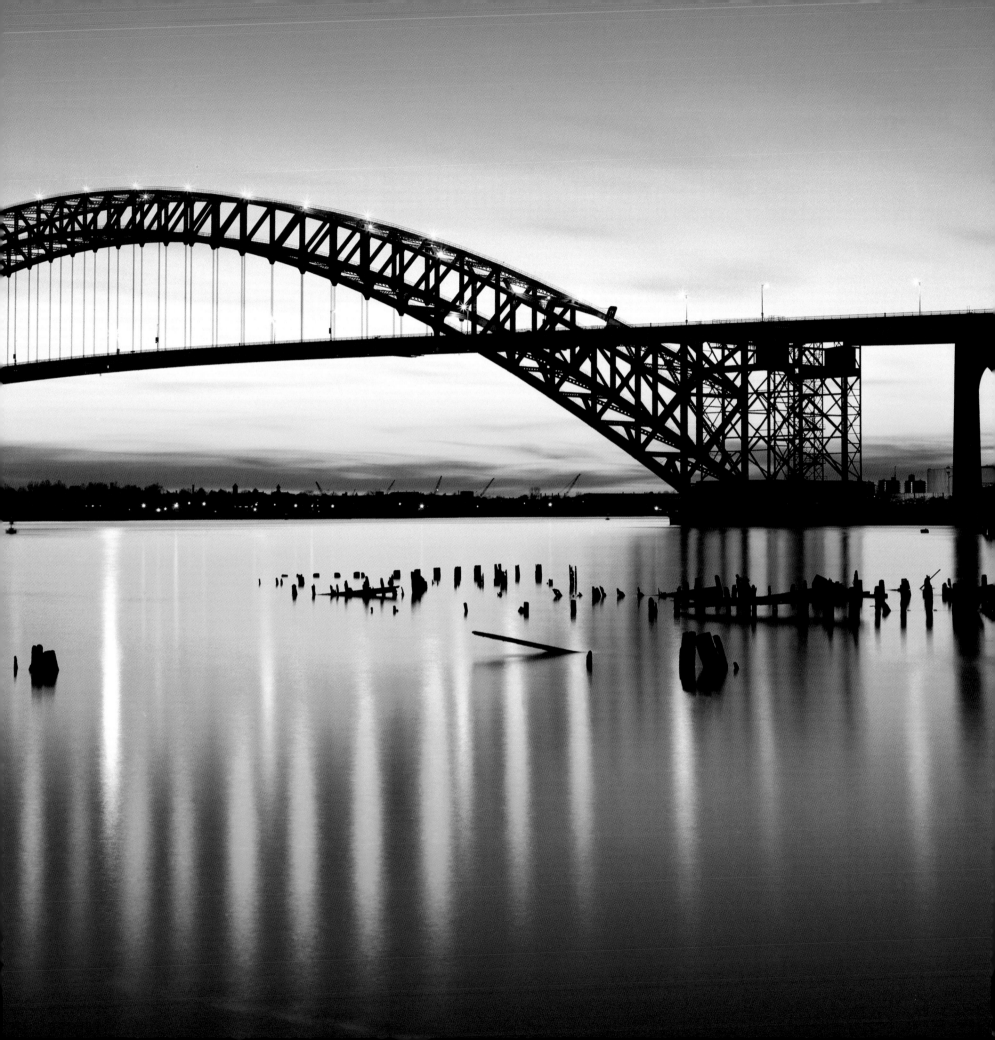

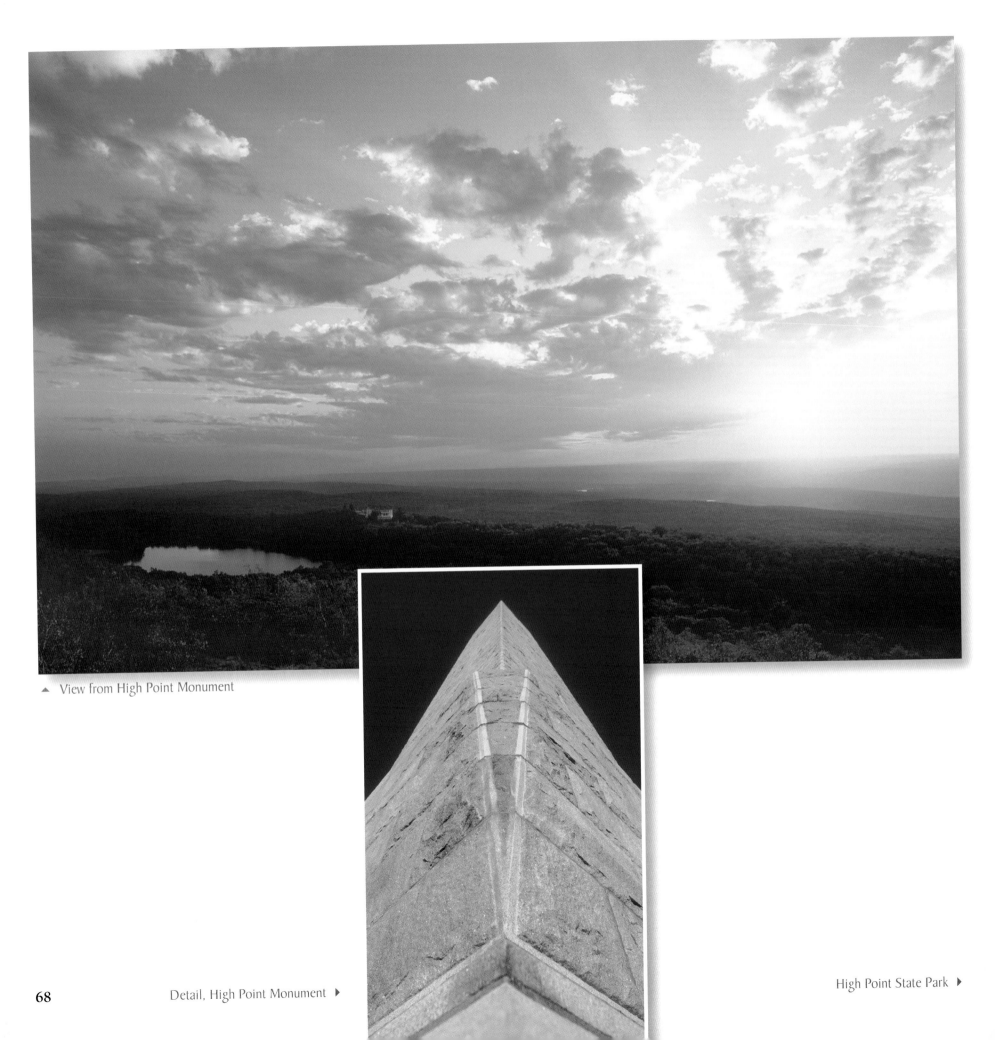

▲ View from High Point Monument

Detail, High Point Monument ▶

High Point State Park ▶

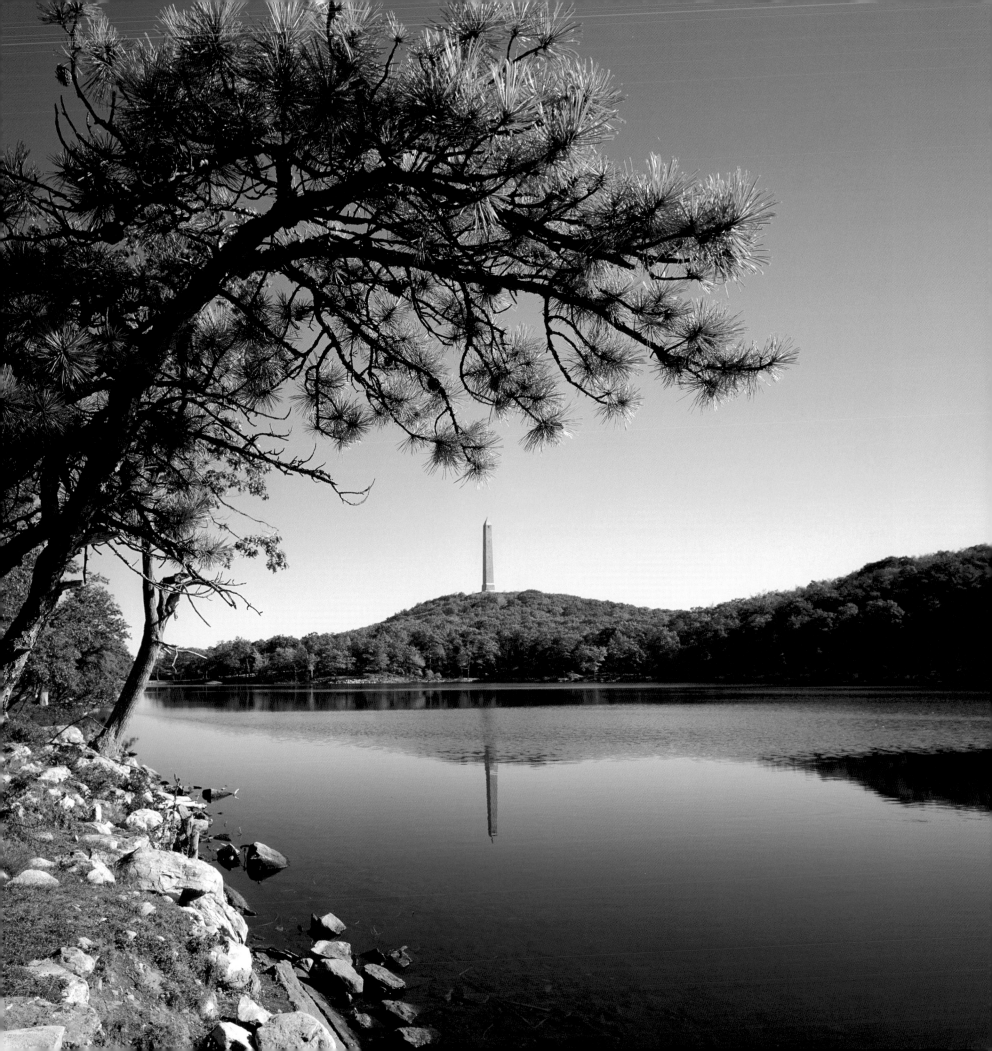

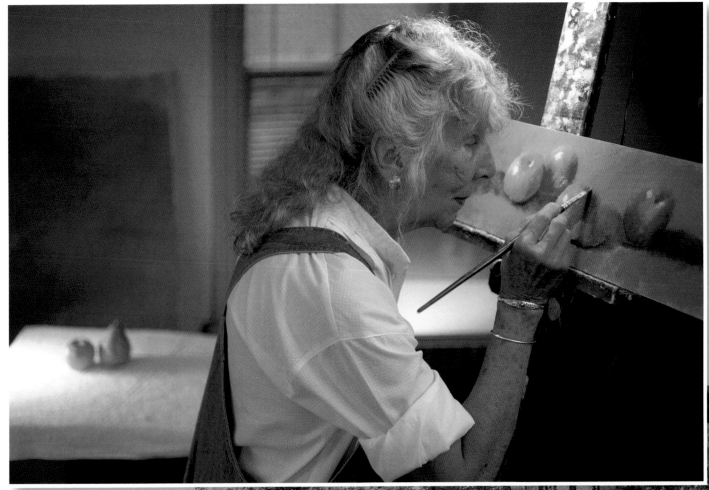

▲ Artist, Suzanne Douglas,
Lambertville

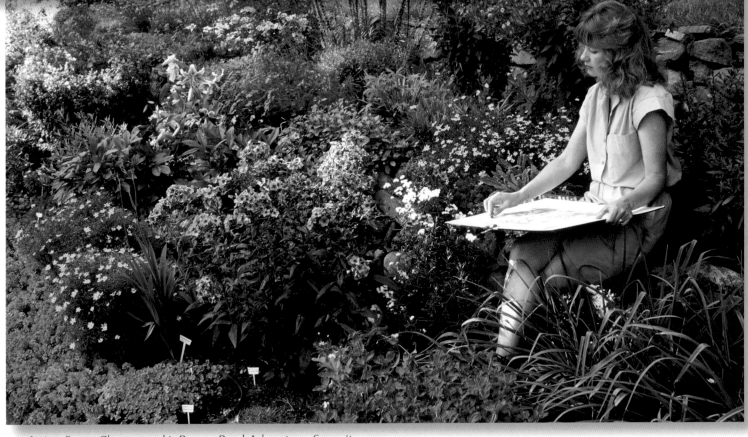

▲ Artist, Susan Choroszewski, Reeves Reed Arboretum, Summit

Ceramic Artist, Toshiko Takaezu, Franklin ▶

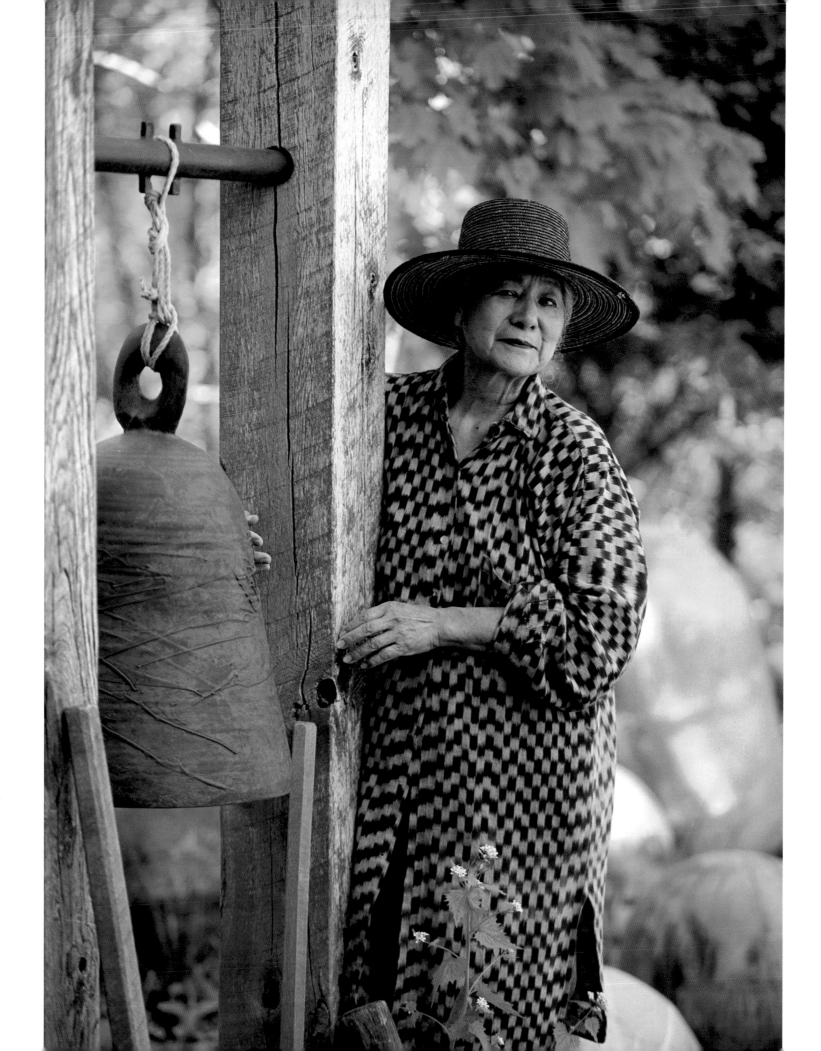

Rooster, Ort Farms,
Long Valley ▶

Ukranian Easter eggs,
Heritage Days Festival,
Trenton ▶

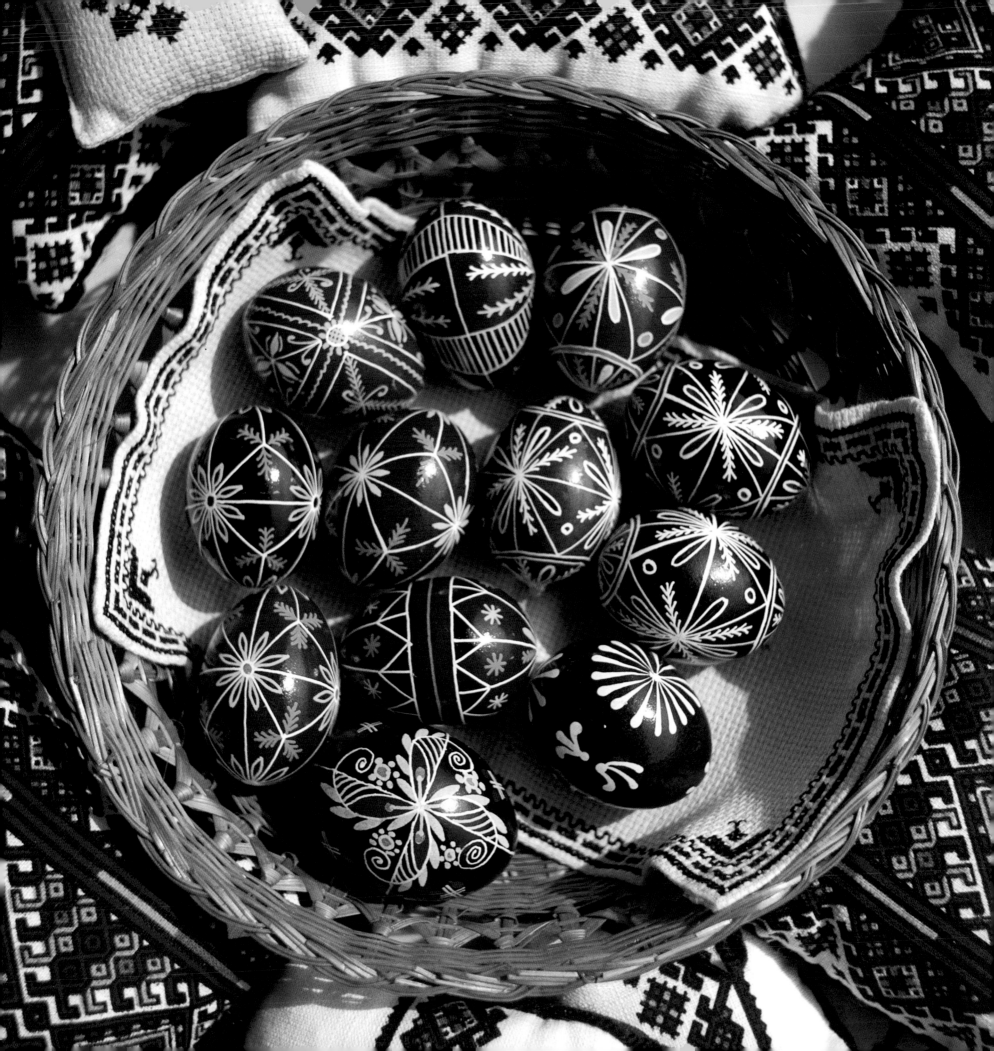

▲ Captain Roberts, Cape May

Point Pleasant Beach ▶

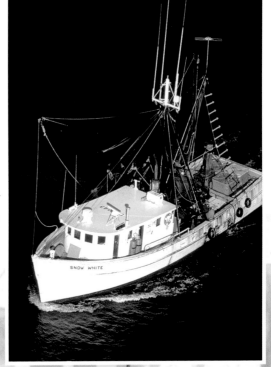

Commercial fishermen of New Jersey have been interesting photo subjects for me since my first trips to Cape May. Their rugged character was familiar to me—similar to that of the coal miners of Pennsylvania.

The portrait of Captain Roberts (above) was rejected by my editor of **NEW JERSEY, A Scenic Discovery,** *as he declared, "No real captain would ever wear a silly hat like that!" To the contrary—Captain Roberts and his hat were quite real. I spent a few hours with him, listening to his tales of the sea while he repaired the docks at Cold Spring Harbor.*

Point Pleasant Beach is the eighth largest commercial fishery on the east coast. This fisherman's photo (right) was selected for the 1991 Bell Atlantic New Jersey telephone directory cover.

The Lewis Family has been commercially fishing for shad on the Delaware River since 1888. The late afternoon shad hauling silhouette (far right) was chosen as the cover for my 1998 book, **LAMBERTVILLE.**

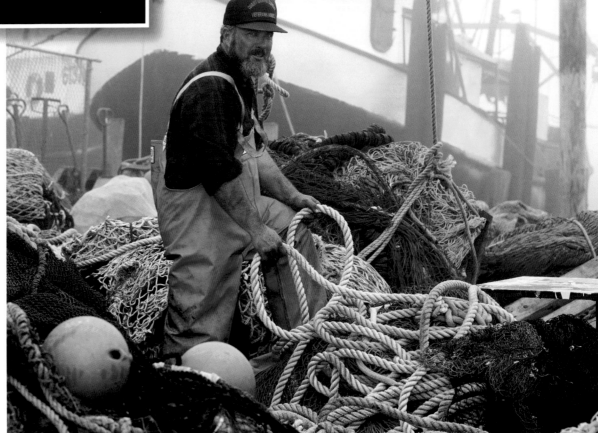

▲ Point Pleasant Beach

Shad hauling, Lambertville ▶

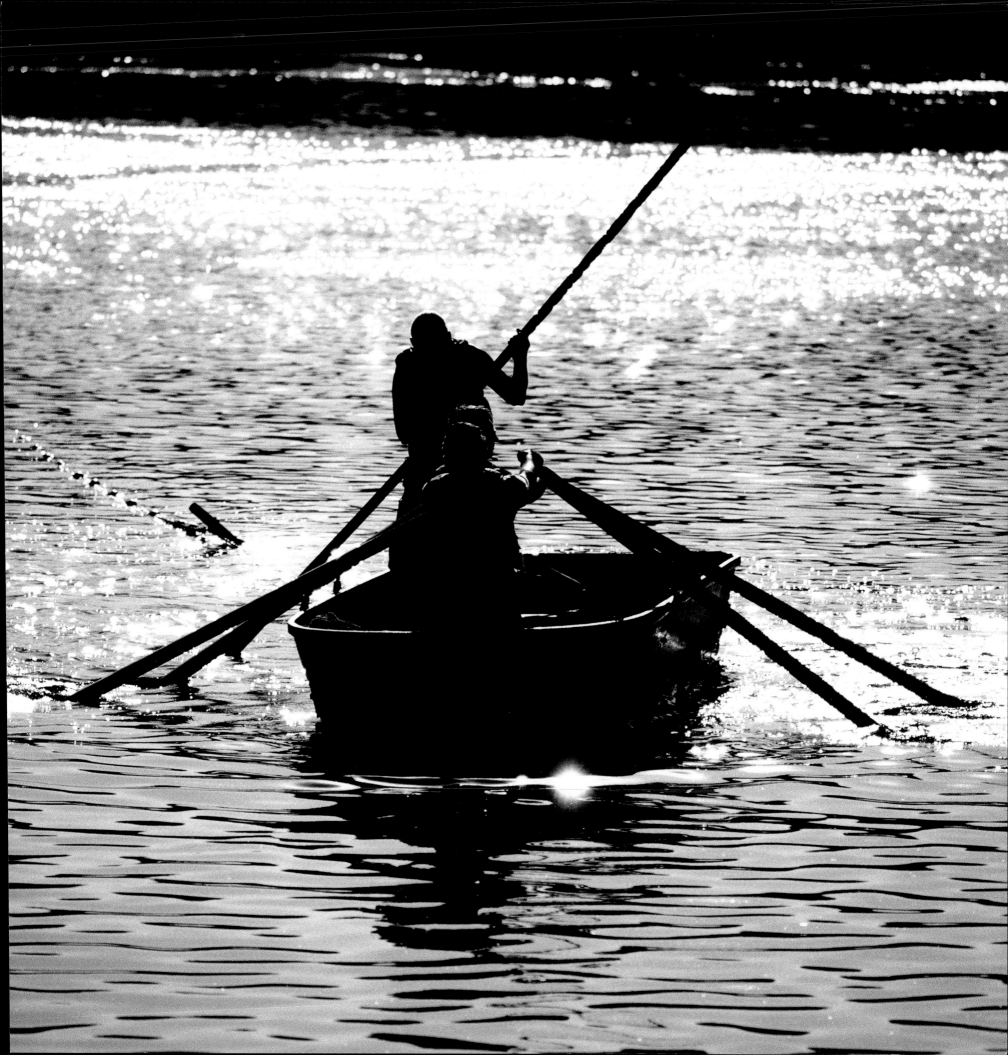

▲ Avalon

▲ Reeds Beach

▲ Manasquan

Brigantine ▶

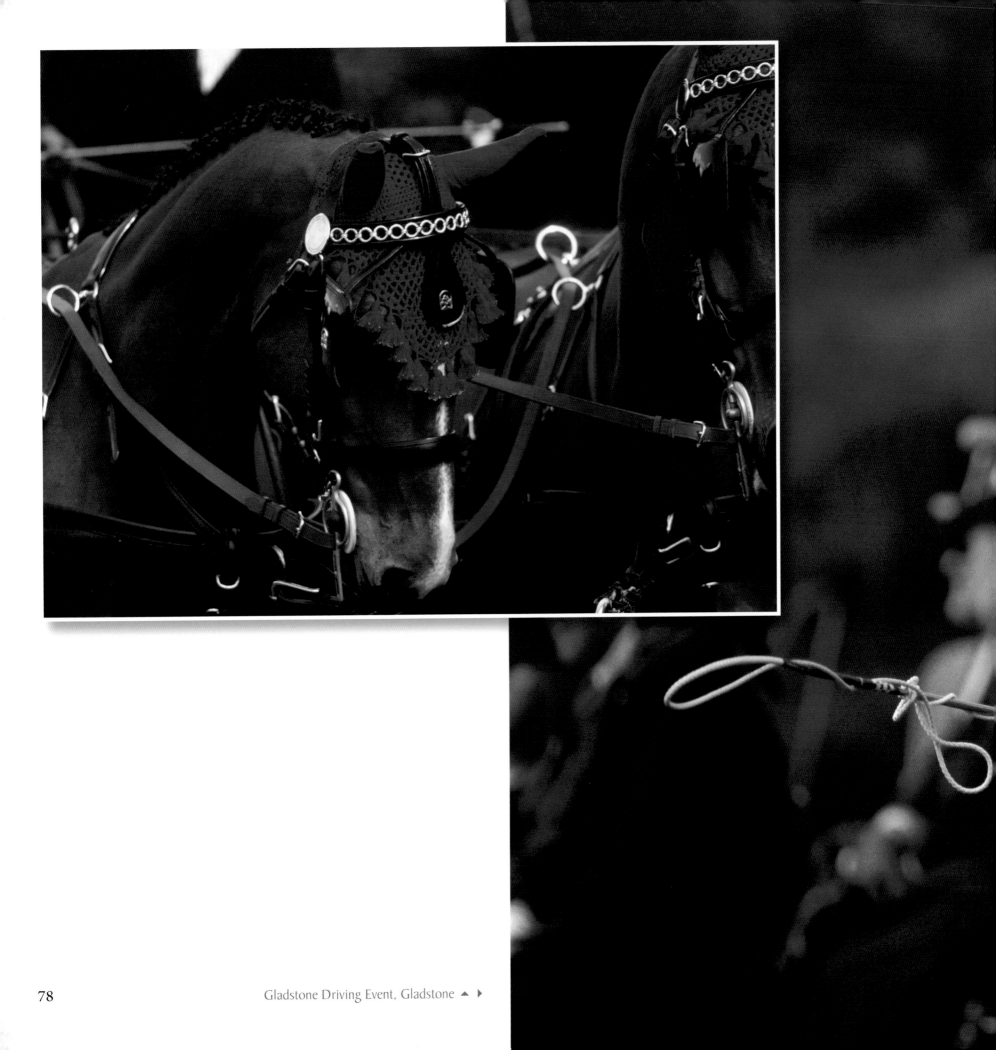

Gladstone Driving Event, Gladstone ▲ ▶

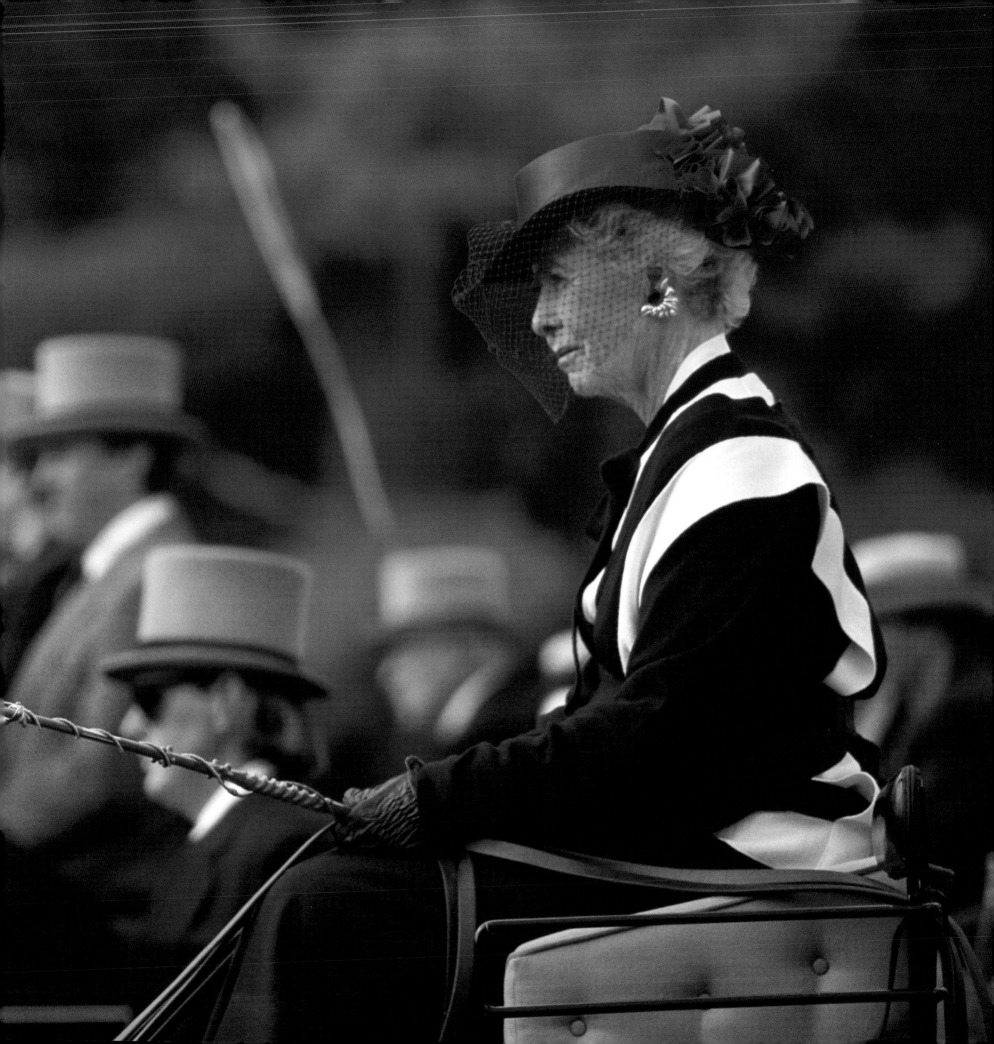

▲ Bedminster

▲ Branchburg

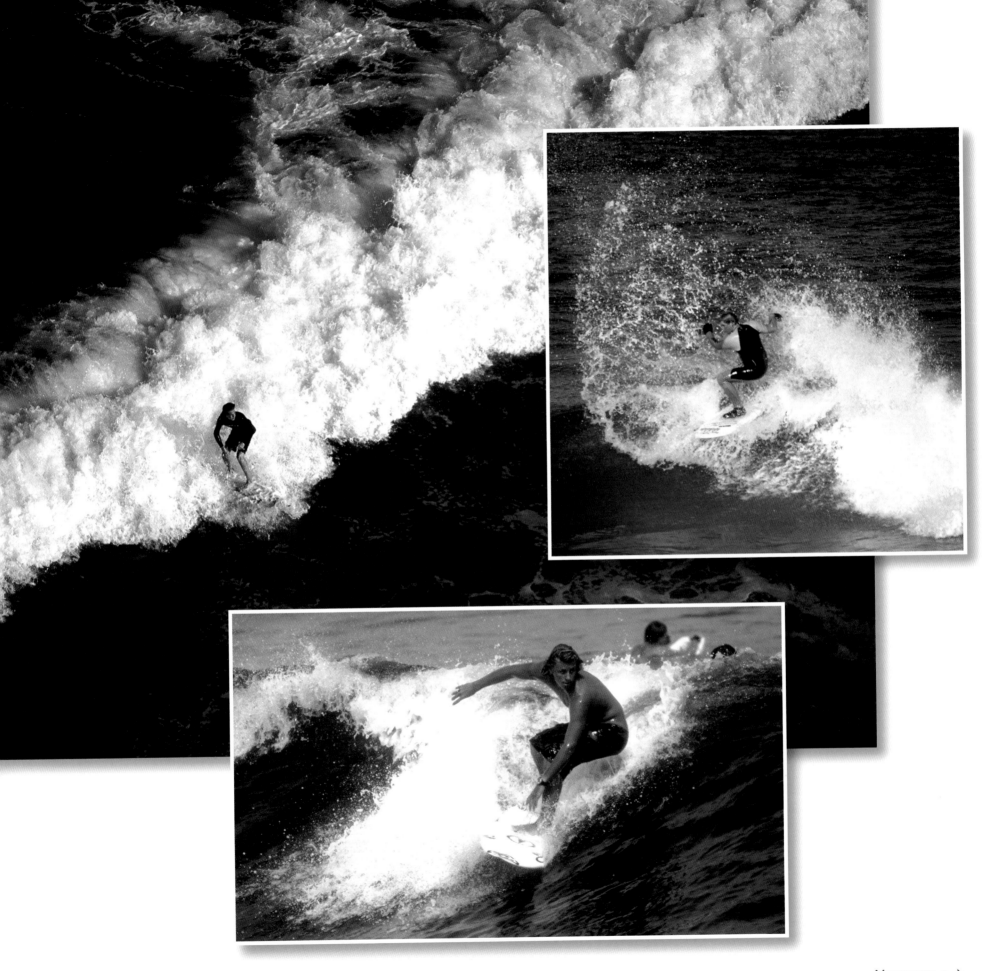

▲ Cape May

▲ Belmar

▲ Tewksbury

Hopewell ▶

▲ Vineland

Echo Lake,
Mountainside ▶

▲ Whitesbog, Brendan T. Byrne State Forest

Leaming's Run Gardens, Swainton ▶

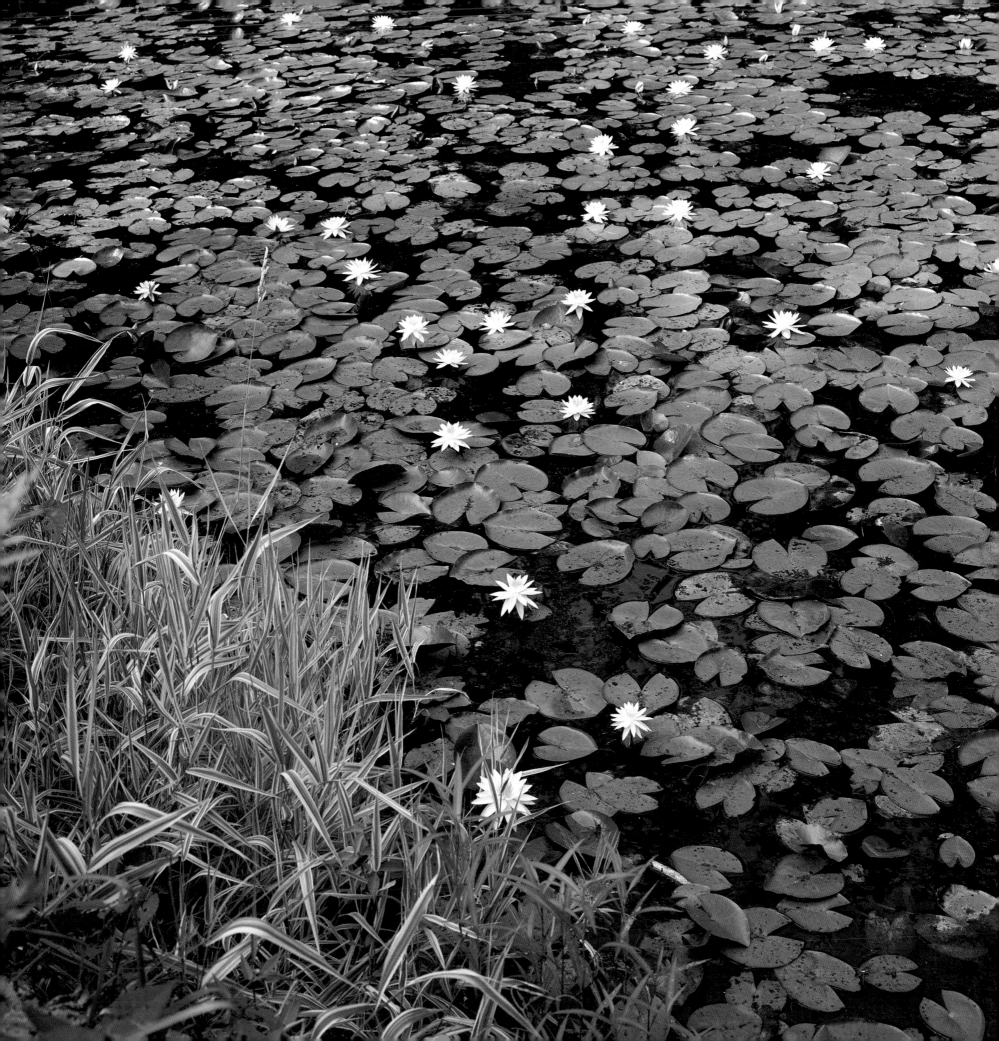

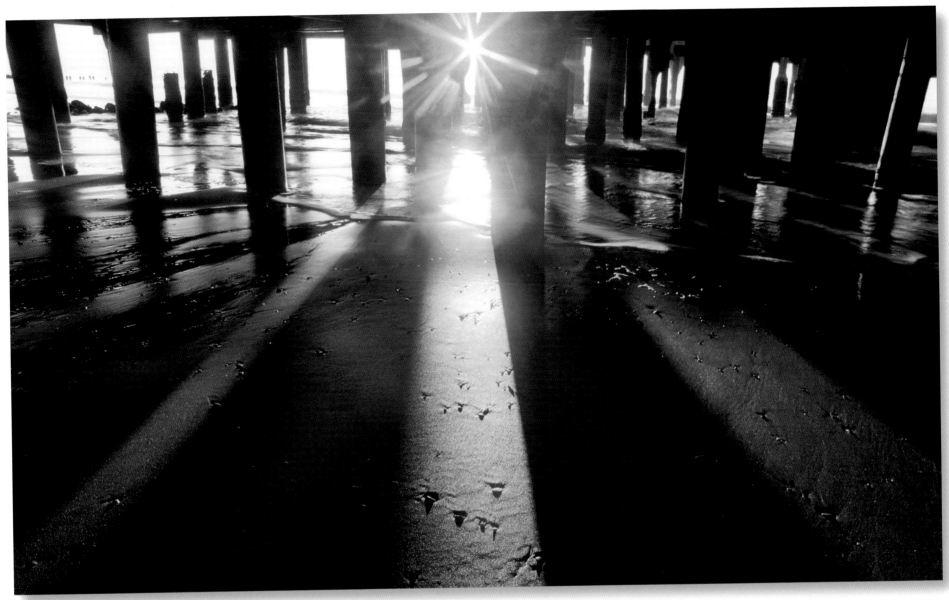

▲ Under the boardwalk, Atlantic City (1987)

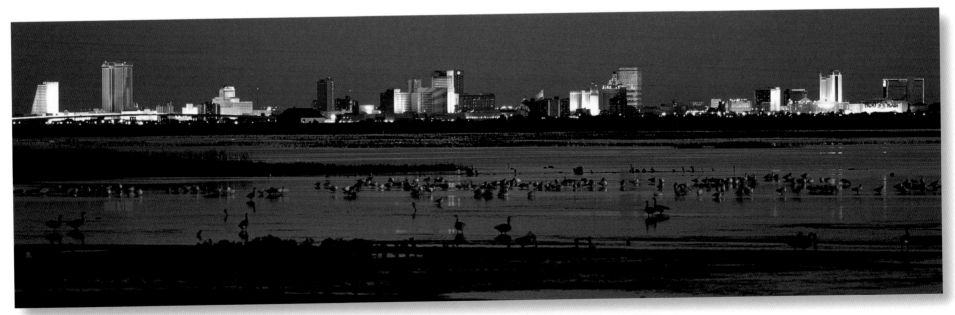

▲ Atlantic City (1993)

Farley Marina, Atlantic City (2004) ▶

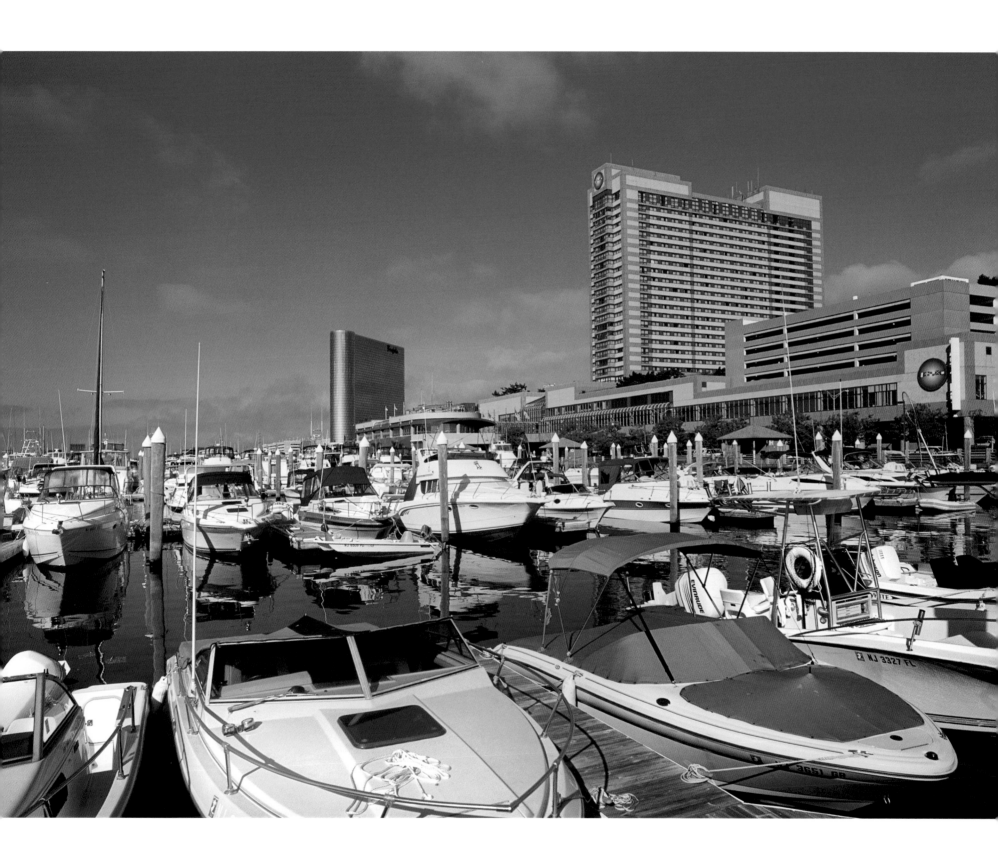

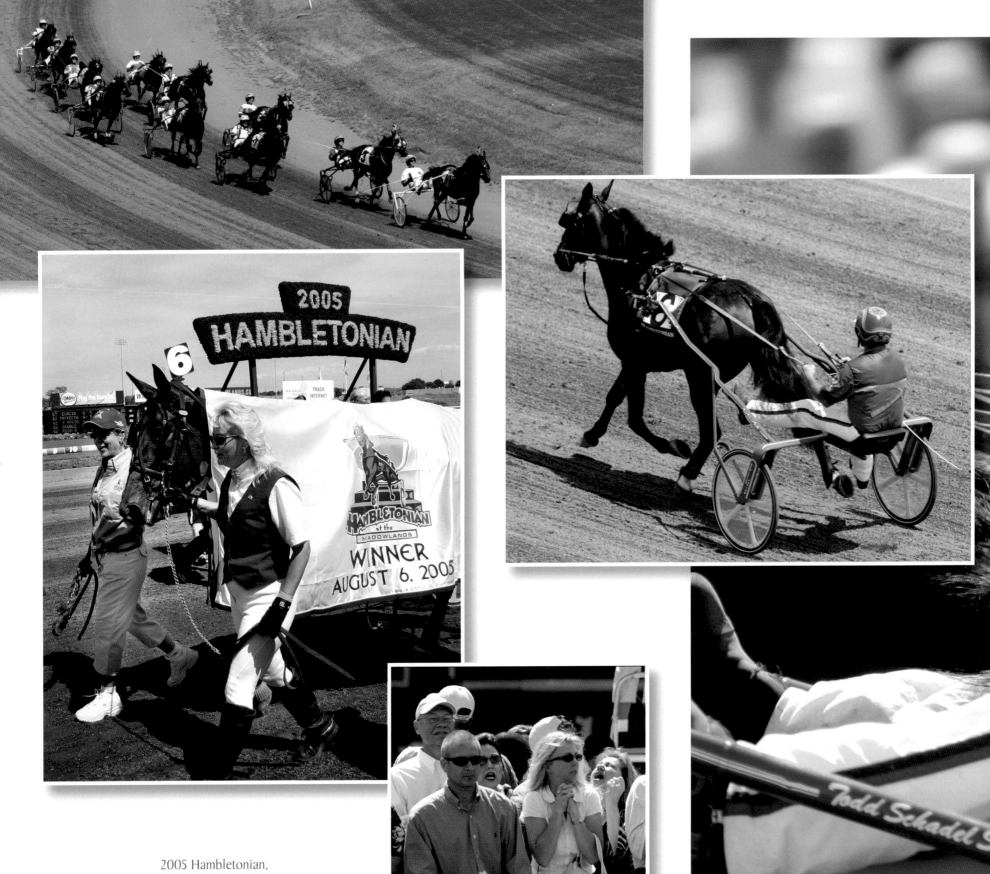

2005 Hambletonian,
The Meadowlands, East Rutherford

Roger Hammer with "Vivid Photo," 2005 Hambletonian Winner, The Meadowlands, East Rutherford ▶

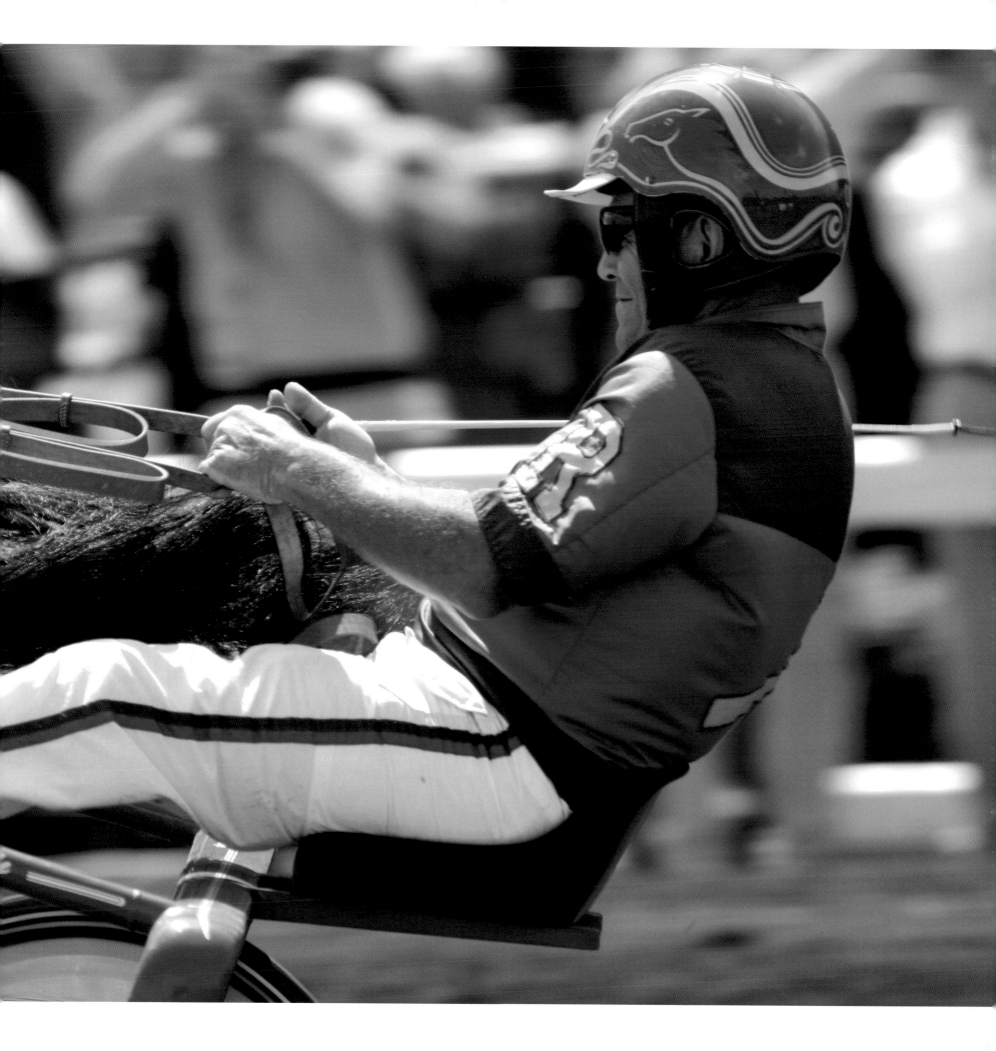

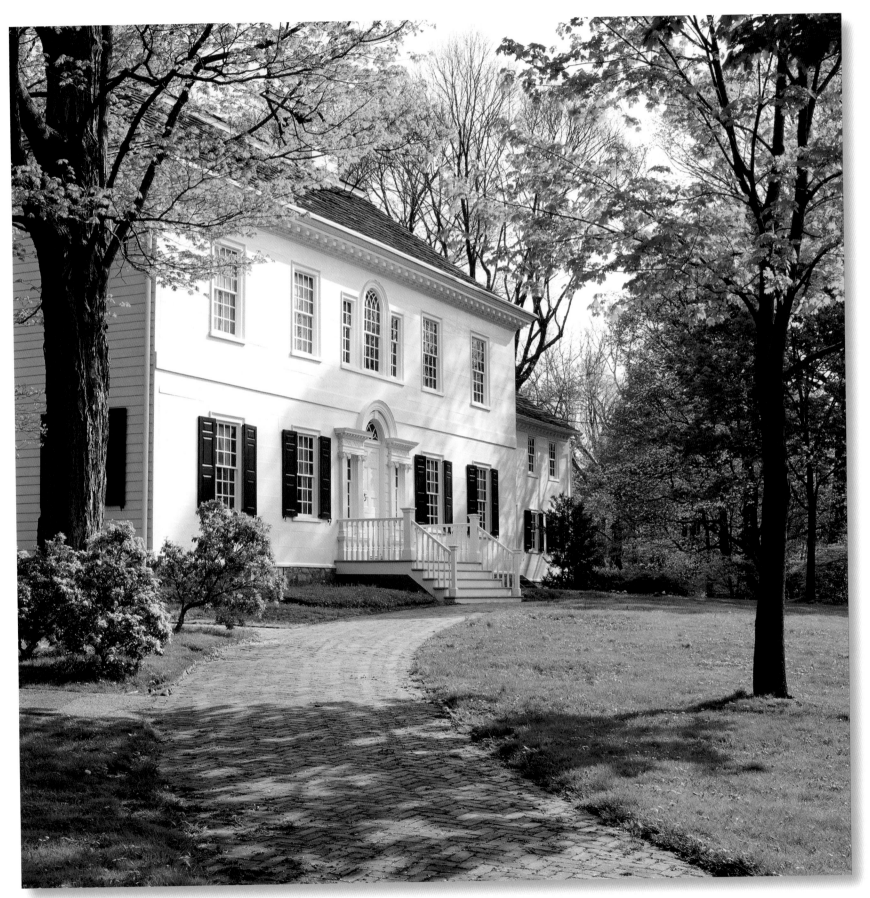

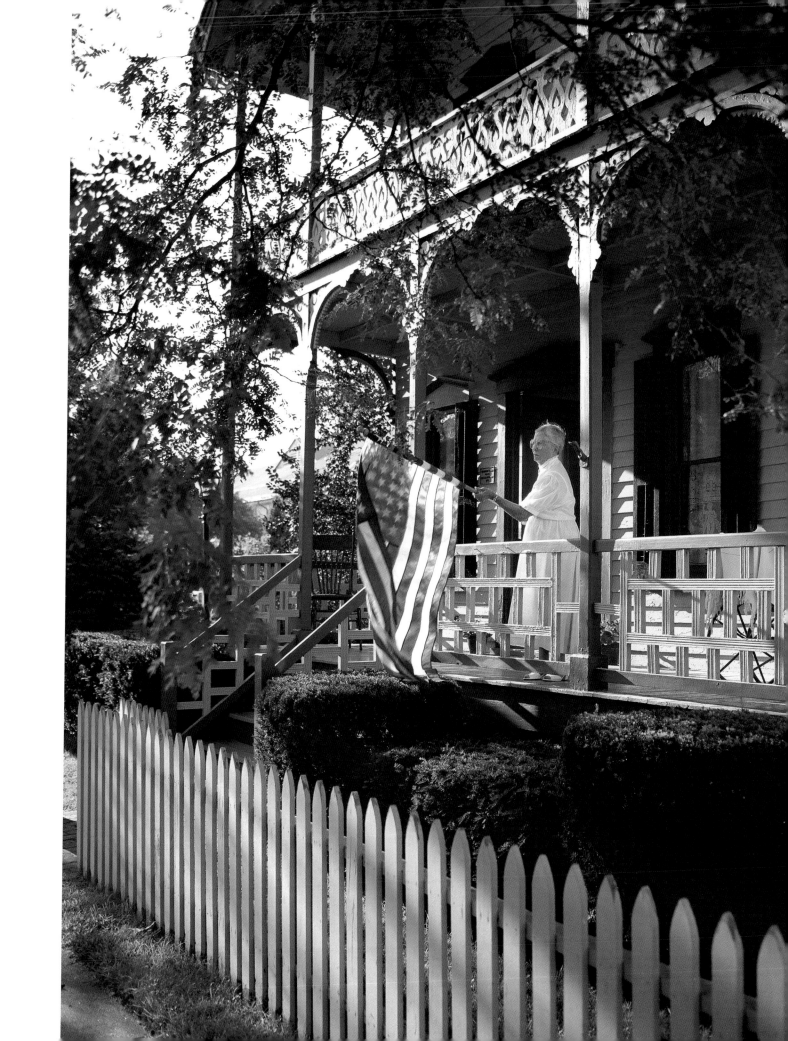

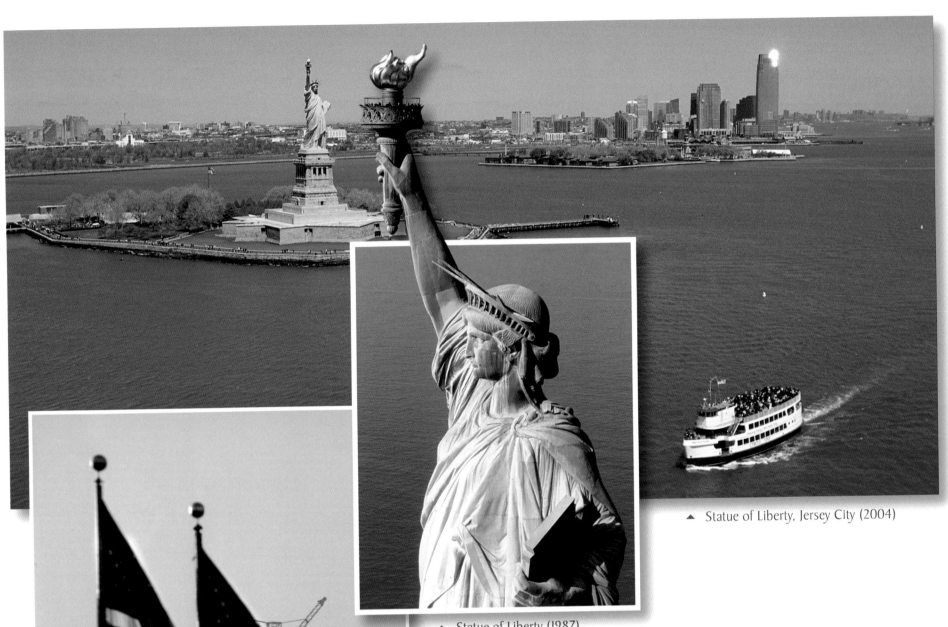

▲ Statue of Liberty, Jersey City (2004)

▲ Statue of Liberty (1987)

Middlesex Water Company
1985 Annual Report

New Jersey Monthly
July 2004

First Jersey National Bank
1982 Annual Report

▲ Statue of Liberty, Liberty State Park, Jersey City (1985)

Statue of Liberty, Jersey City, view from Brooklyn, NY (1982) ▶

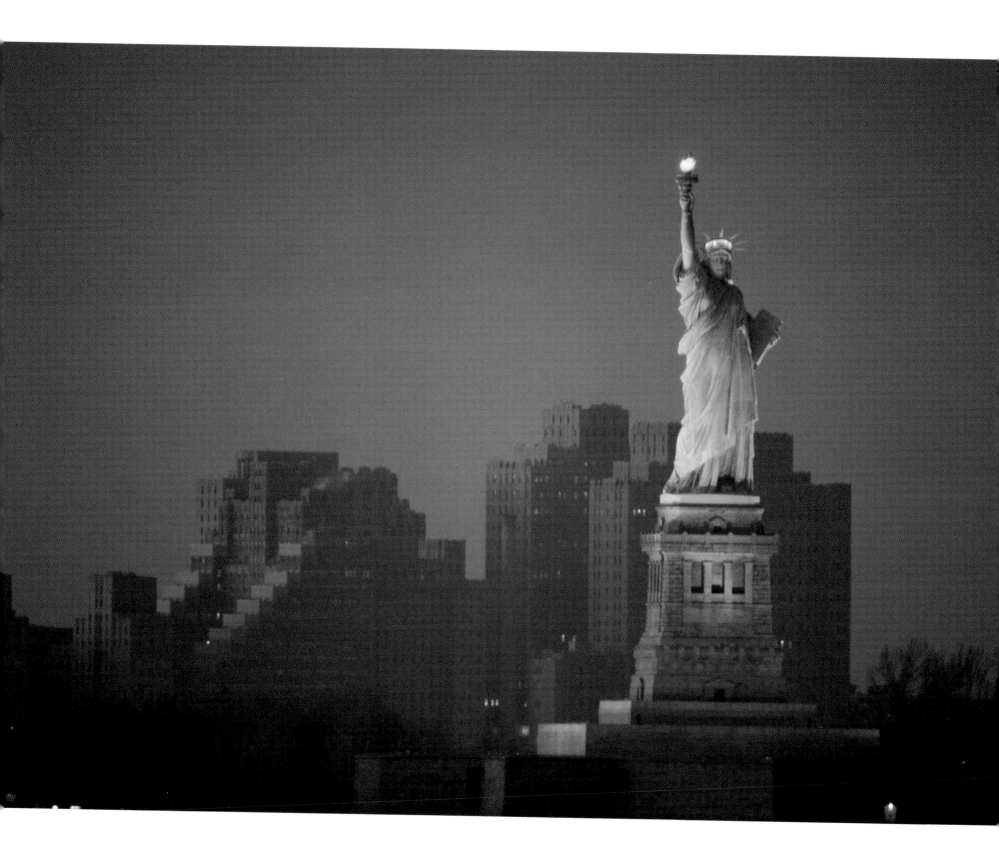

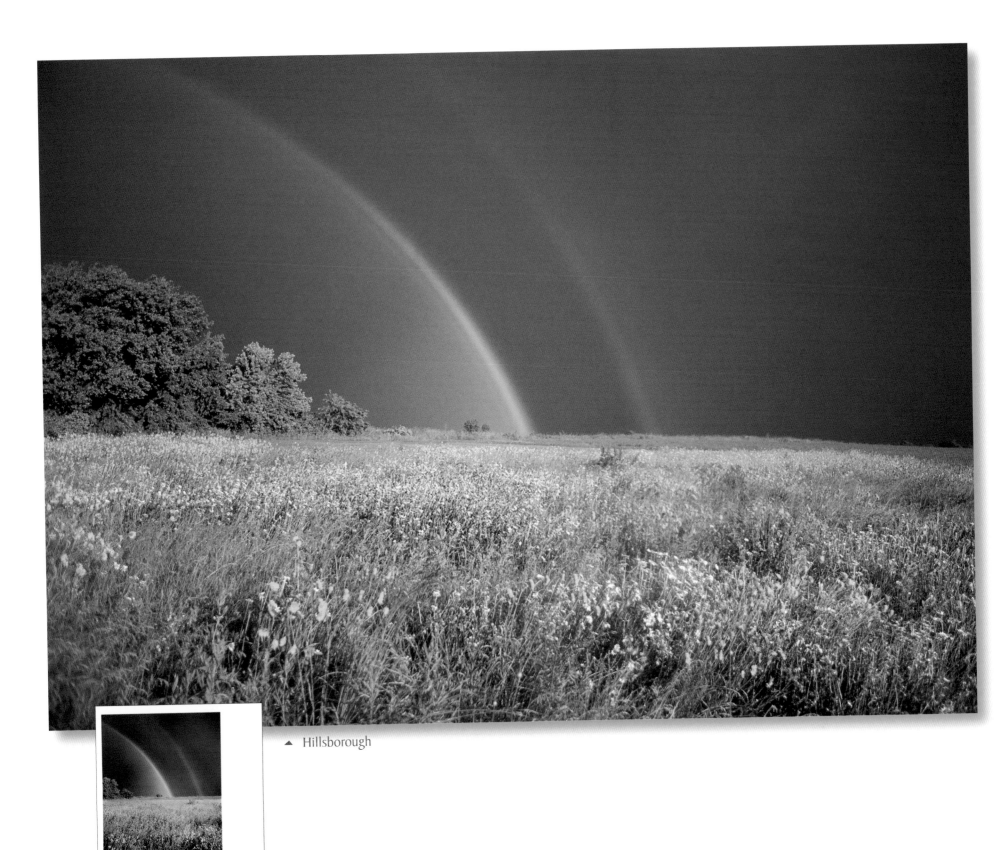

▲ Hillsborough

Great Falls, Paterson ▶

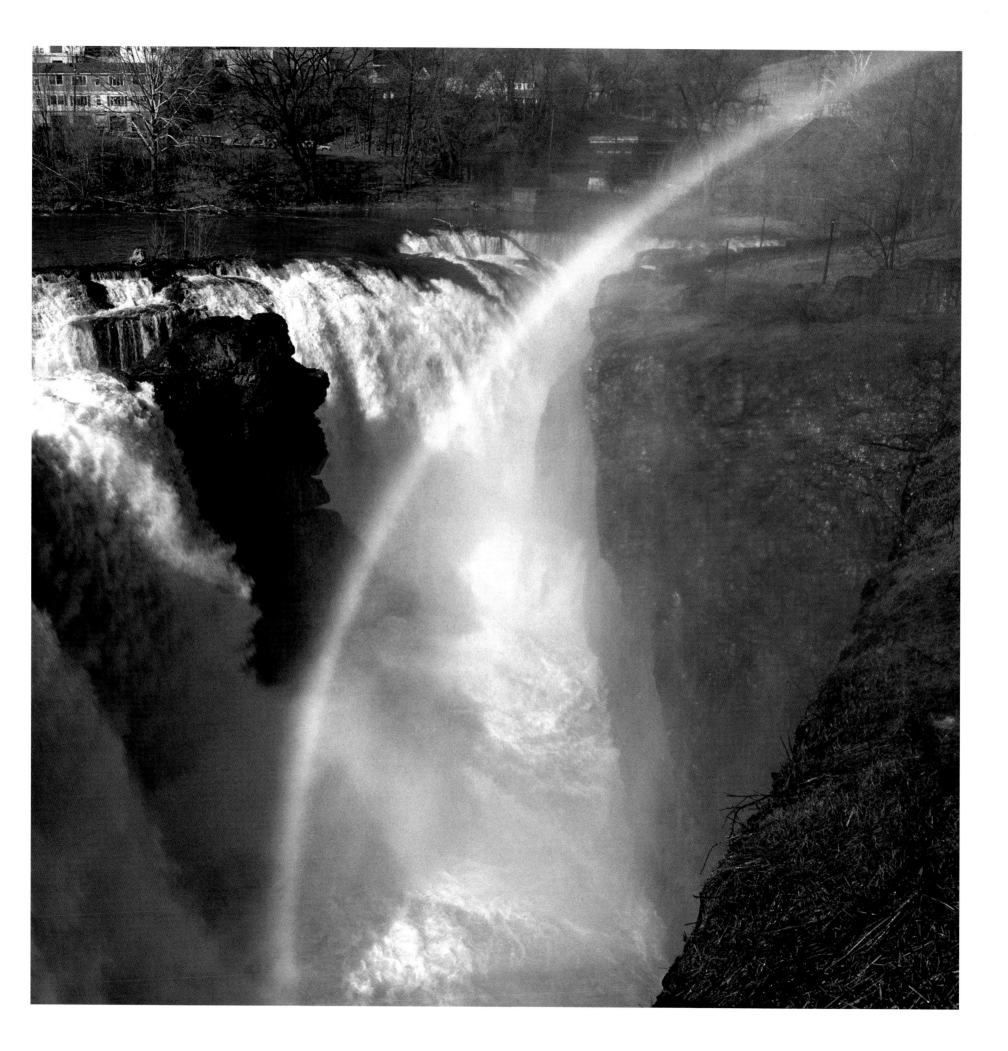

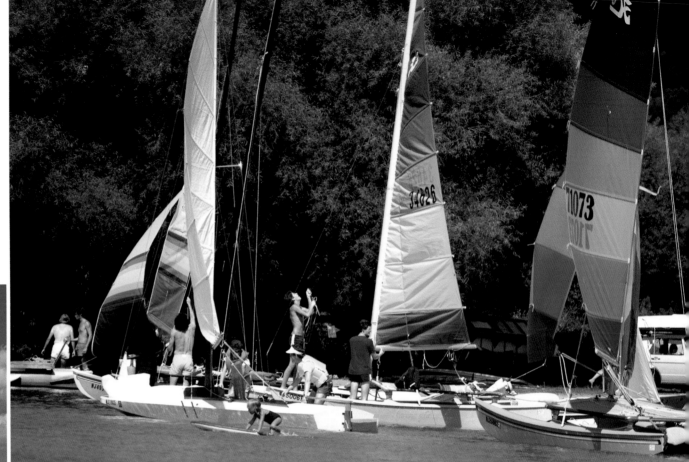

▲ Spruce Run Reservoir, Clinton Township

▲ Spring Lake

When I told my friend, Gary Benson, about a magazine assignment to photograph Hobie Cat races in Wildwood Crest (right), he said I would never get the desired shots using my existing camera equipment and suggested that I rent a Canon EOS 1 with new "auto focus" technology zoom lenses.

Canadian High pressure brought crystal clear air and strong northwesterly winds which made for fast action. I was riding on the busy rescue boat and was tossed about on the rough seas. Gary was right, I would not have succeeded with my old camera and I was glad I followed his advice. Until that day, I was a Nikon "purist" using only manual focus, fixed focal length lenses. After seeing the amazing results, I immediately purchased a new Canon system with the new "auto focus" lenses and "auto exposure" controls ...why work so hard!

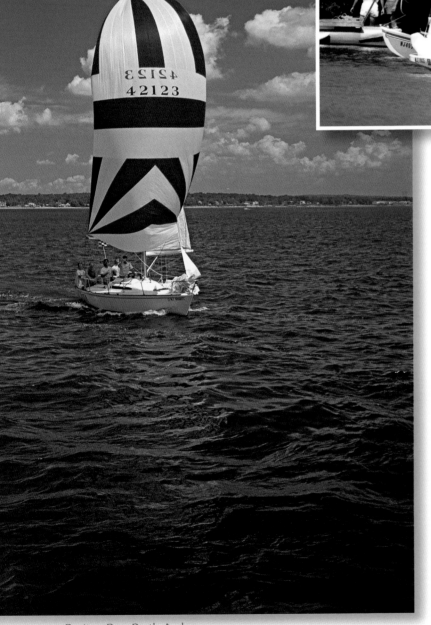

▲ Raritan Bay, Perth Amboy

Hobie Cat Classic, Wildwood Crest (1992) ▶

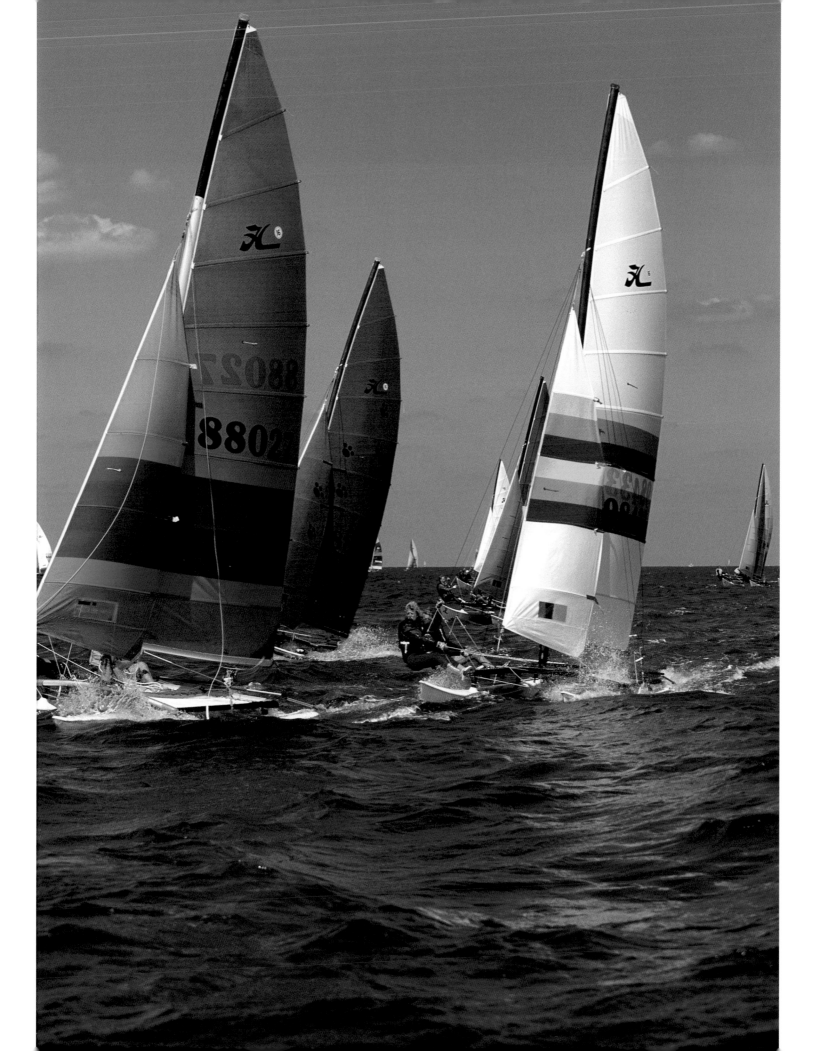

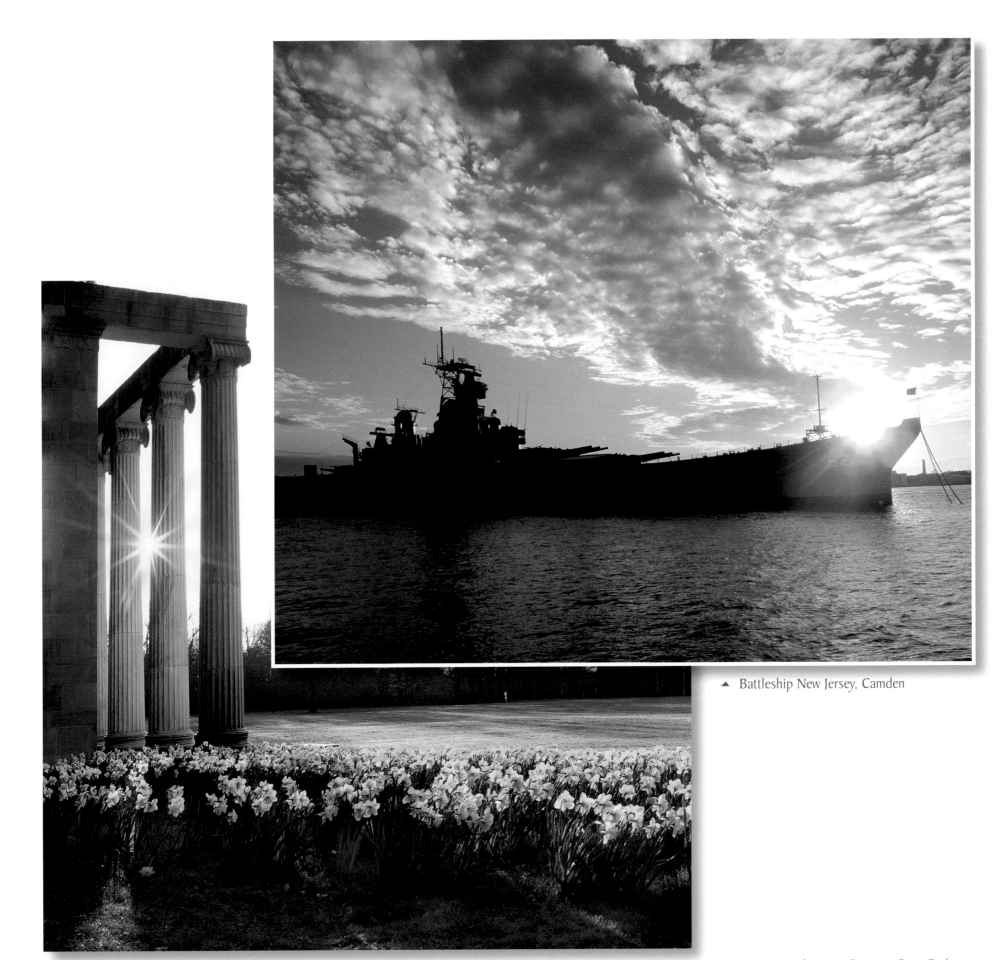

▲ Battleship New Jersey, Camden

▲ Mercer Portico, Princeton Battlefield State Park, Princeton

Washington Crossing State Park ▶

Jockey Hollow, Morristown National Historical Park ▶▶

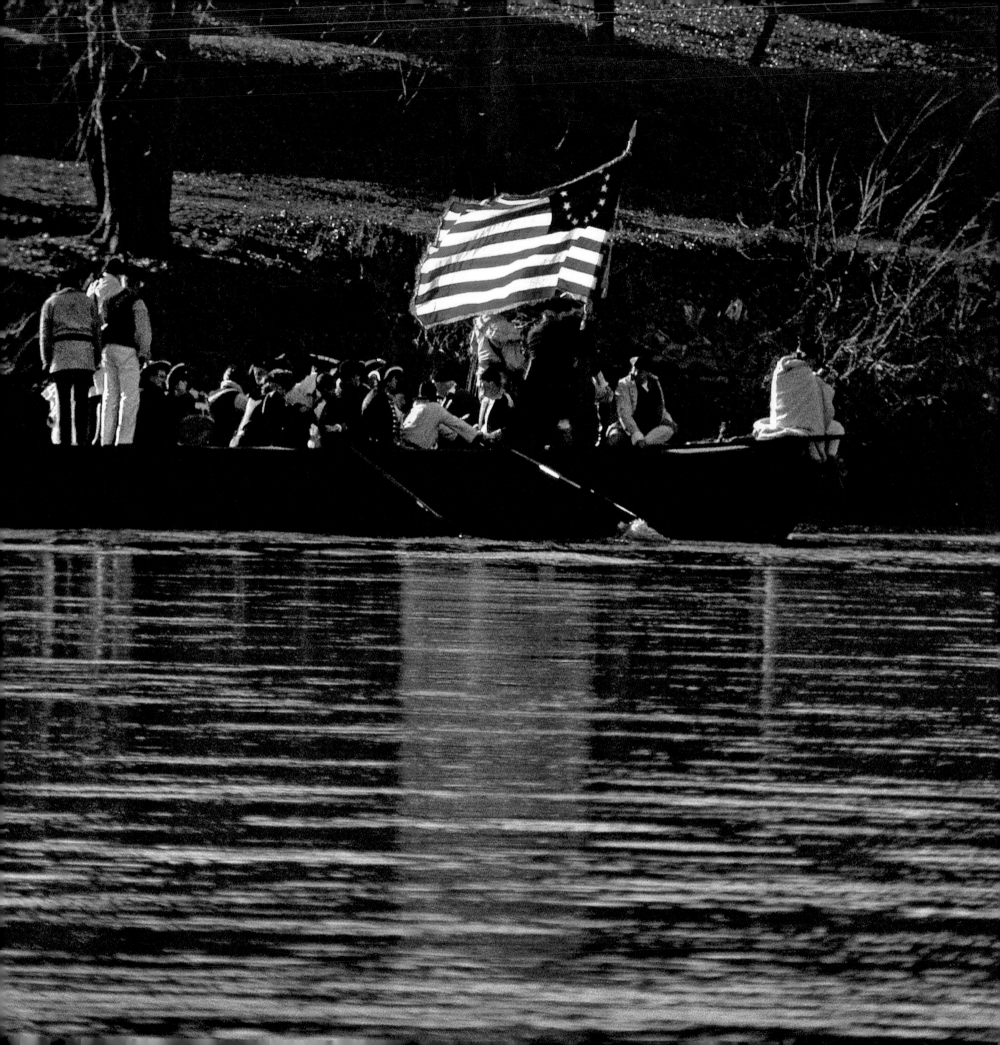

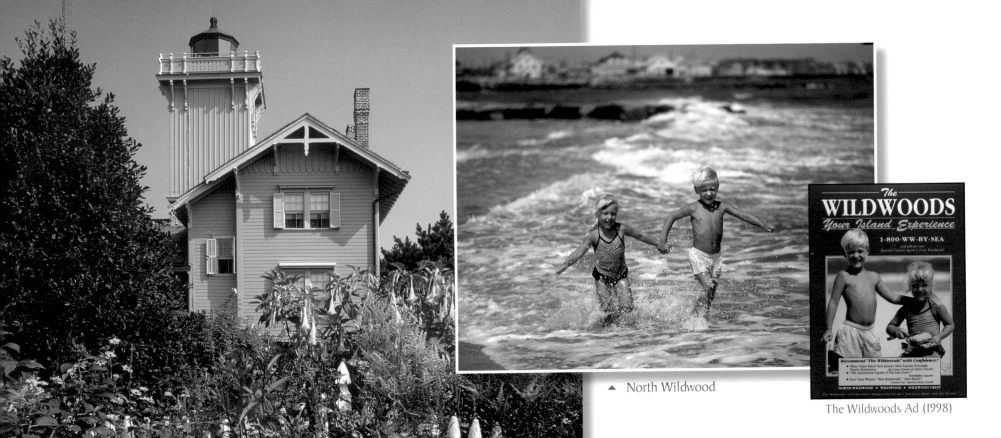

▲ North Wildwood

The Wildwoods Ad (1998)

▲ Hereford Inlet Light, North Wildwood

My childhood memories of the Jersey shore were made in Wildwood. When I was a child, my Uncle Joe took me to Wildwood Crest where we would stay at the Yankee Clipper or the Park Lane.

I continued the Wildwood tradition with my own family. We chose to stay in North Wildwood, with regular visits to the Time & Tide, morning bike rides on the boardwalk, followed by breakfast at Samuel's Pancake House. We then toured the Hereford Inlet Light and gardens and afternoons were spent on the vast beach. We ended our days with rides, food and fun on the boardwalk until midnight.

During these Wildwood days, I also shot photographs professionally and I produced brochures and advertising for The Wildwoods and North Wildwood.

▲ Wildwood

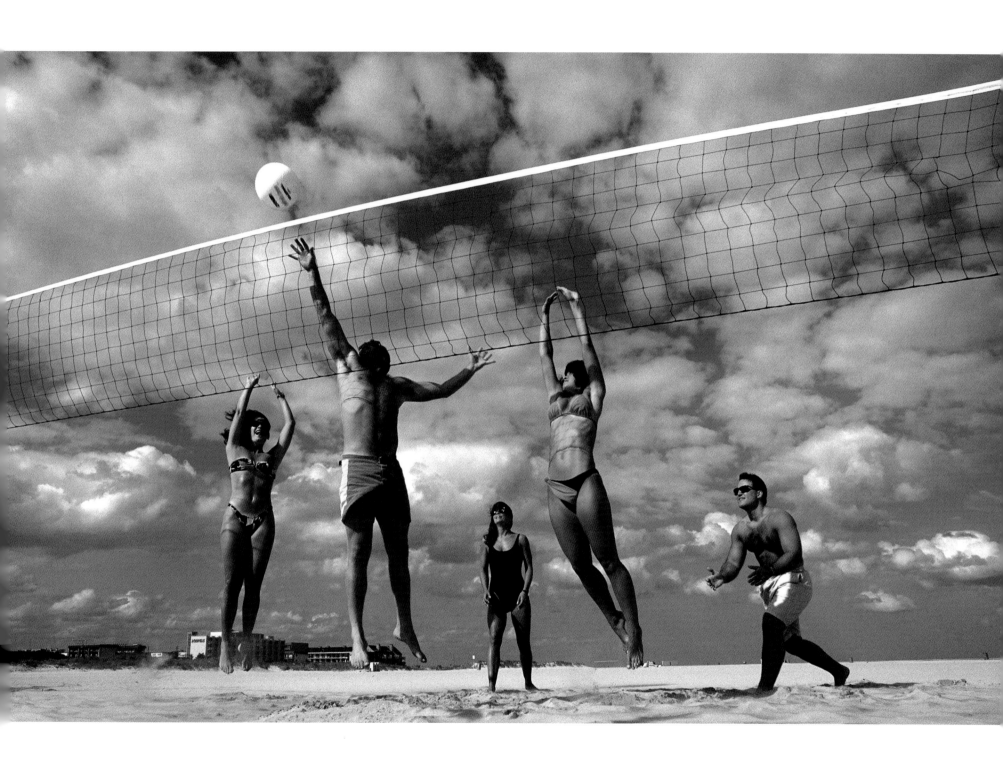

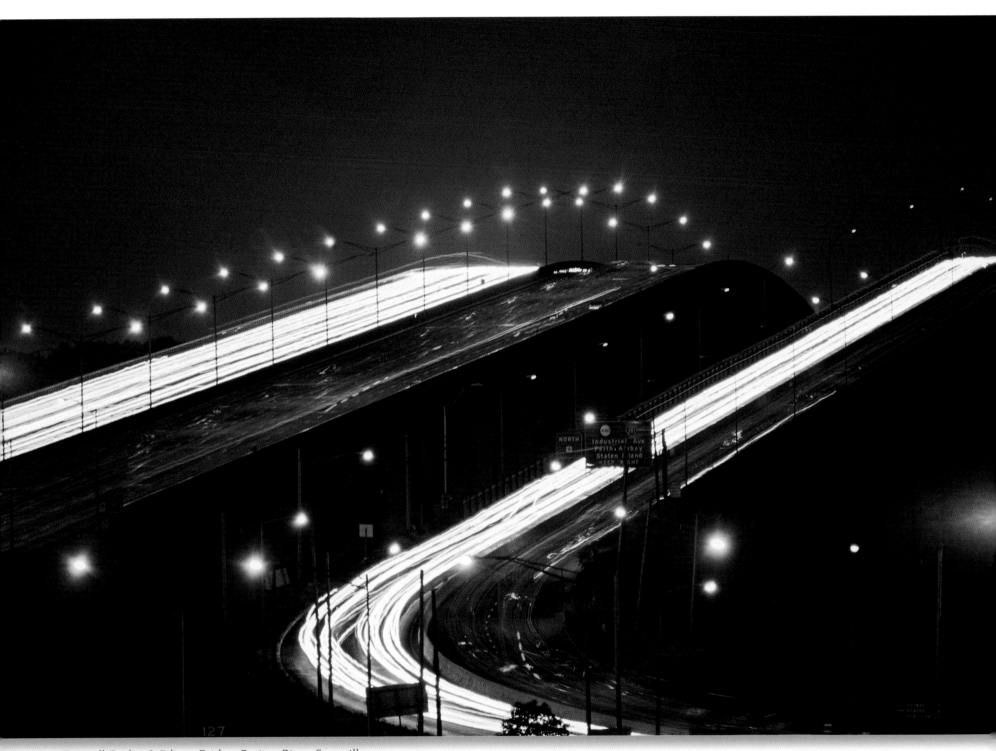

▲ Driscoll Bridge & Edison Bridge, Raritan River, Sayreville

Exit 14, New Jeresey Turnpike, Newark ▶

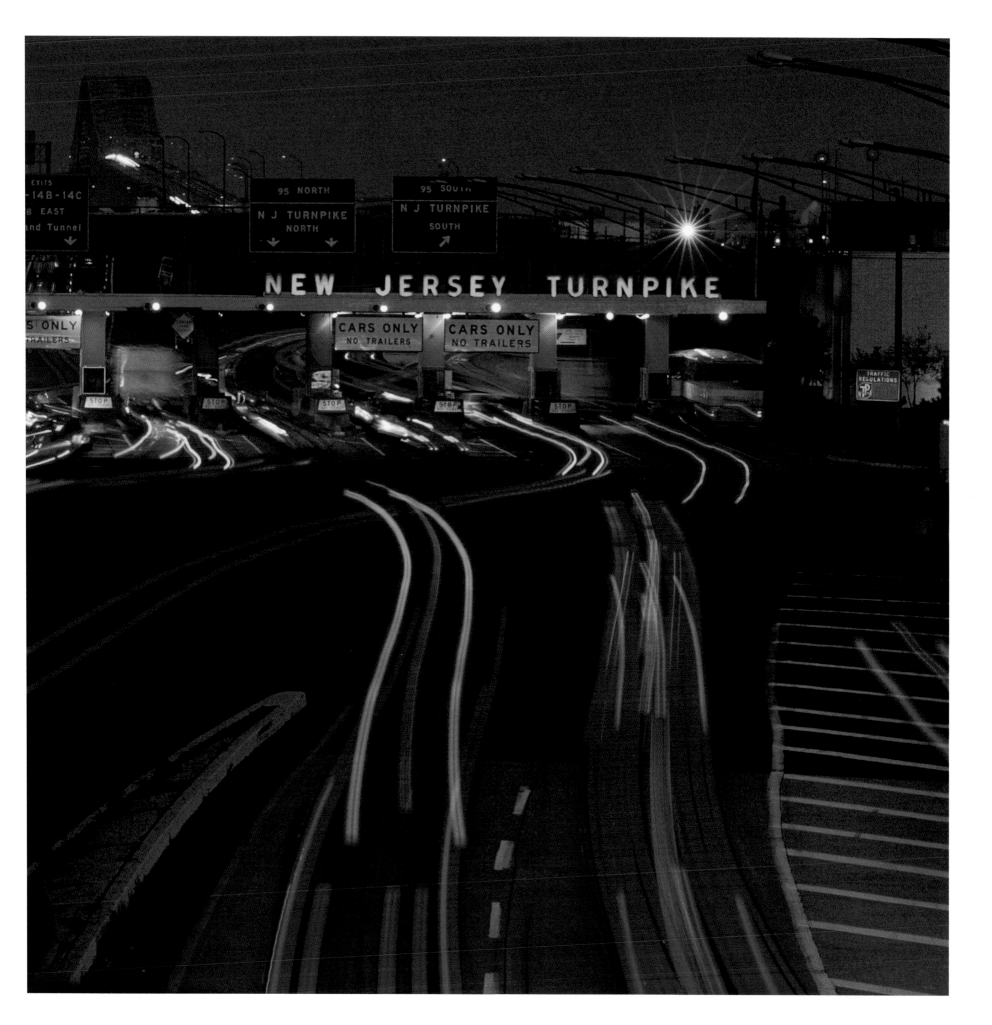

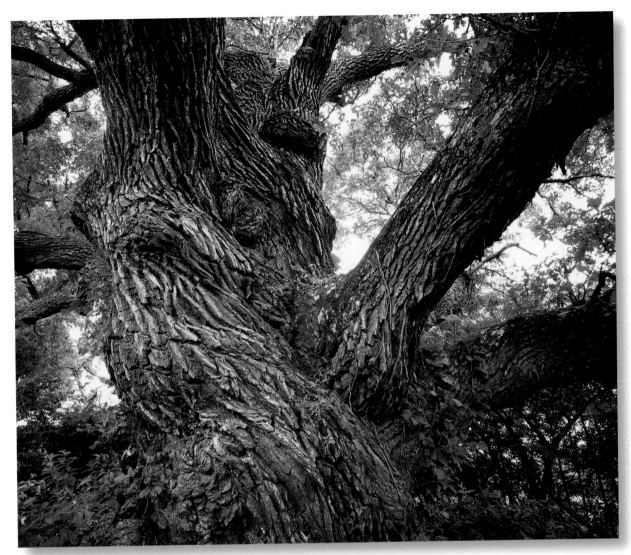

▲ White Swamp Oak, Jobstown

▲ Sycamore, Haddonfield

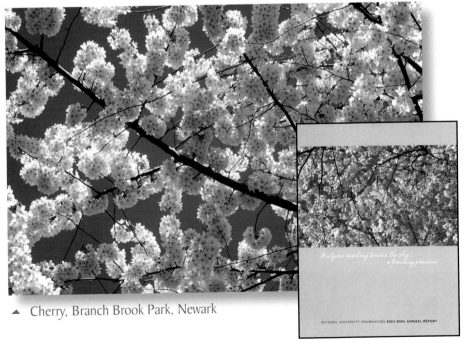

▲ Cherry, Branch Brook Park, Newark

Rutgers University Foundation
2003-2004 Annual Report

I photographed the Salem Oak (right) in 1989 for an annual report which featured the historic trees of New Jersey. I wanted to create a mixed lighting exposure at dusk and include the neon lights of the nearby diner which bore the same name as the tree.

The image was taken on a 4x5 view camera using a small aperture, long exposure. Large format photography requires the use of a black focusing cloth. For this photo I incorporated a special lighting technique using a hand-held flash unit. I moved through the scene, dressed in black with the black focusing cloth draped over my head and flowing behind me like a cape. With my back to the camera I painted the scene with the strobe light. During the 2 minute exposure, I popped the flash many times to illuminate the dark shadows.

It must have been a strange site in this quiet South Jersey town. As a mother and her young son walked by, I heard the boy exclaim, "Mommy, it's Batman! It's Batman...it really is. He's in the cemetery!" I shouted back, "Yes, I am Batman!"

His mother just pulled him along and did not acknowledge him, me or the strange superhero-like flashes of light coming from the First Presbyterian Cemetery. (Tim Burton's popular film Batman, a dark Gothic interpretation, was released that summer!)

Salem Oak Tree, Salem ▶

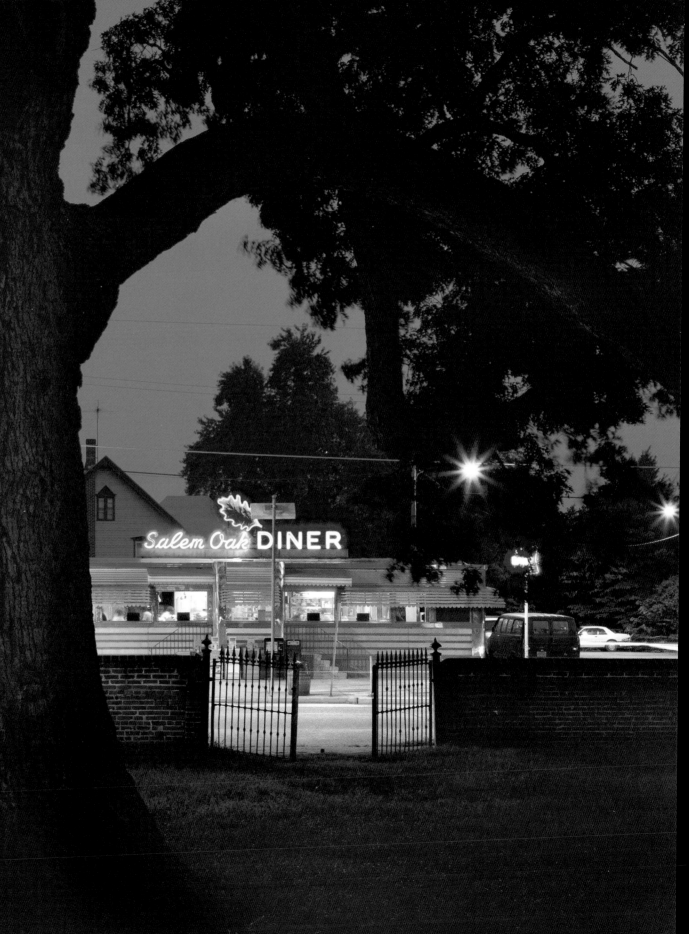

▲ Gladstone

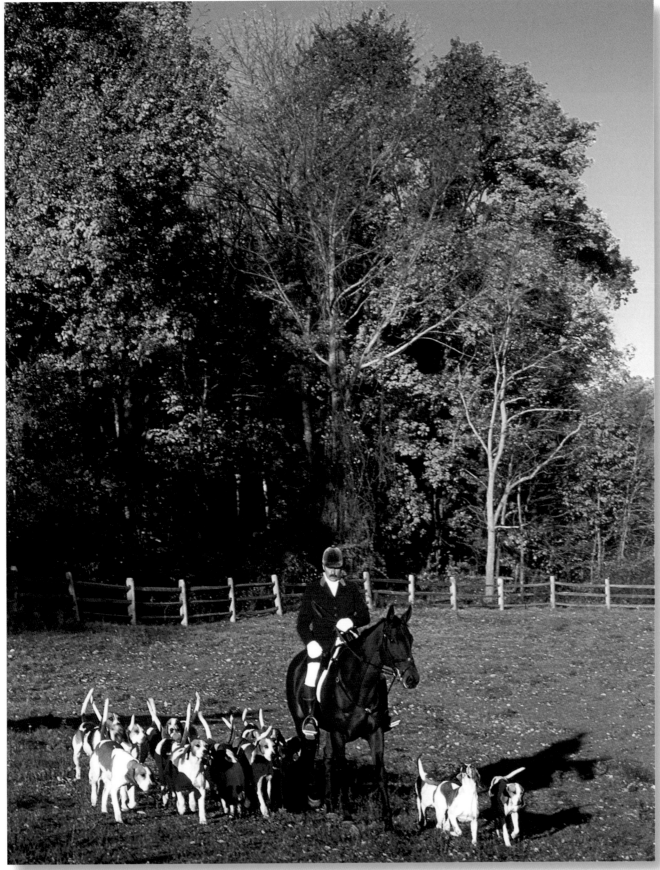

▲ Essex Fox Hounds, Peapack (2002)

Turpin Real Estate
Brochure

Peapack-Gladstone Bank
2003 Calendar

Essex Fox Hounds, Peapack (1980) ▶

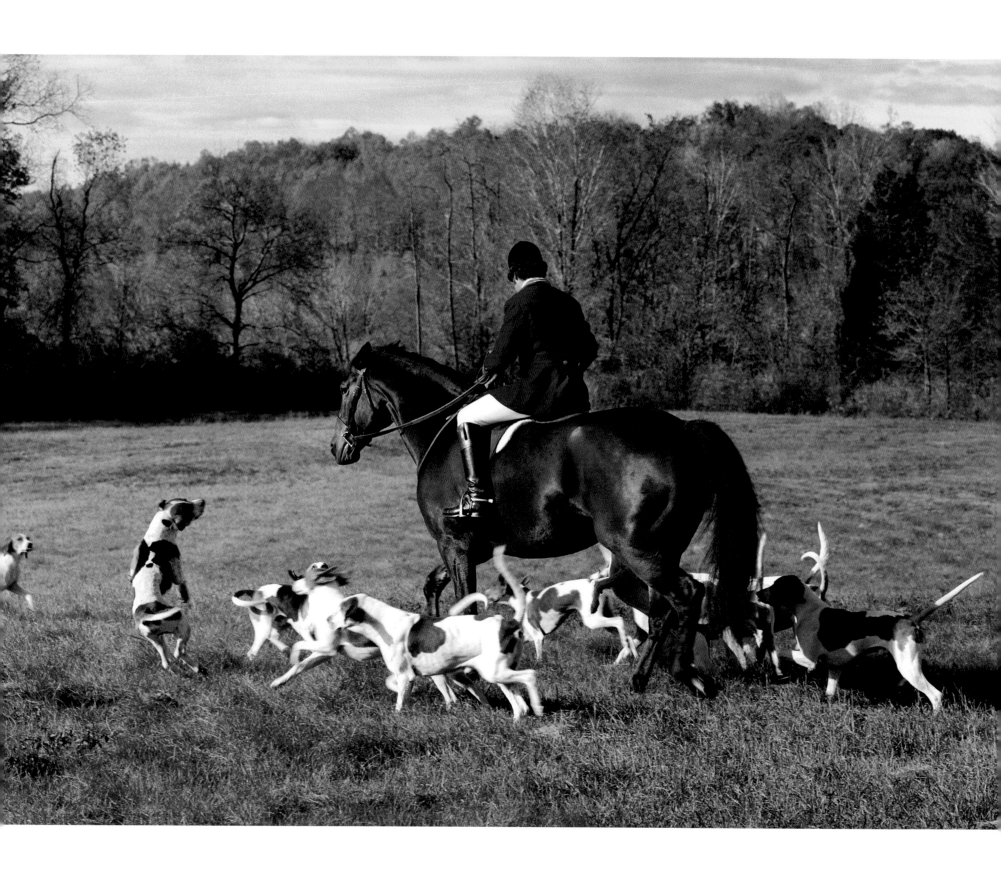

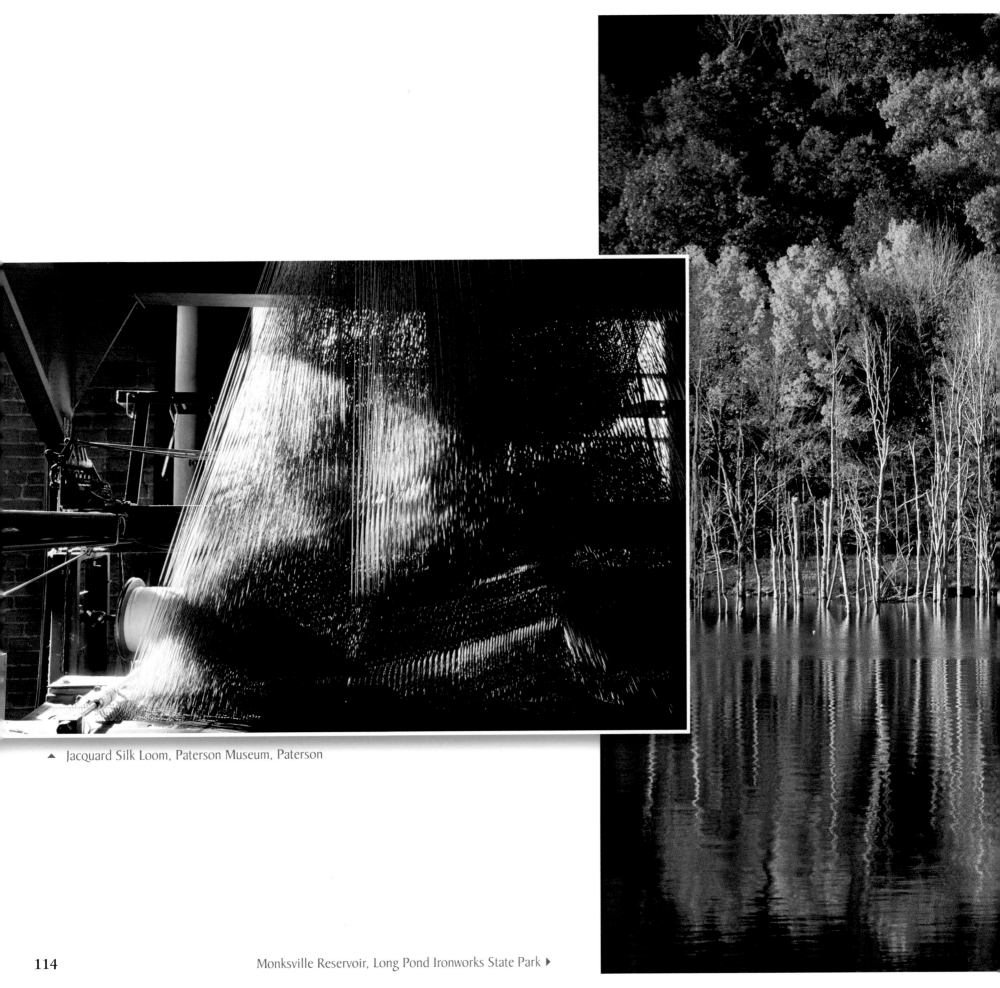

▲ Jacquard Silk Loom, Paterson Museum, Paterson

Monksville Reservoir, Long Pond Ironworks State Park ▶

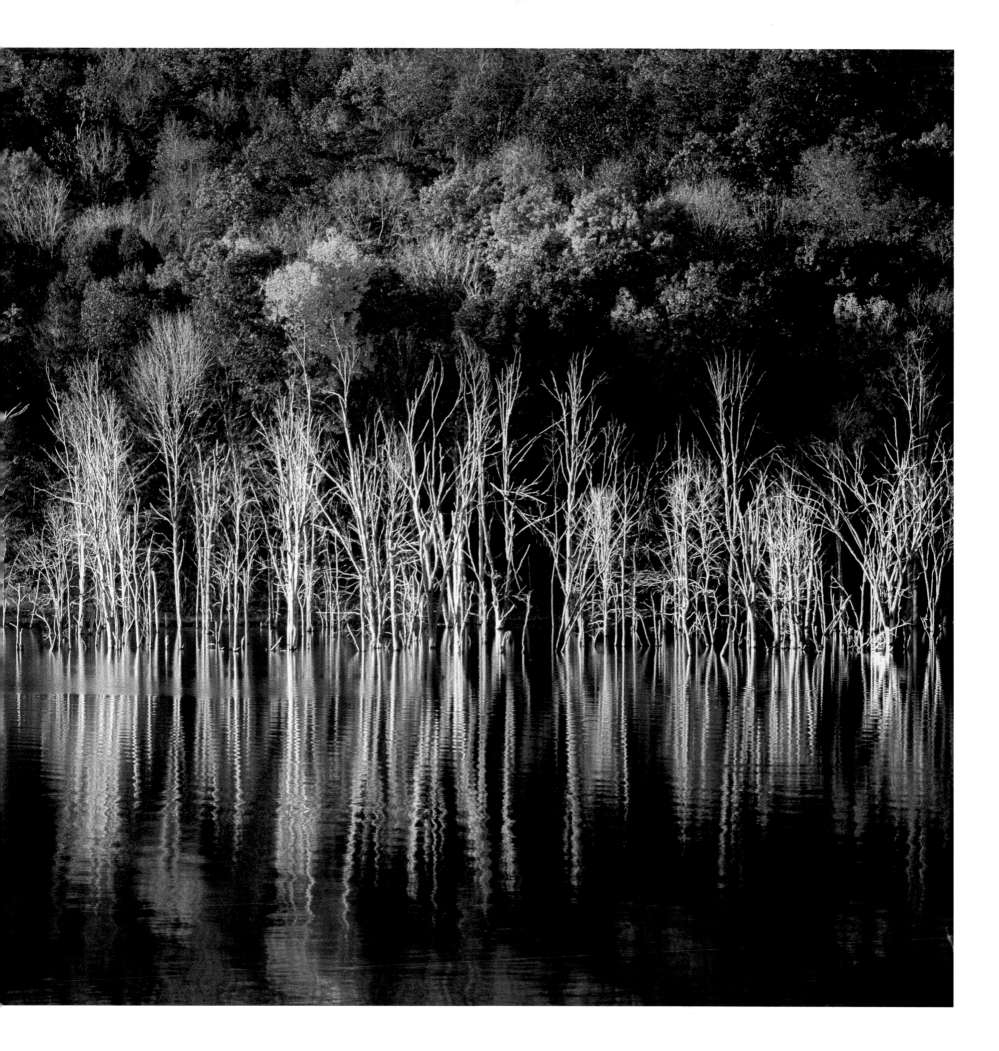

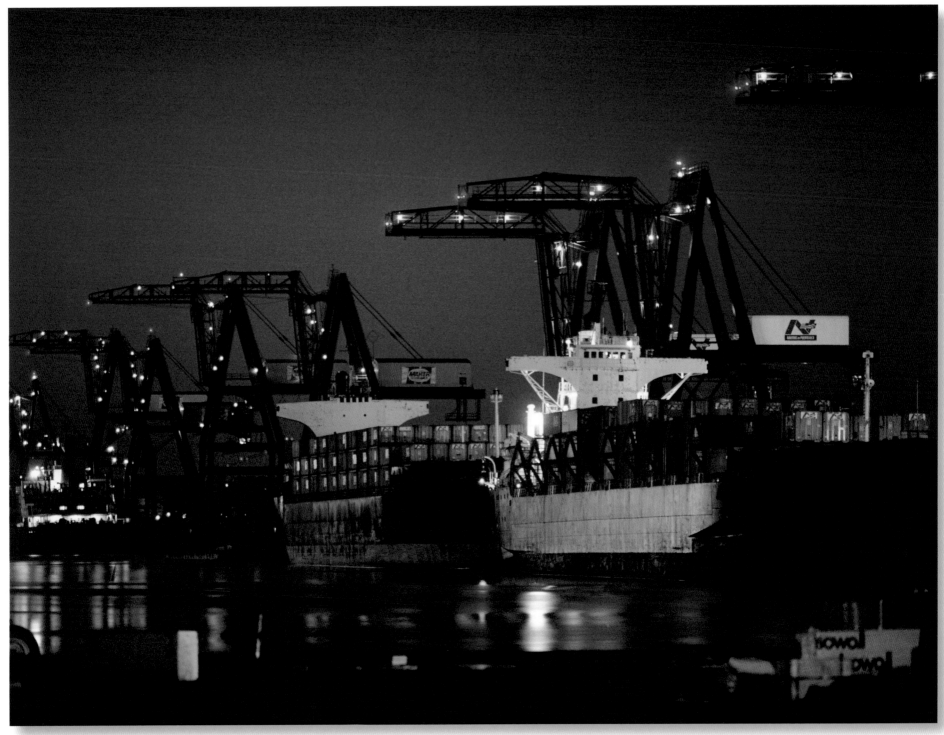

▲ Port Elizabeth

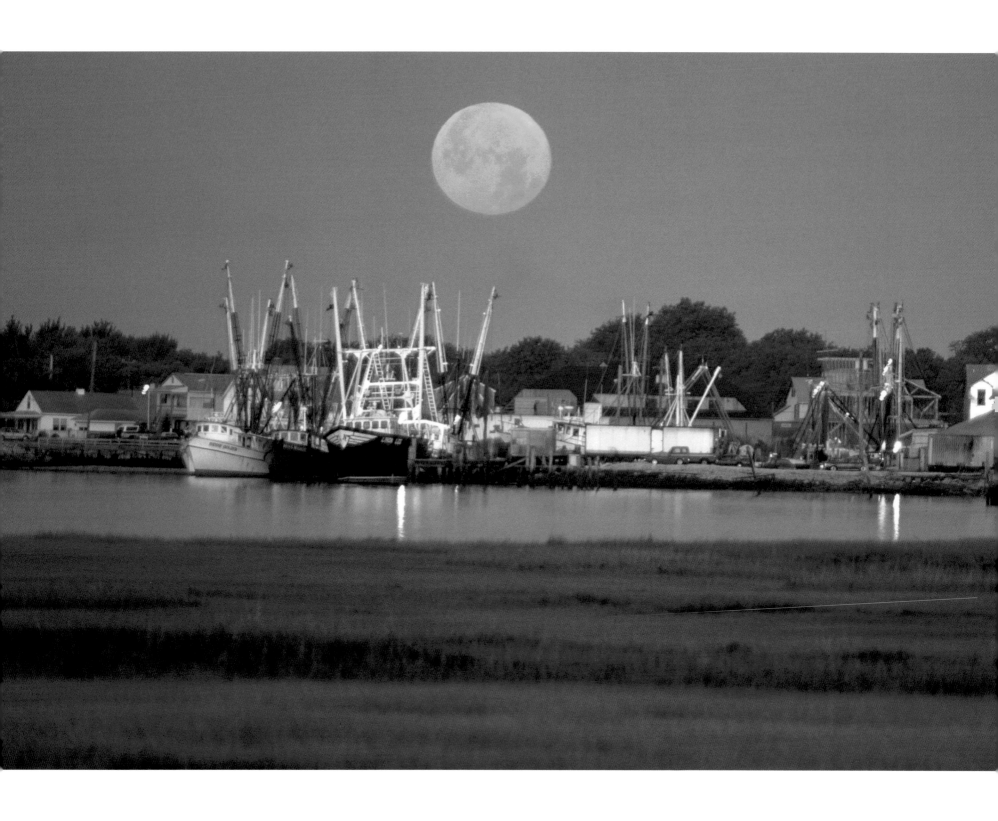

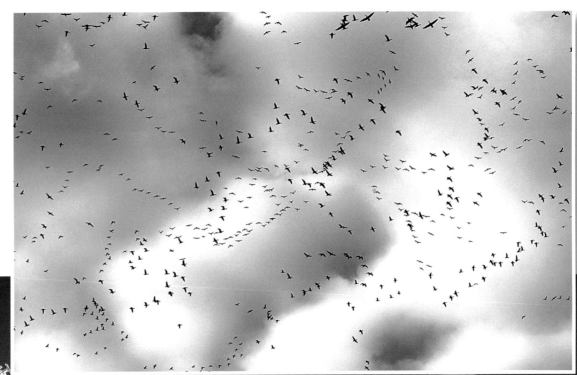

Snow Geese, Brigantine ▶

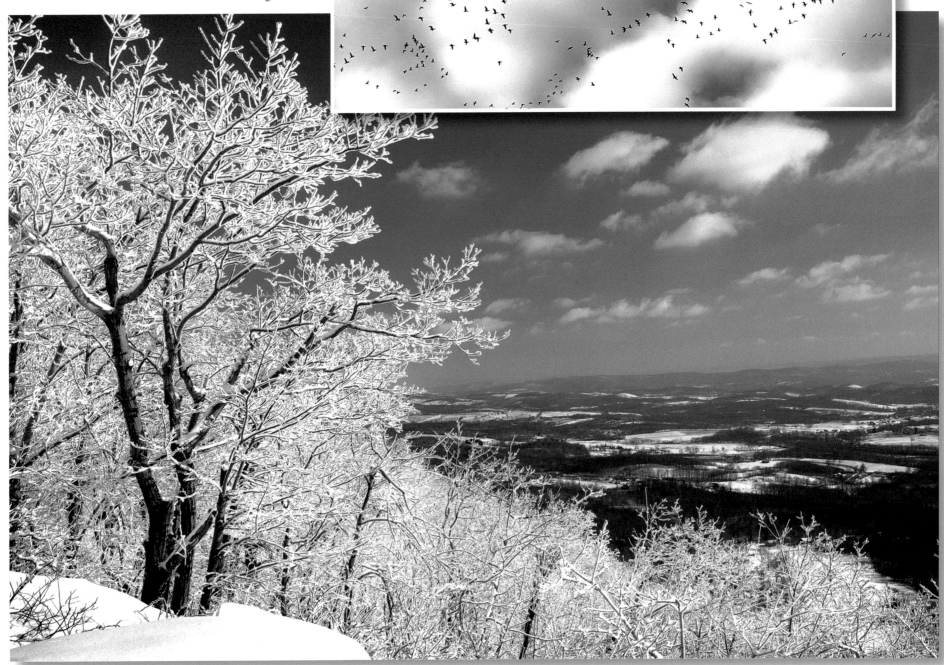

▲ Sunrise Mountain, Stokes State Forest

Rudolf W. van der Goot Rose Garden, Colonial Park Arboretum, Franklin ▶

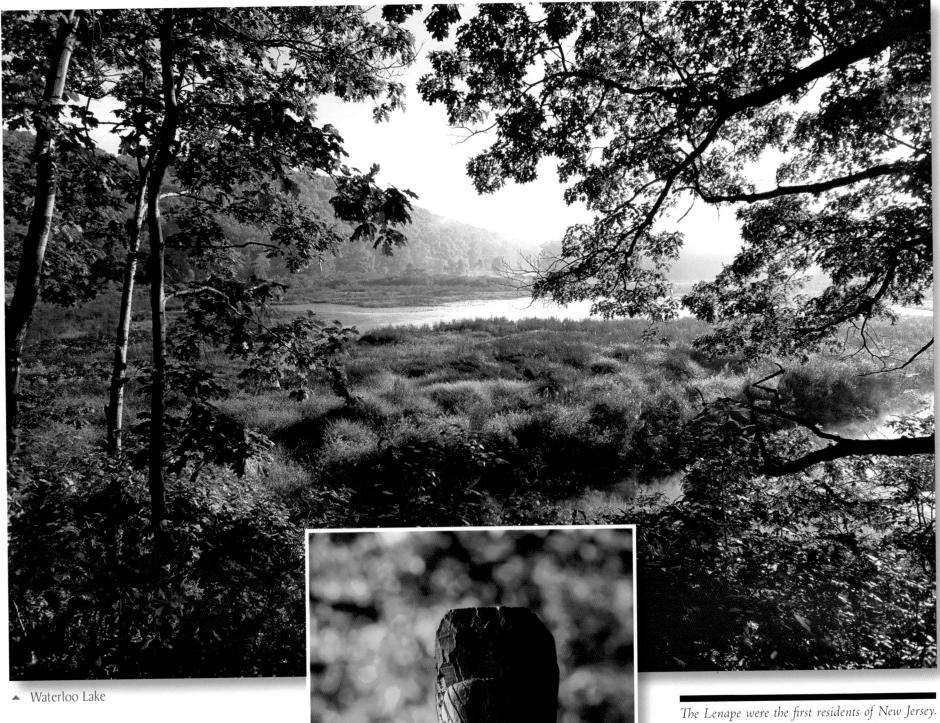

▲ Waterloo Lake

▲ Eastern Box Turtle, Hacklebarney S.P.

Lenape Village, Waterloo ▶

The Lenape were the first residents of New Jersey. I had the privilege of meeting and photographing James "Lone Bear" Revey at the Lenape Village at Waterloo where he graciously posed for me in traditional Lenape clothing.

Revey, a descendant of the Sand Hill Delaware tribe, had passed from this world in the spring of 1998. As a renowned spokesperson and educator about the Lenape, he served for many decades as Chairman of the New Jersey Indian Office in Orange.

James "Lone Bear" Revey, Waterloo ▶

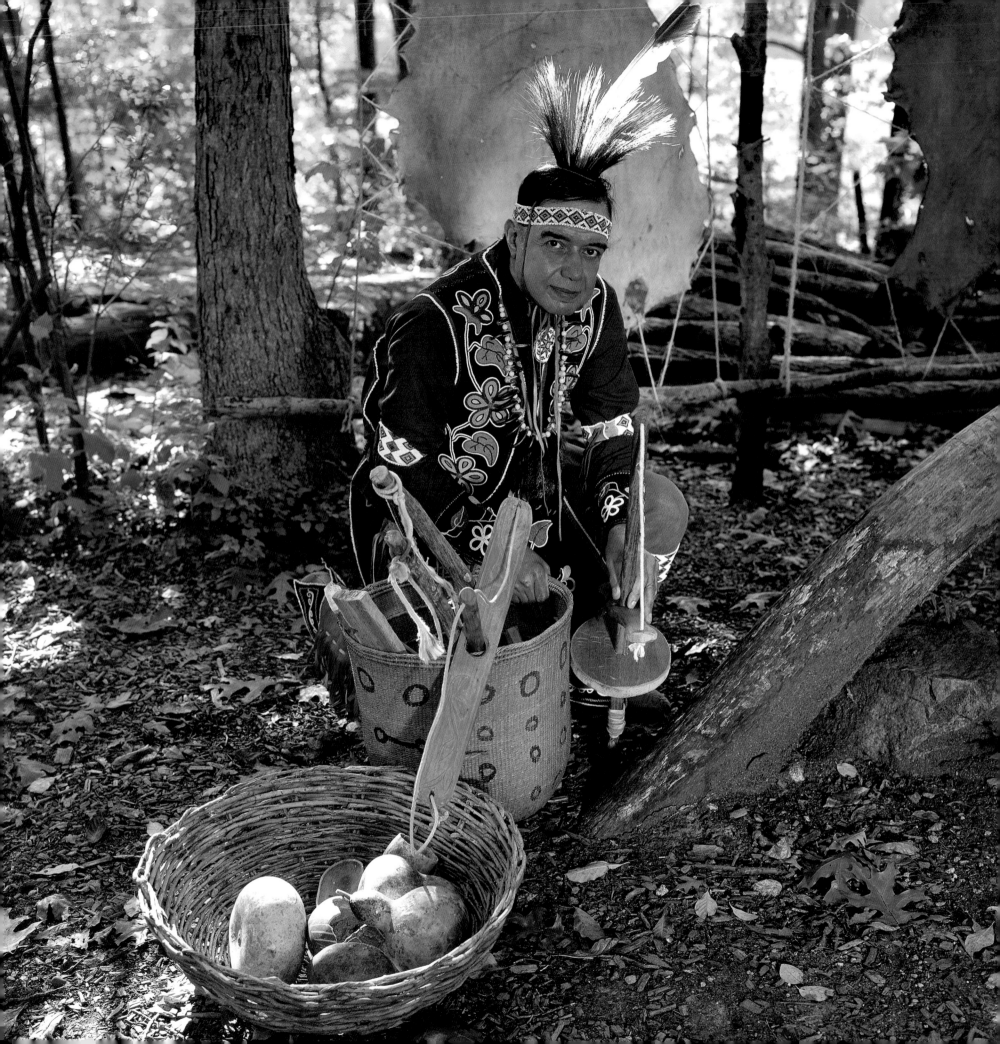

▲ Sussex County Fair, Augusta

▲ Sussex County Fair, Augusta

▲ Gloucester County 4-H Fair, Mullica Hill

The photo of the sleeping pigs (right), taken in 1980, holds special meaning for me. The editor of **NEW JERSEY, A Scenic Discovery**, *said that it was his favorite image. My wife, Susan, found a small figurine, similar to this photo, and gave it to me as a gift the day my first book arrived at our home.*

▲ Flemington Fair, Flemington

122

Flemington Fair, Flemington ▶

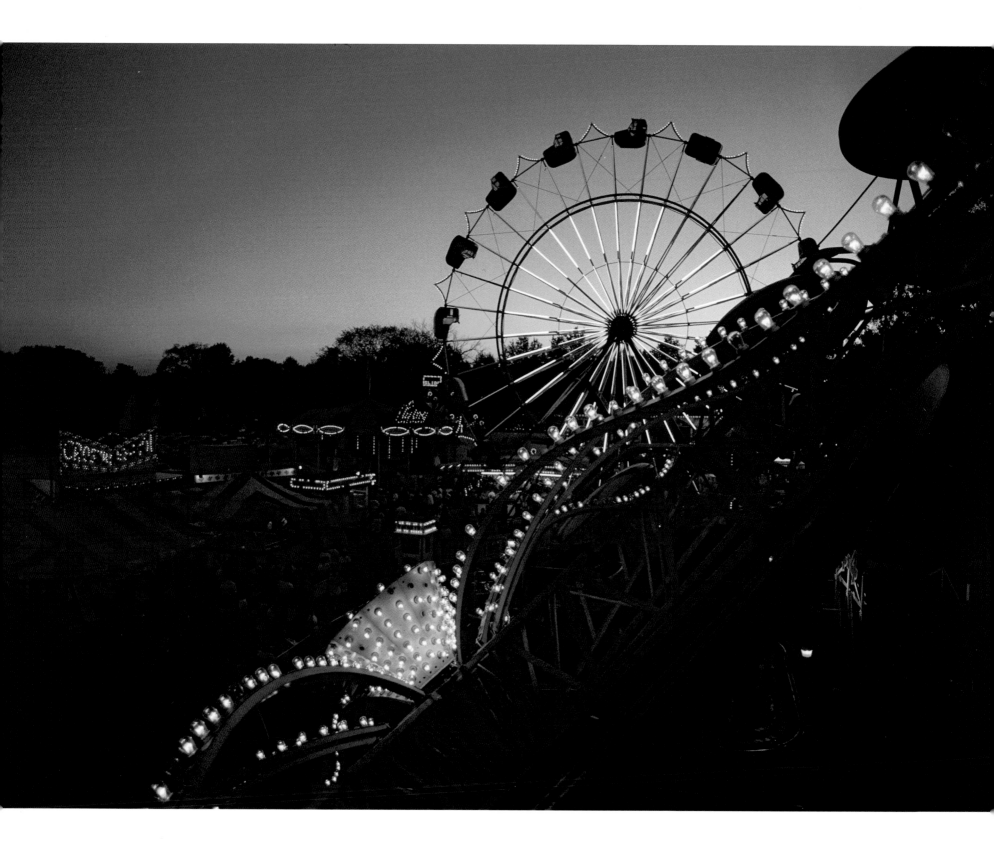

Drew University, Madison

University In The Forest

Rowan University, Glassboro

Henry Rutgers Baldwin Gate, Rutgers University, New Brunswick ▶

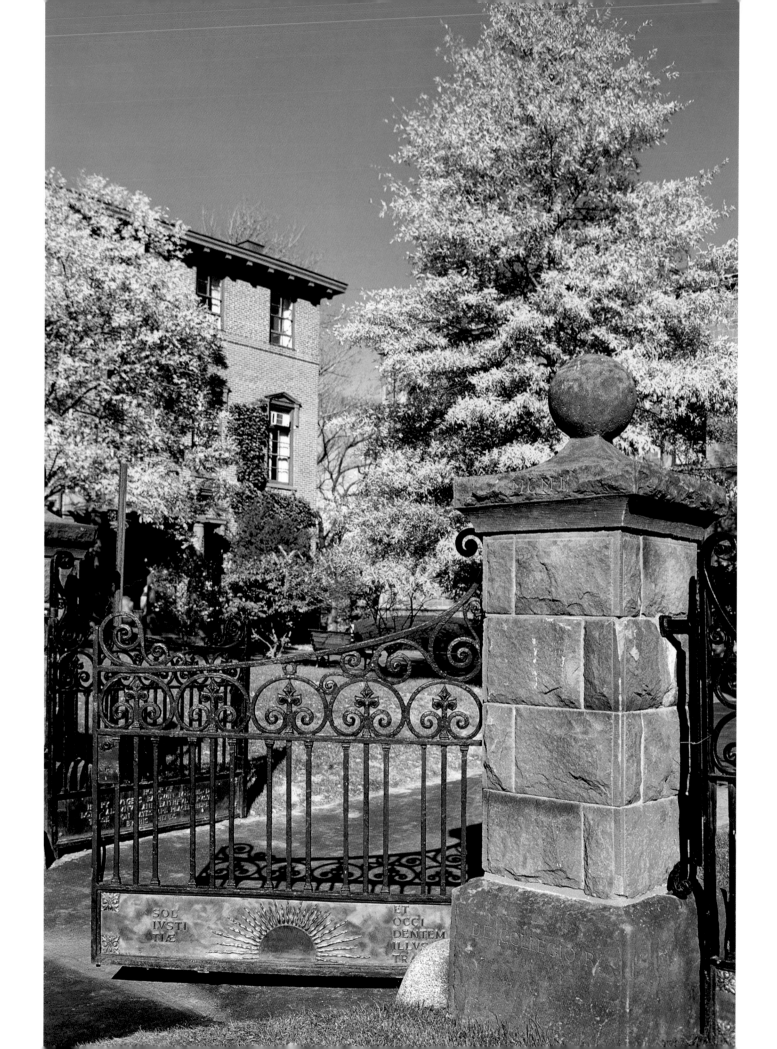

SOL
IVSTI
TIÆ

ET
OCCI
DENTEM
ILLVS
TRA

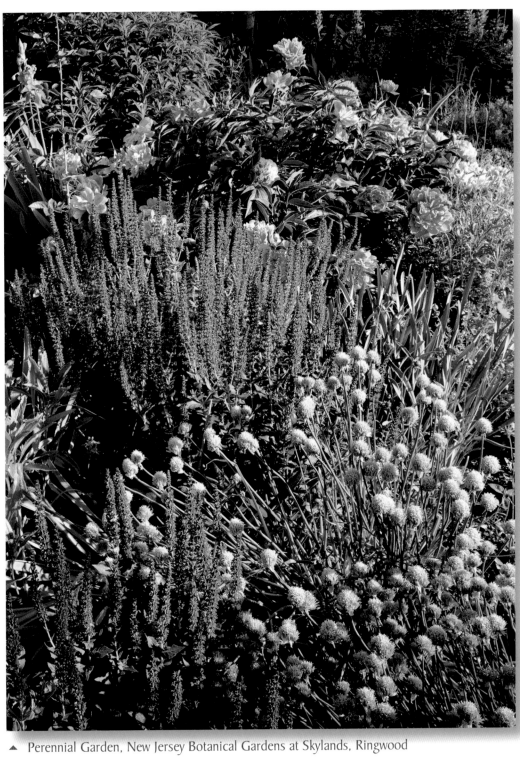

▲ Perennial Garden, New Jersey Botanical Gardens at Skylands, Ringwood

Jenny Jump State Forest ▶

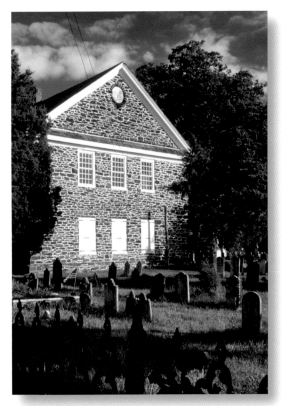

▲ Fairfield Presbyterian Church, Fairton

The Presbyterian Church, Westfield ▶

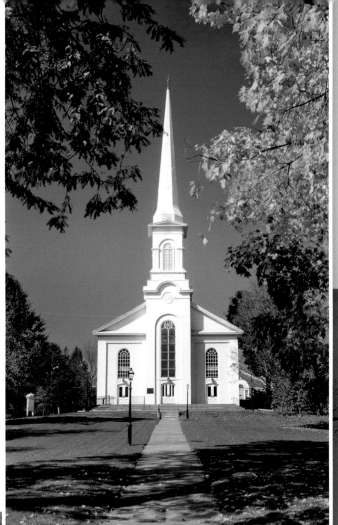

Editors at **New Jersey Monthly** *magazine noticed that my photo of the tombstone angel (right) which appeared in* **NEW JERSEY, A Scenic Discovery**, *bore a striking resemblance to then Saddle River resident, and former president, Richard M. Nixon. I agree!*

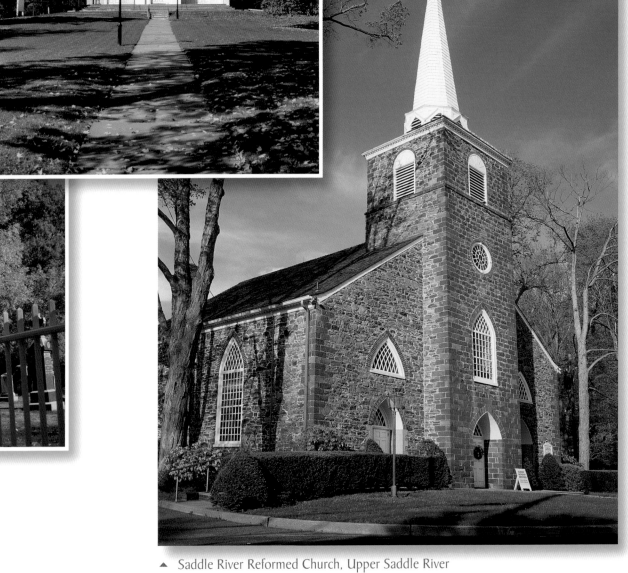

▲ Christ Episcopal Church, Shrewsbury

▲ Saddle River Reformed Church, Upper Saddle River

Tombstone detail, First Presbyterian Church Cemetery, Springfield ▶

▲ Rockport

Lucy The Margate Elephant, Margate ▶

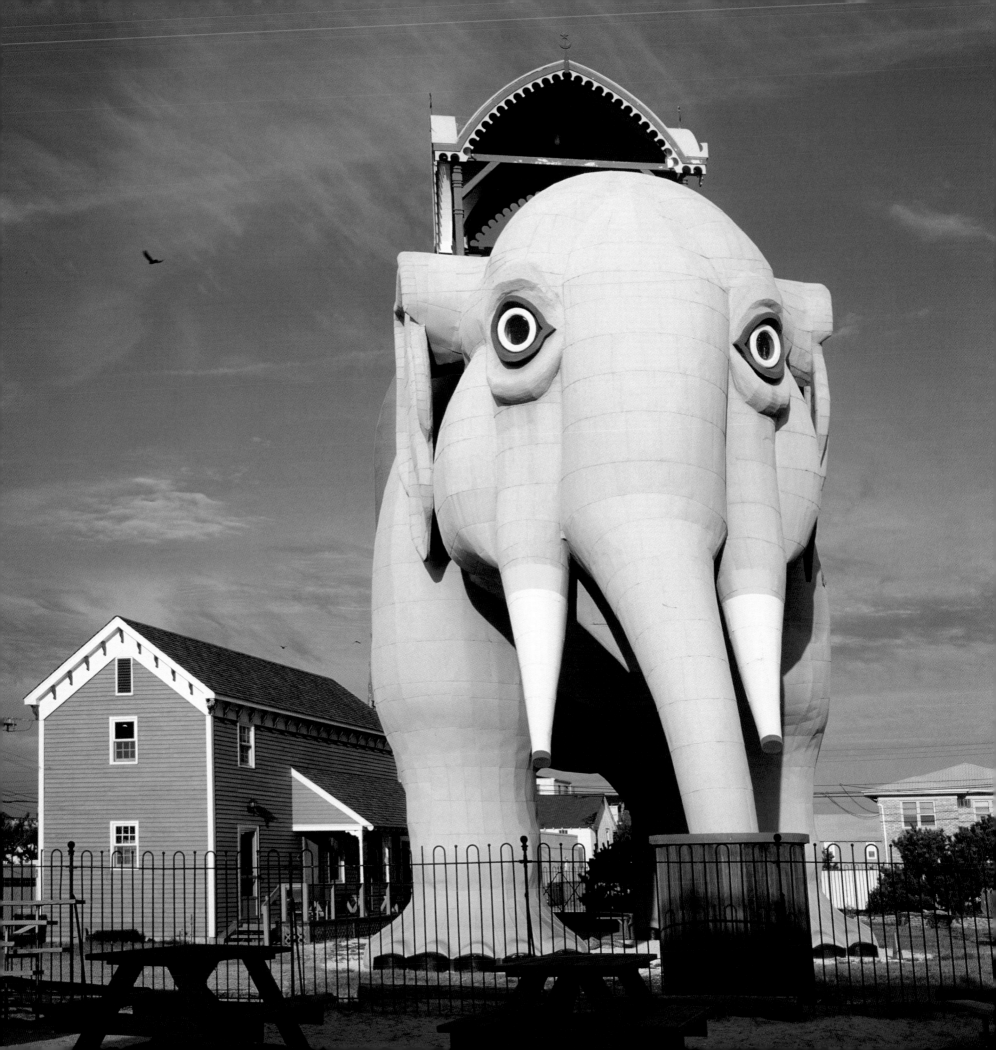

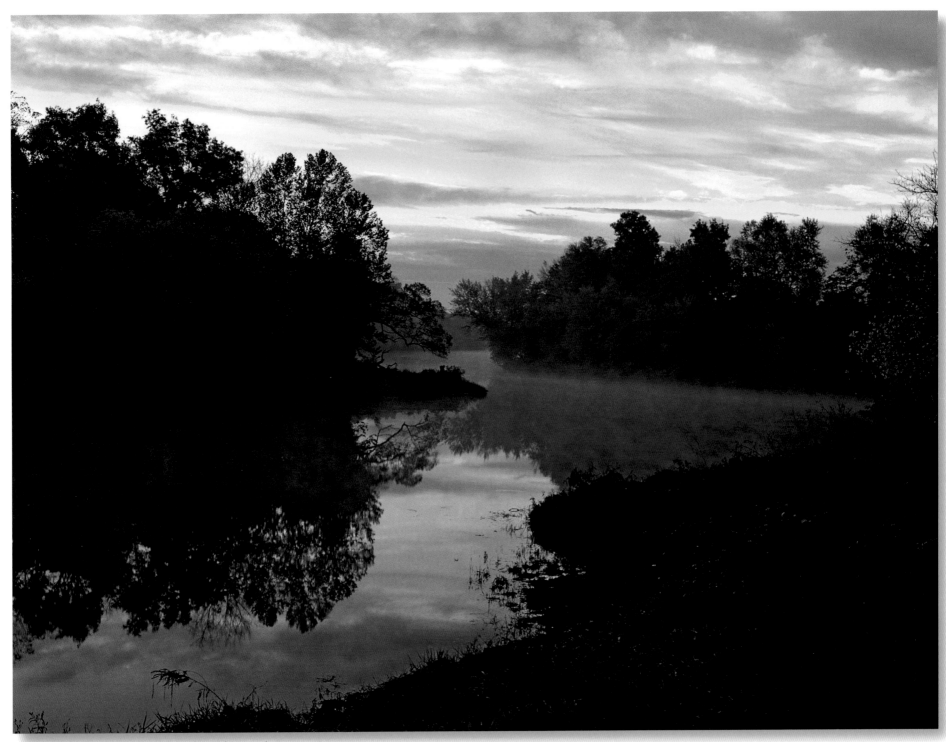

▲ Confluence, North Branch and South Branch Raritan River

The Raritan is my favorite of all New Jersey rivers! Something draws me to these waters again and again. Perhaps it is the voices of the Raritan and Sanhikan (Unami) Tribes of Lenapehoking that lived along its banks for thousands of years; maybe it's the history of the early Dutch explorers who made their way upstream in the 1600s; or perhaps it's just the wonderful sound of clean water flowing downstream from its headwaters in the New Jersey Highlands. The epicenter of my attraction to this river is the confluence area in Somerset County (above). I loved this area so much that my family and I moved within a mile of it and made our home in the village of South Branch.

In Hunterdon County the South Branch Raritan (right) passes through a natural area called Ken Lockwood Gorge. This spectacular stretch of river, with glacial boulders strewn about, attracts fly fishing enthusiasts and nature lovers as well. Visiting the gorge, in any season, guarantees great photos.

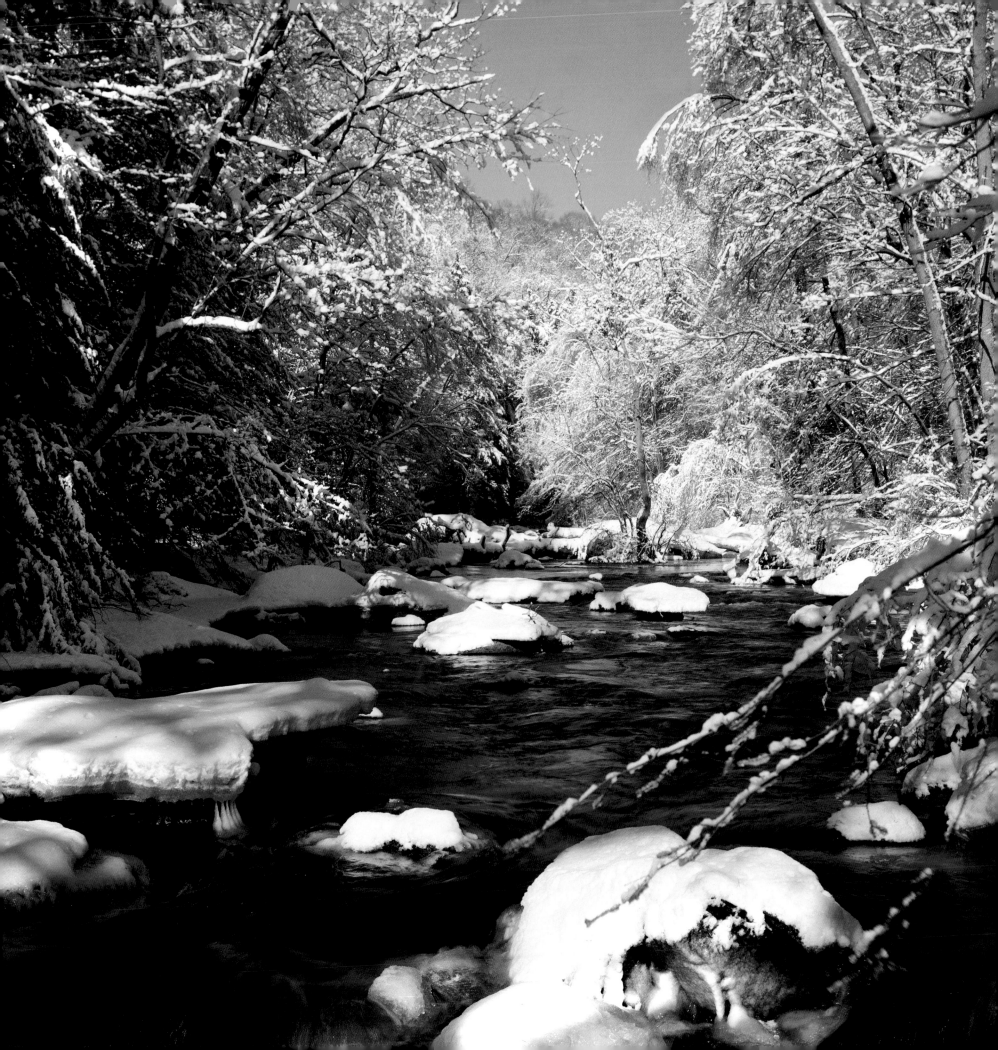

▲ Double Trouble State Park

▲ Chatsworth

Cranberry harvest, Chatsworth ▶

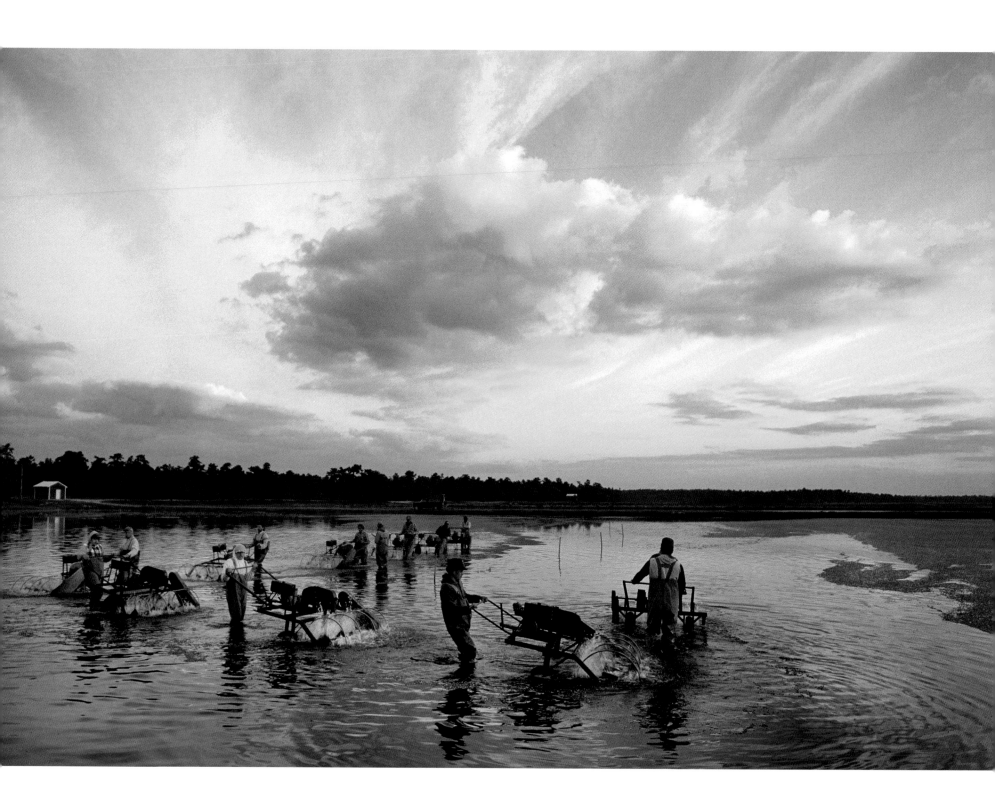

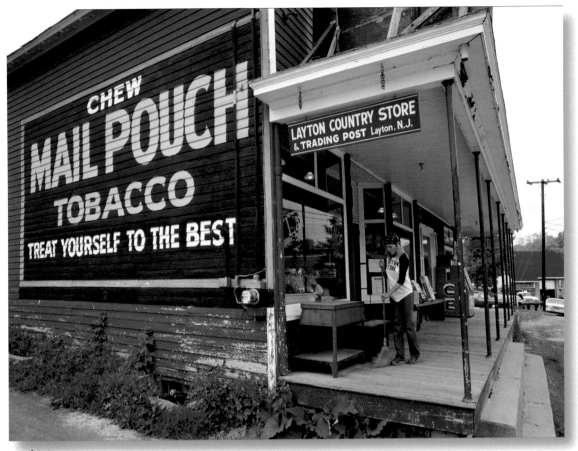

▲ Layton

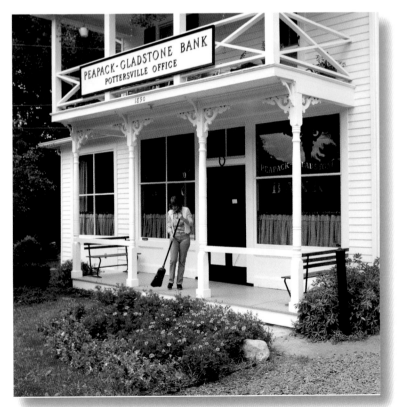

▲ Pottersville

Oldwick ▶

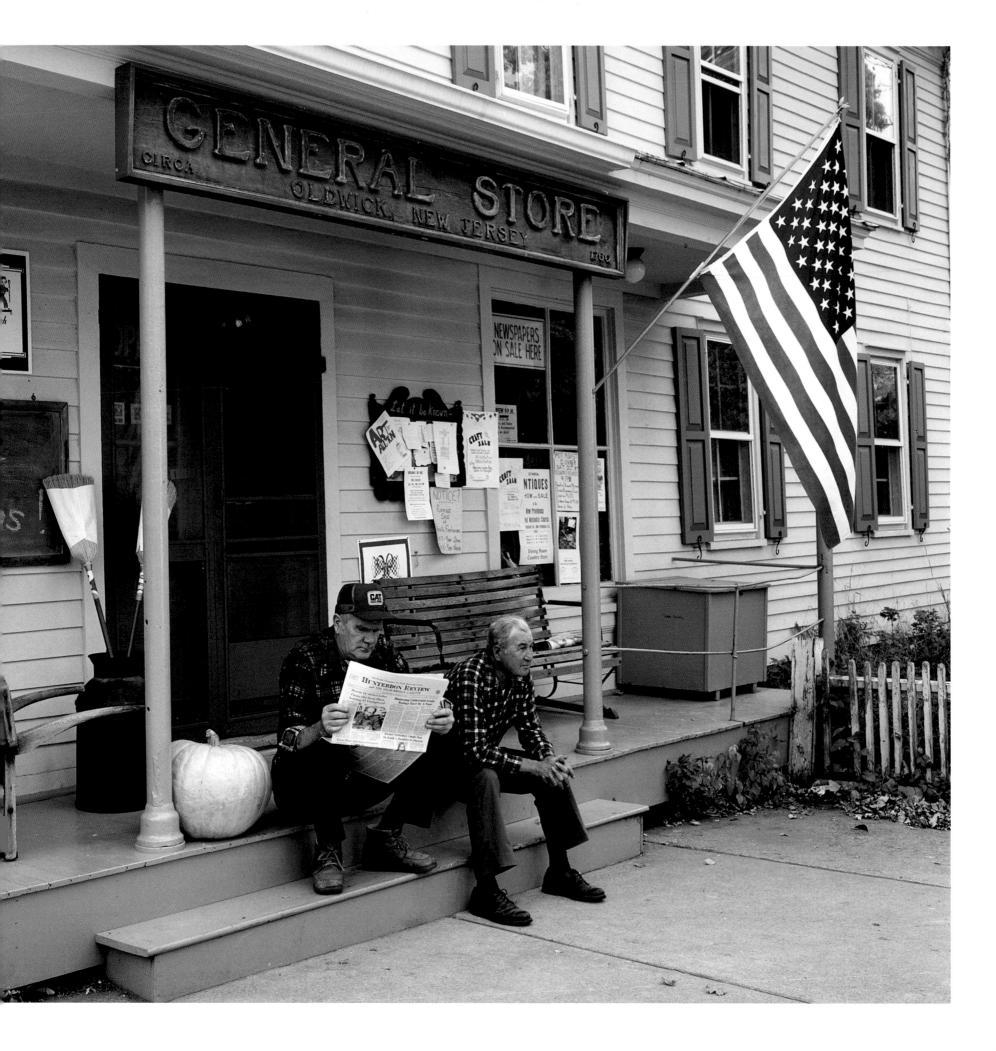

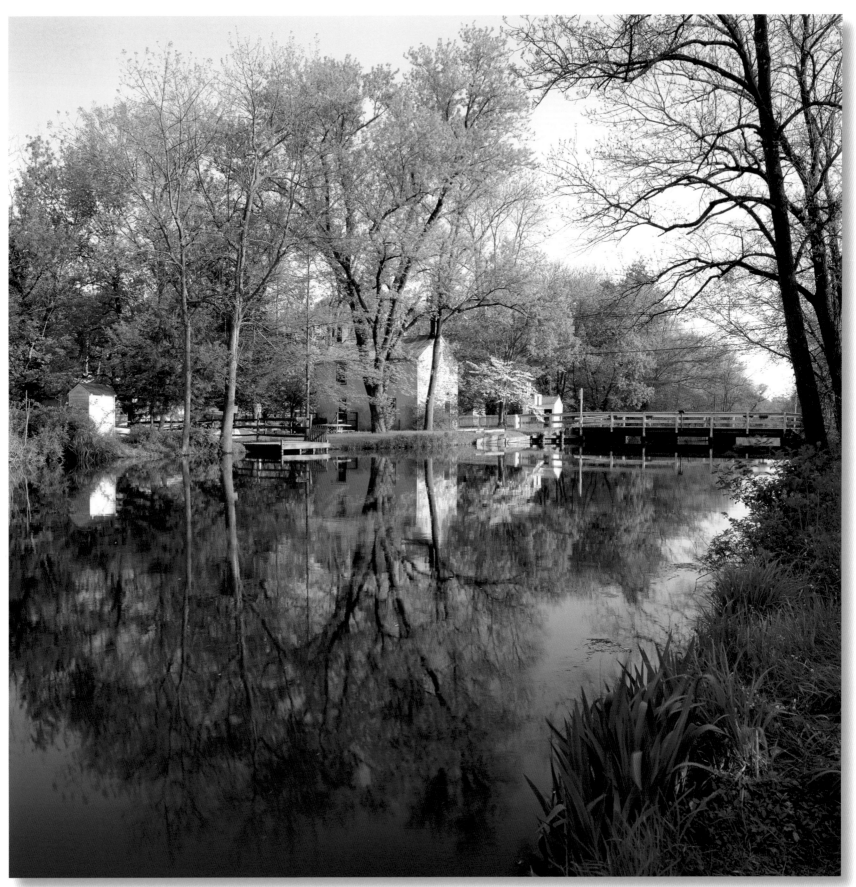

▲ Delaware & Raritan Canal, Griggstown

Morris Canal (remnant), Waterloo Village ▶

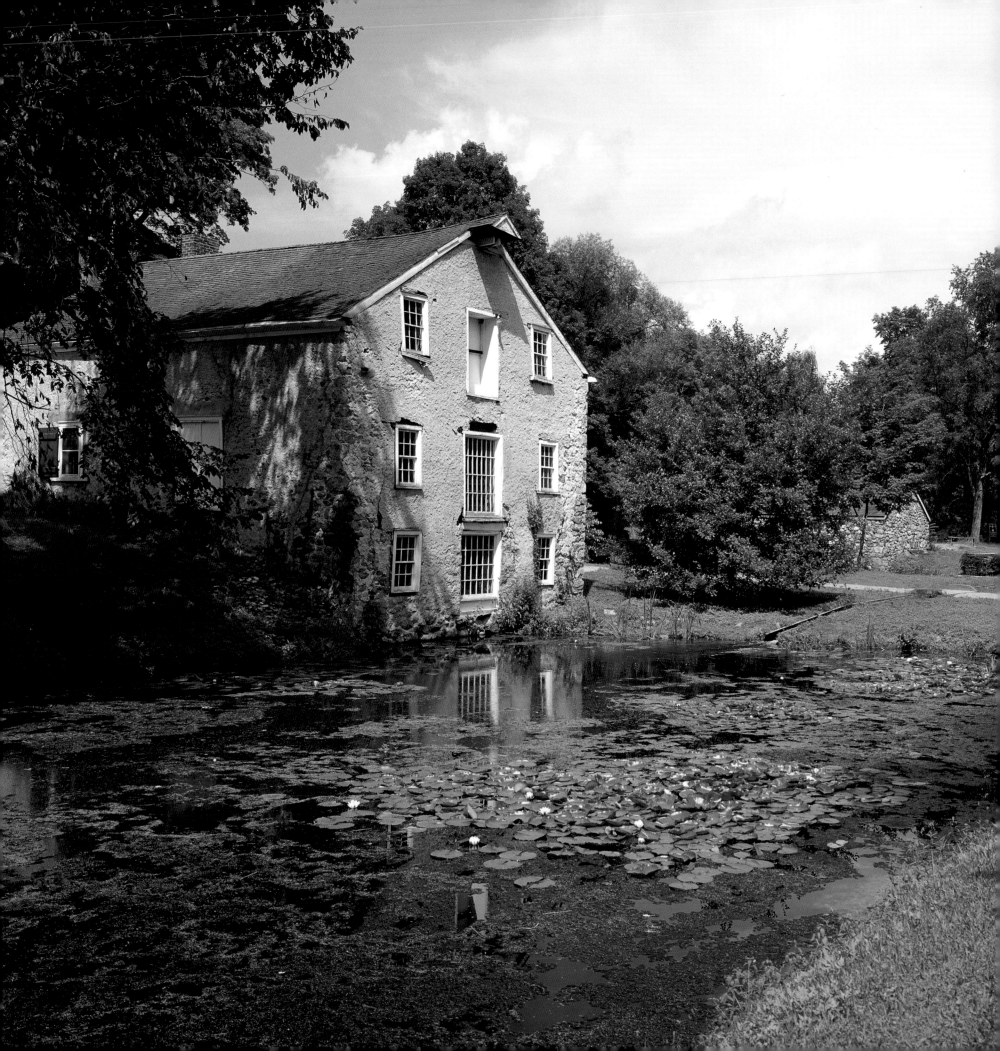

▲ Corson's Inlet State Park, Strathmere
◄ Island Beach State Park

Barnegat Inlet, Island Beach State Park ▶

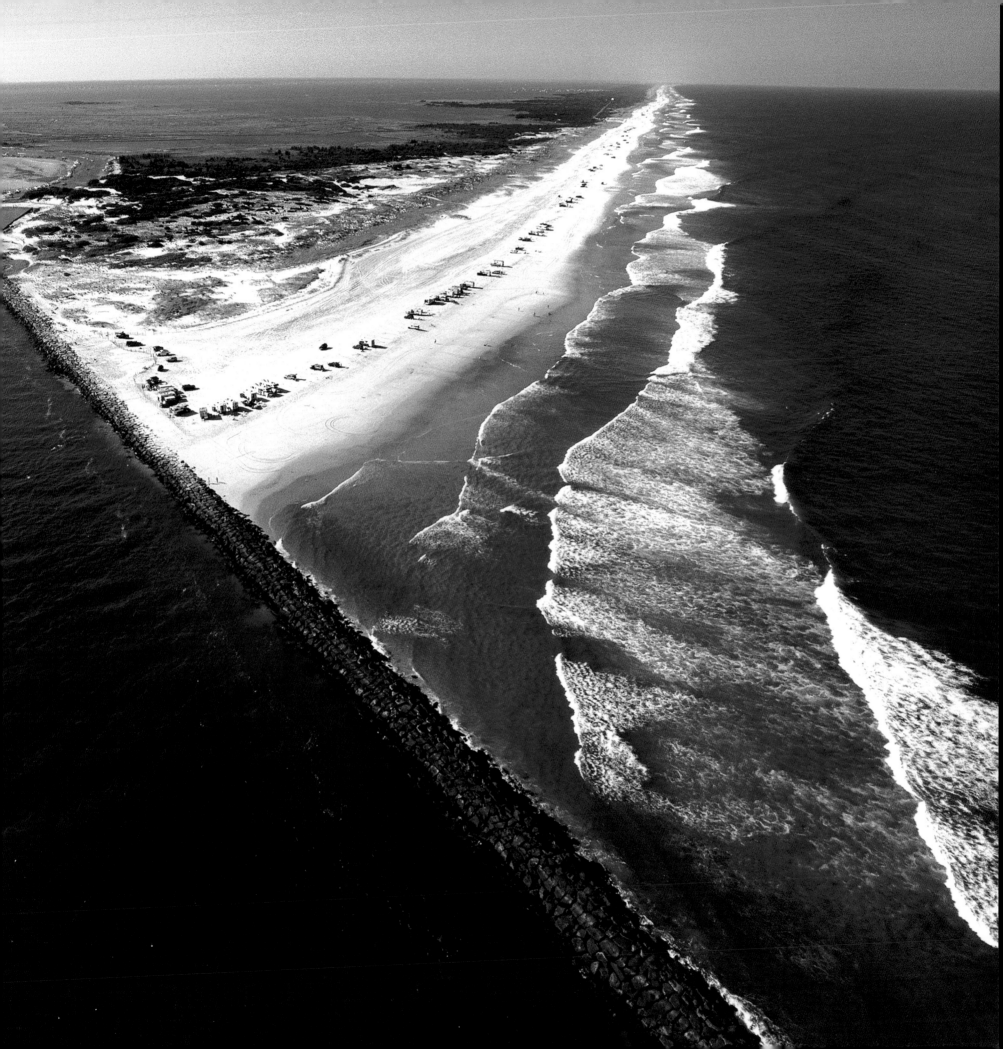

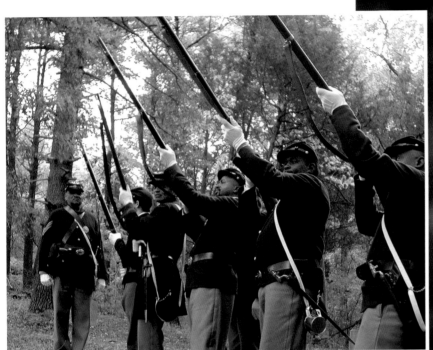

▲ 22nd US Colored Troops Infantry Regiment at the Rededication of Lamington Black Cemetery, Bedminster (2001)

I met "Buzzy" in 1999 while I was producing a 150th anniversary book for the South Branch Reformed Church. "Buzzy" was researching his family's genealogy and was visiting the church to look up records. We immediately became friends and he shared with me his vast knowledge of black history of New Jersey.

He then told me about a recently discovered "old slave cemetery" in Bedminster that he and others were in the process of restoring. I thought this was a great story and I photographed him (right) at the site for my book **SOMERSET COUNTY, A Millennial Portrait**. This photograph in my book shed new light and awareness on the project and led to increased funding and volunteerism. The Lamington Black Cemetery was formally rededicated in October 2001.

Thanks to the efforts of "Buzzy" and other historians, black history sites are finally receiving their deserved recognition and restoration. The Peter Mott House (opposite) in Lawnside, was photographed in 2001 for a **New Jersey Monthly** article on the Underground Railroad sites in the state.

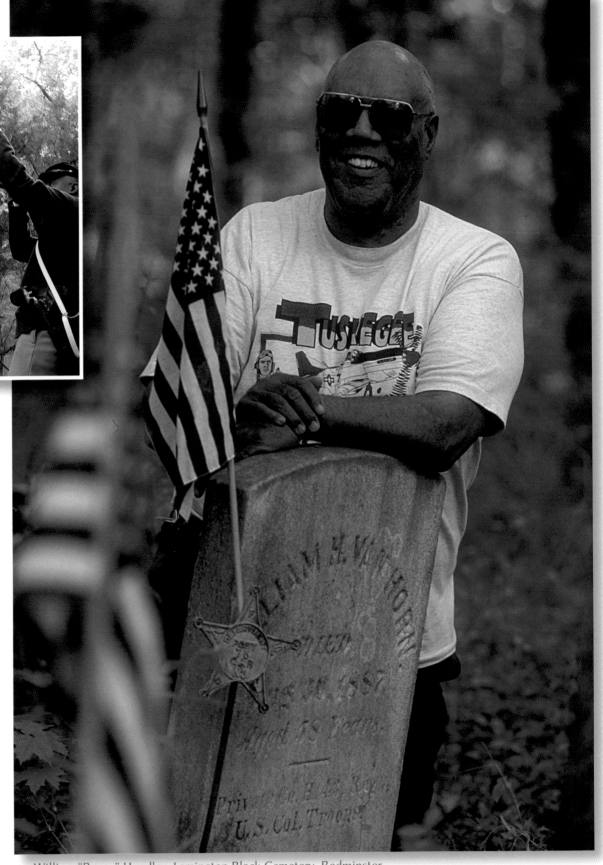

▲ William "Buzzy" Hundley, Lamington Black Cemetery, Bedminster

Undergound Railroad site, Peter Mott House, Lawnside ▶

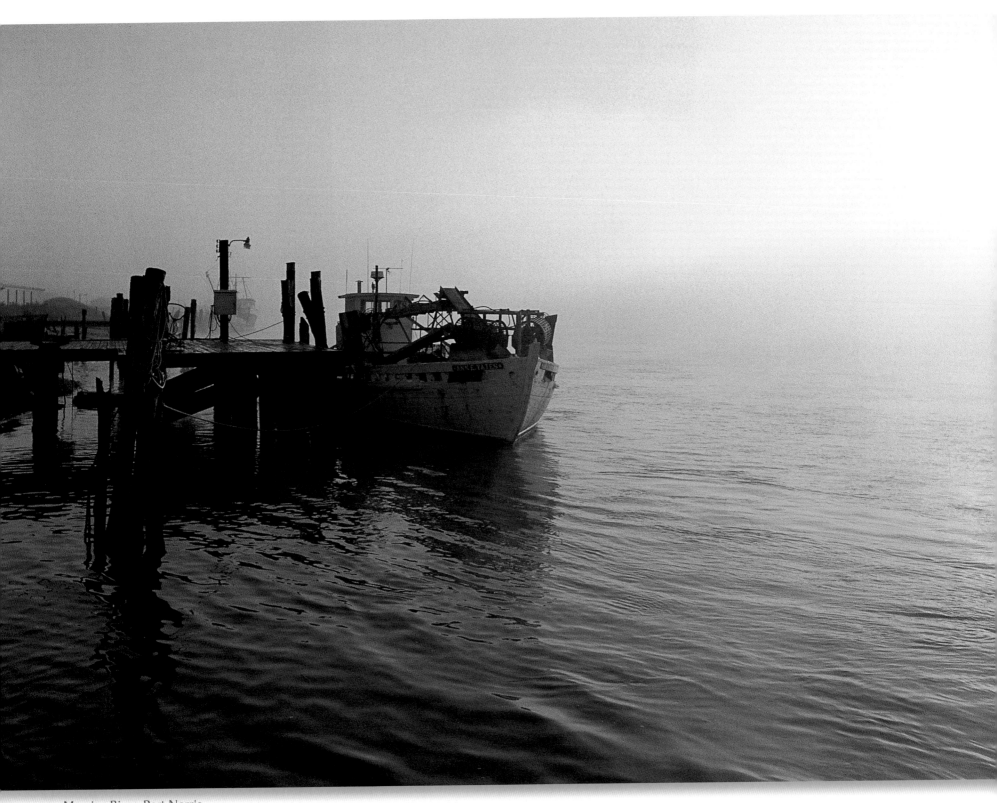

▲ Maurice River, Port Norris

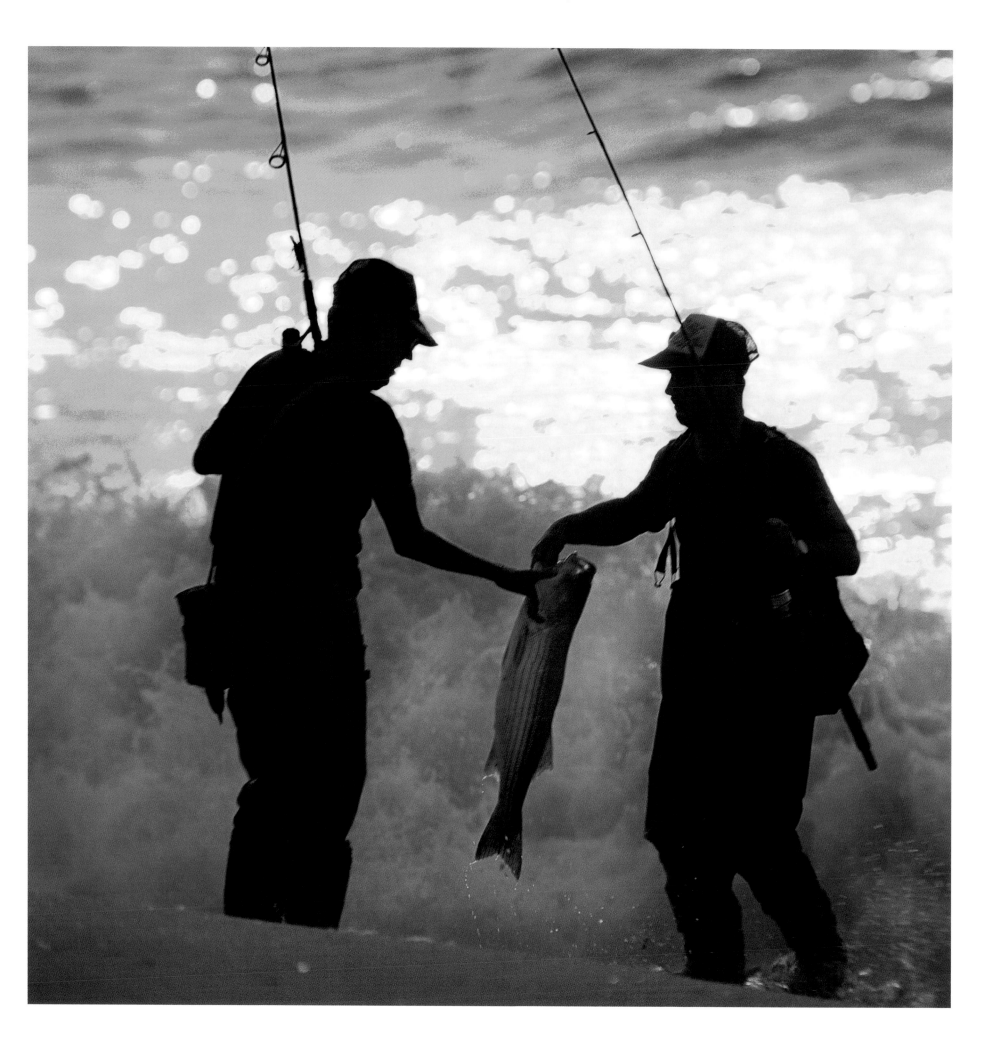

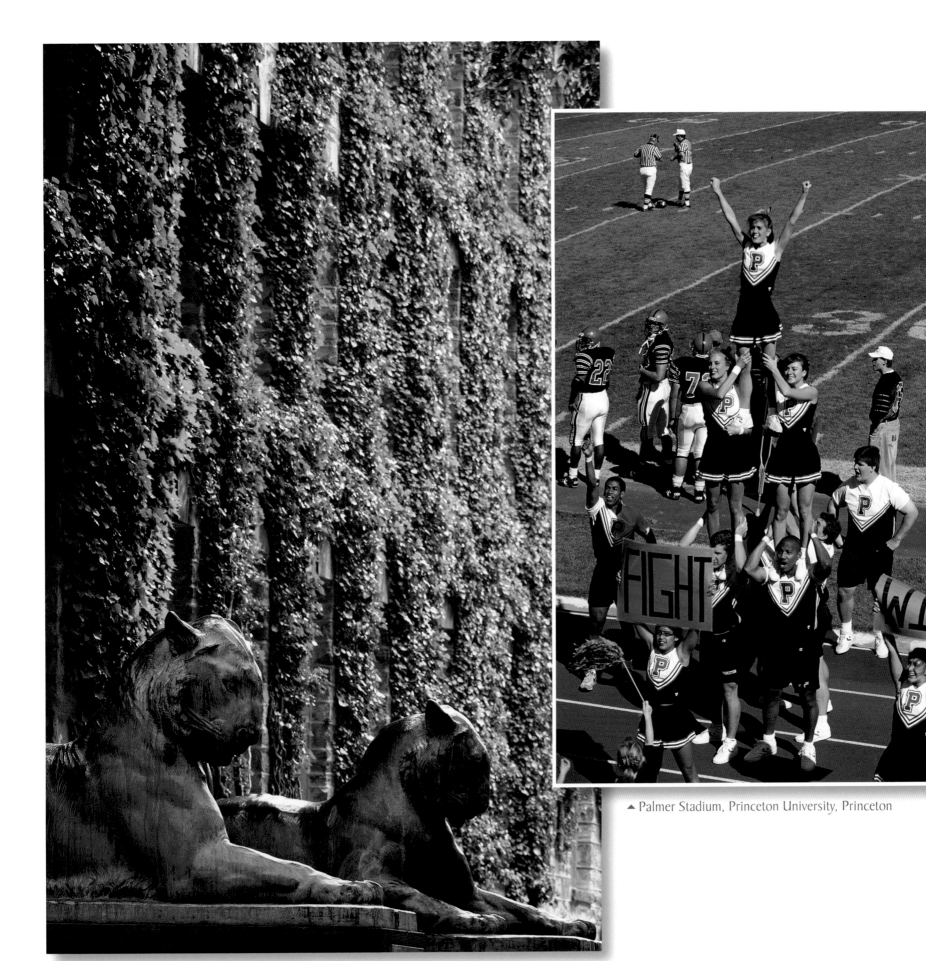

▲ Palmer Stadium, Princeton University, Princeton

▲ Nassau Hall, Princeton University, Princeton

Nassau Hall, Princeton University, Princeton ▶

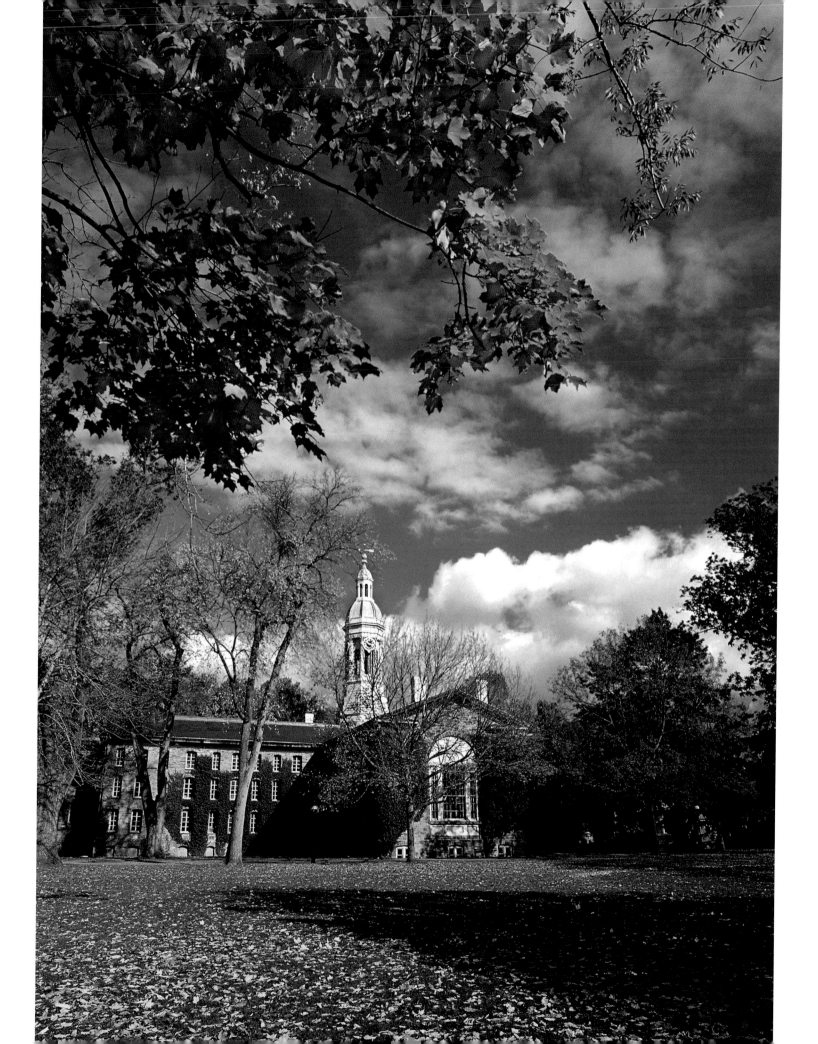

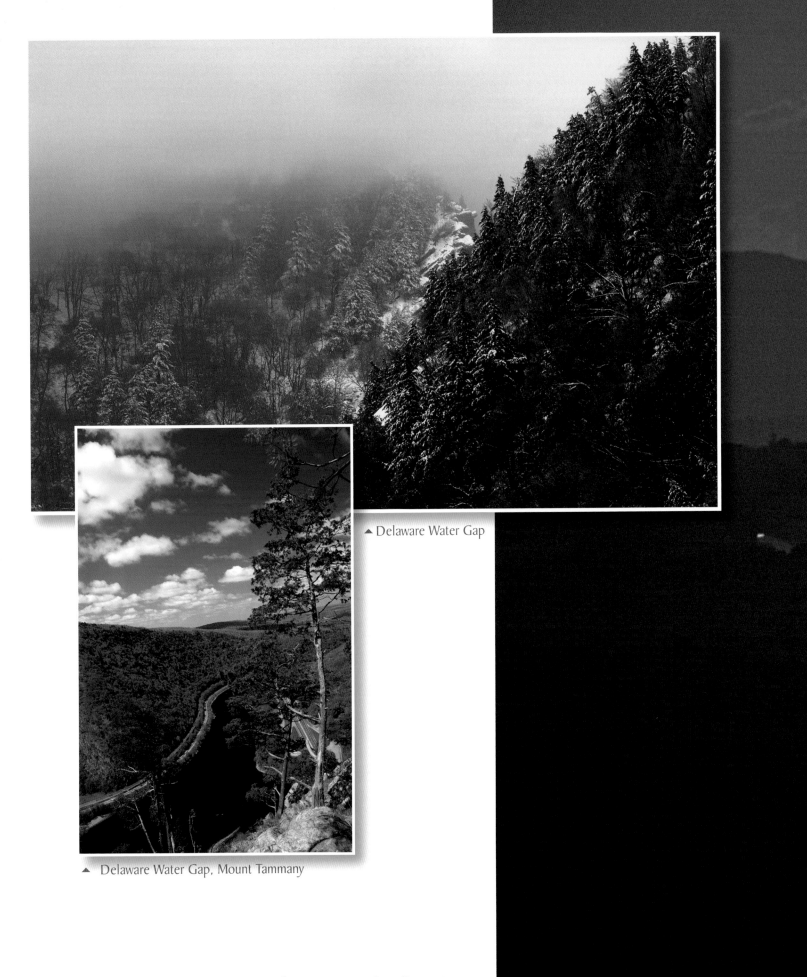

▲ Delaware Water Gap

▲ Delaware Water Gap, Mount Tammany

Delaware Water Gap, view from Jenny Jump State Forest ▶

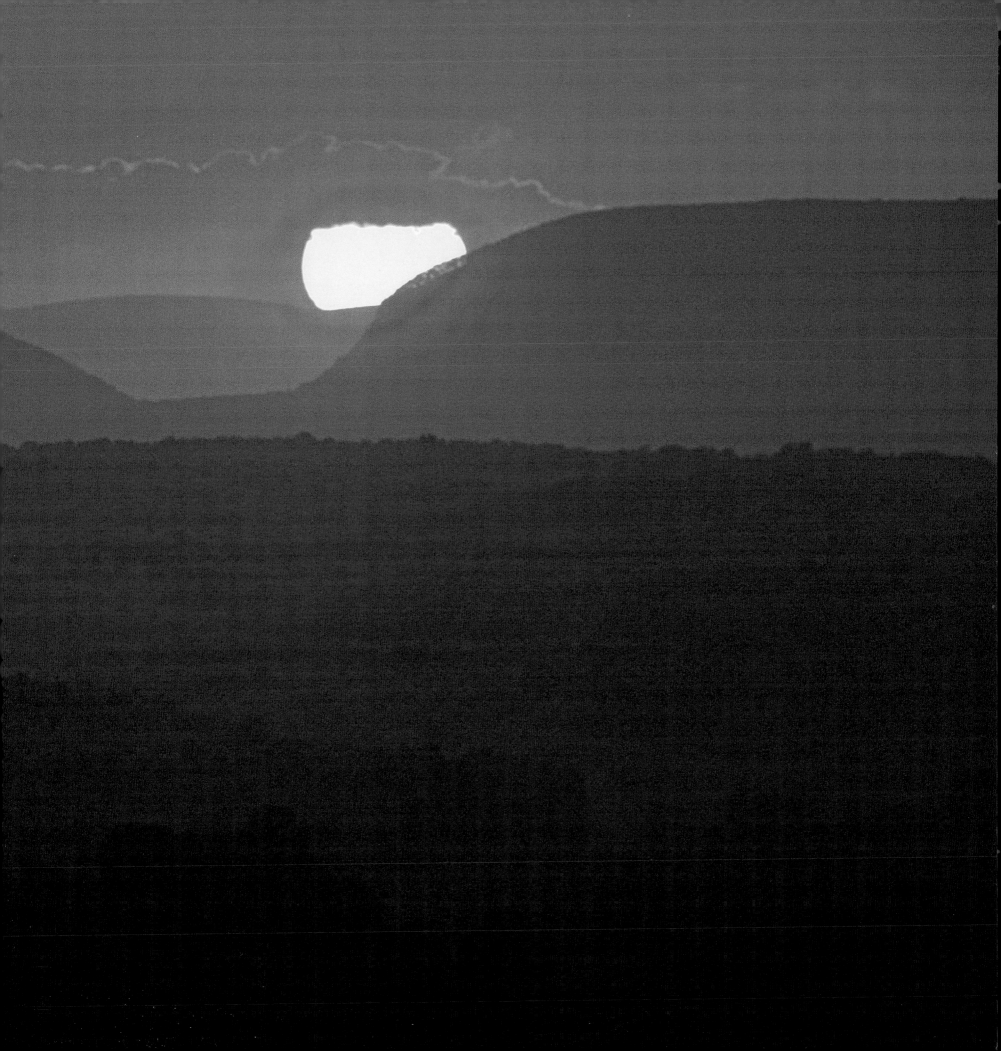

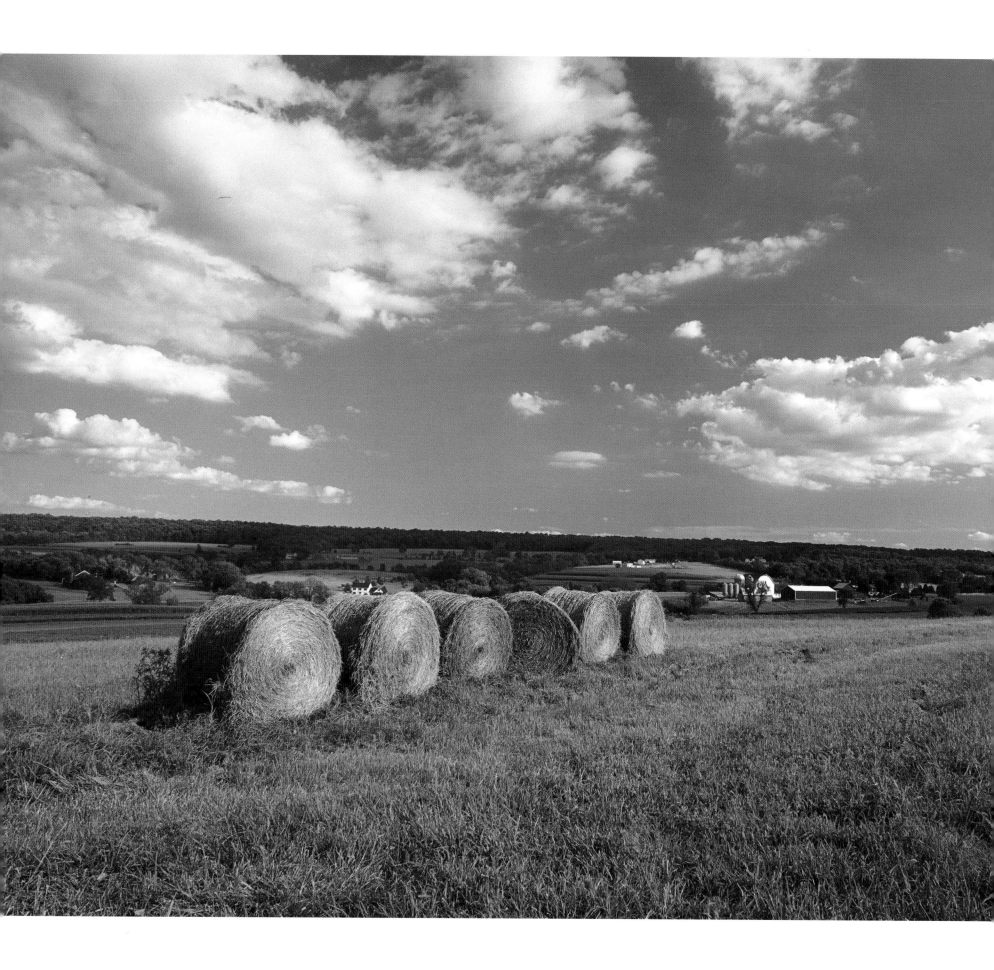

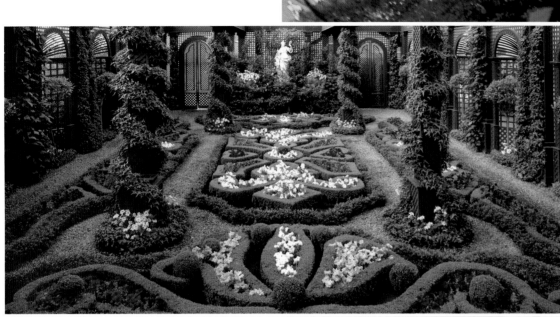

▲ French Garden, Duke Farms, Hillsborough

Duke Farms 2005 Calendar

In 1993, I was fortunate to be granted permission to photograph Duke Gardens for my book **THE GARDEN STATE In Bloom**. This was a very rare opportunity as I was the first photographer allowed such a privilege in many decades. The book was published just prior to Doris Duke's death. I had sent a gift copy of my book to Miss Duke. I was told that in her final days she enjoyed seeing the photographs of her gardens.

In the following years, I continued to photograph the magnificent gardens and the Duke estate and provided photography for Duke Farms postcards, brochures, website and calendars.

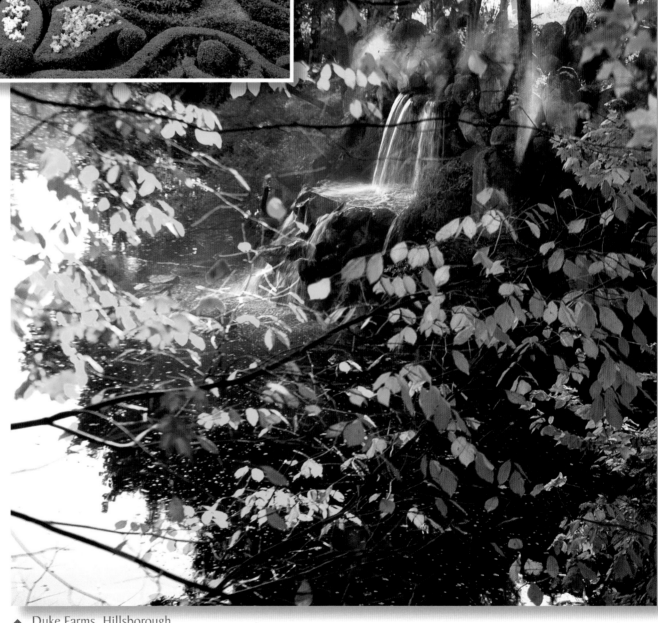

▲ Duke Farms, Hillsborough

Italian Garden, Duke Farms, Hillsborough ▶

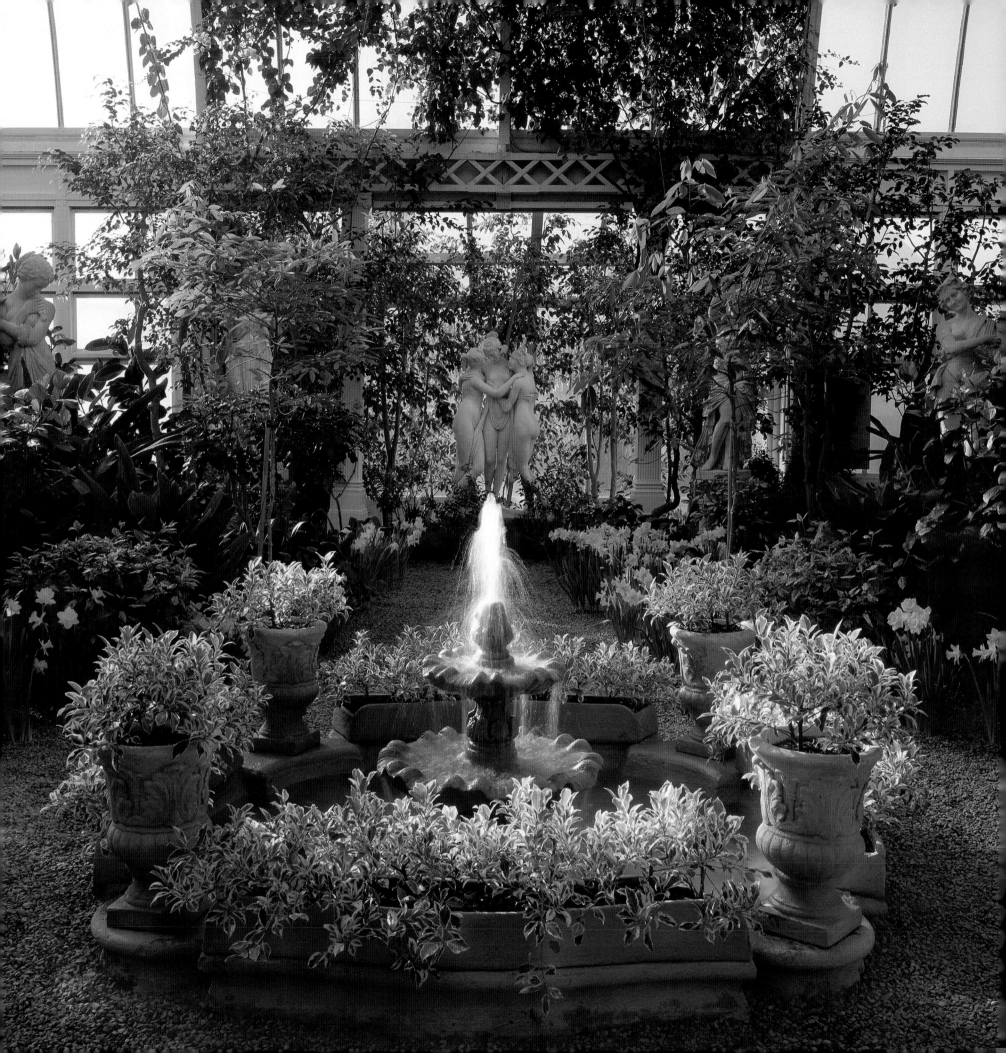

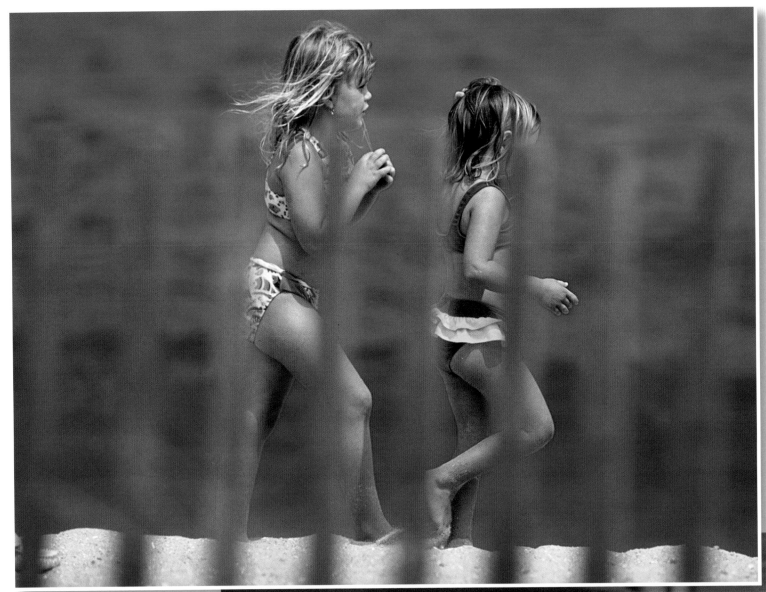

▲ Bay Head

I was standing on the beach—watching the waves, when I noticed an elderly woman standing next to me doing the same—watching the waves. I was intrigued by the "wave" pattern on her swimsuit and how the lines flowed into her age lines on her back and arms.

This photo (far right) generated a buzz when it was first published in my book **NEW JERSEY, A Photographic Journey**, and again when it was included in a traveling art show of my prints. People either loved it or hated it. One art gallery owner decided to "hide" the print in the corner! Some young women reacted strongly to the photo with audible expressions of shock and dismay, whereas older women just smiled.

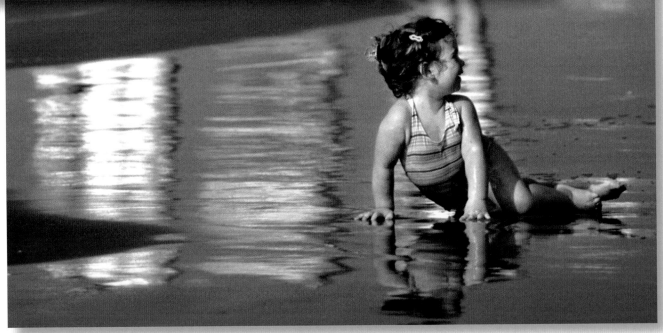

▲ Ocean City

Watching the waves, Point Pleasant Beach ▶

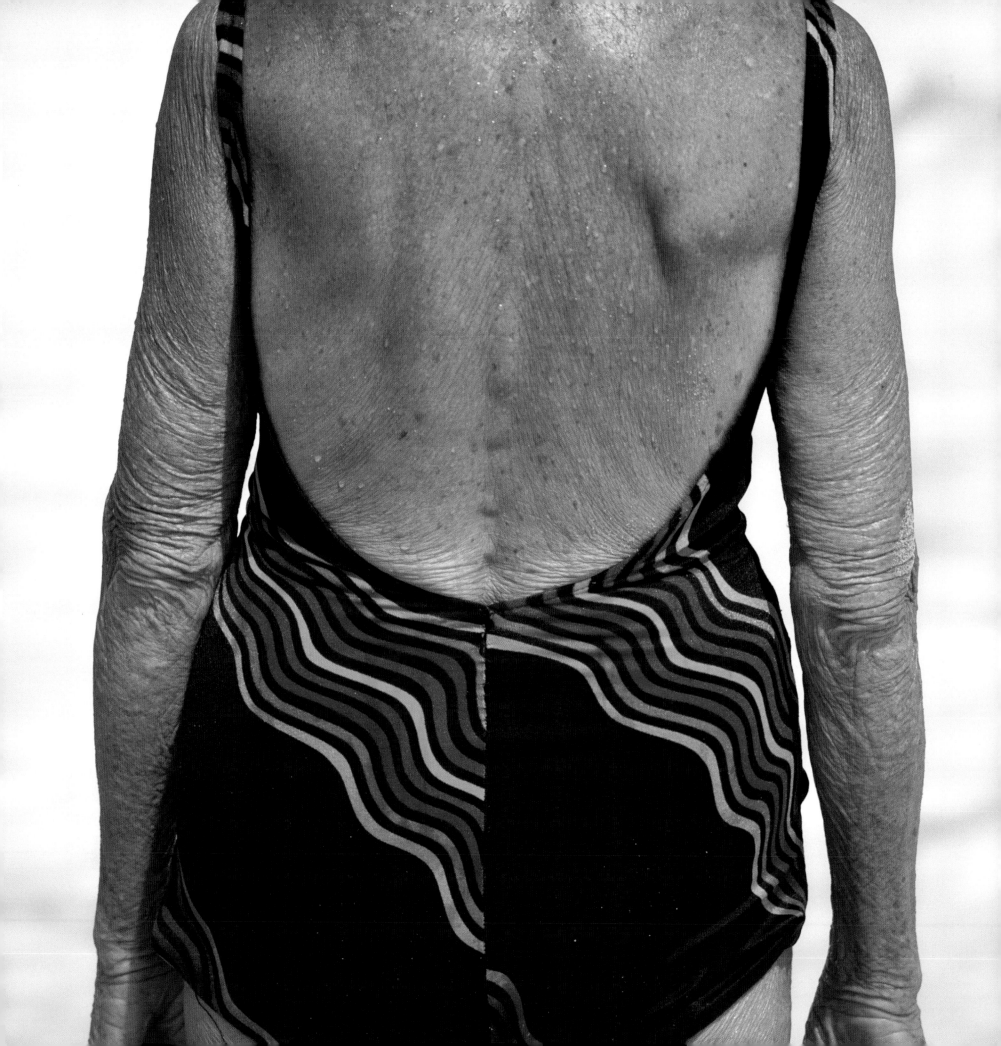

▲ Cape May Point

Sourland Mountain ▶

Buttermilk Falls,
Delaware Water Gap N.R.A. ▶

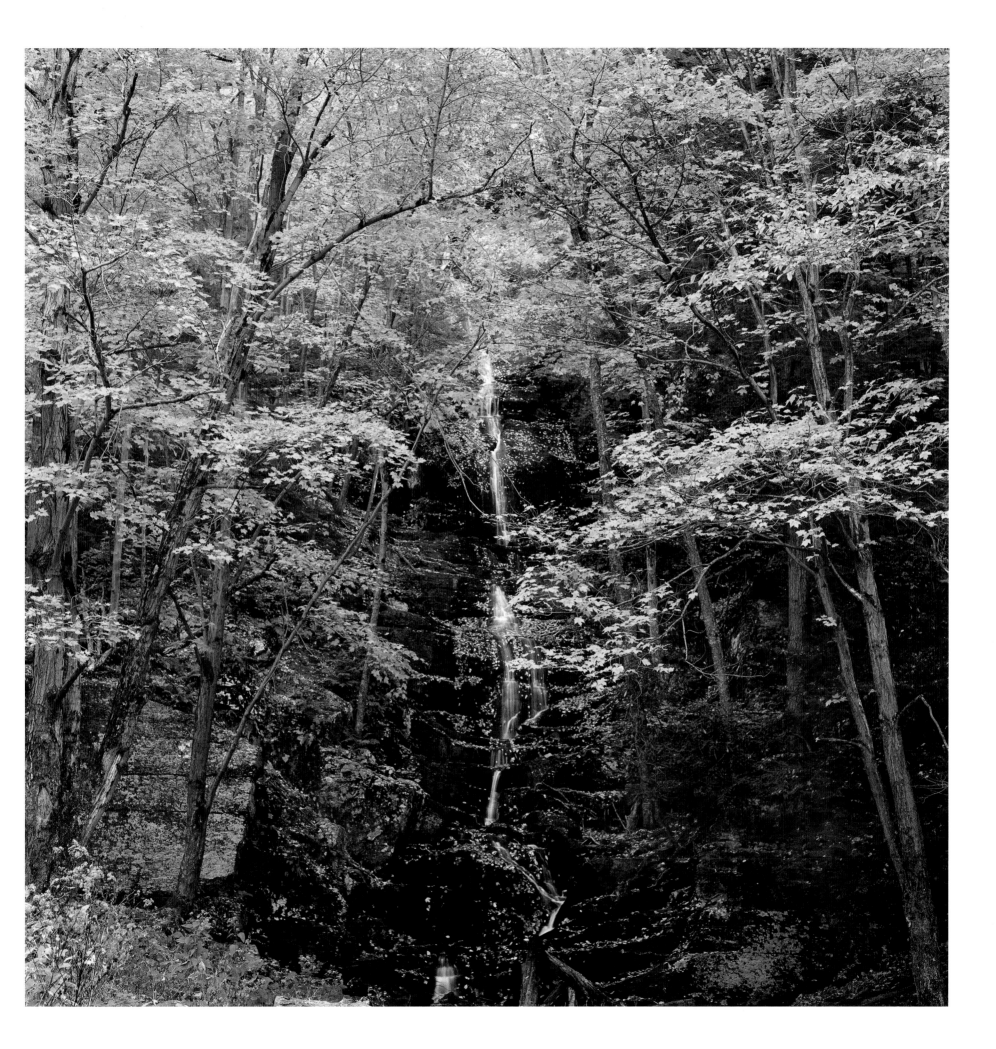

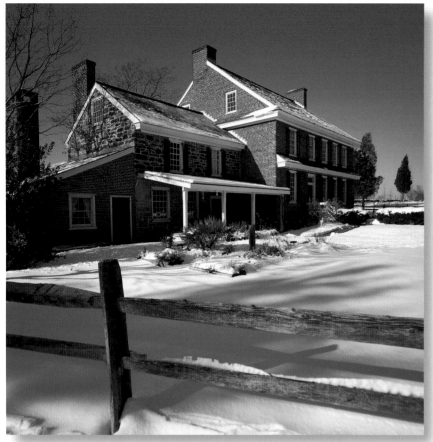

▲ Whitall House, National Park

▲ Hermitage, Ho-Ho-Kus

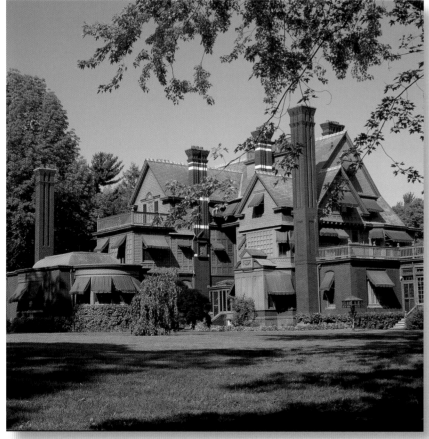

▲ Glenmont, Llewellyn Park

▲ Skylands Manor, Ringwood

Barclay Farmstead, Cherry Hill ▶

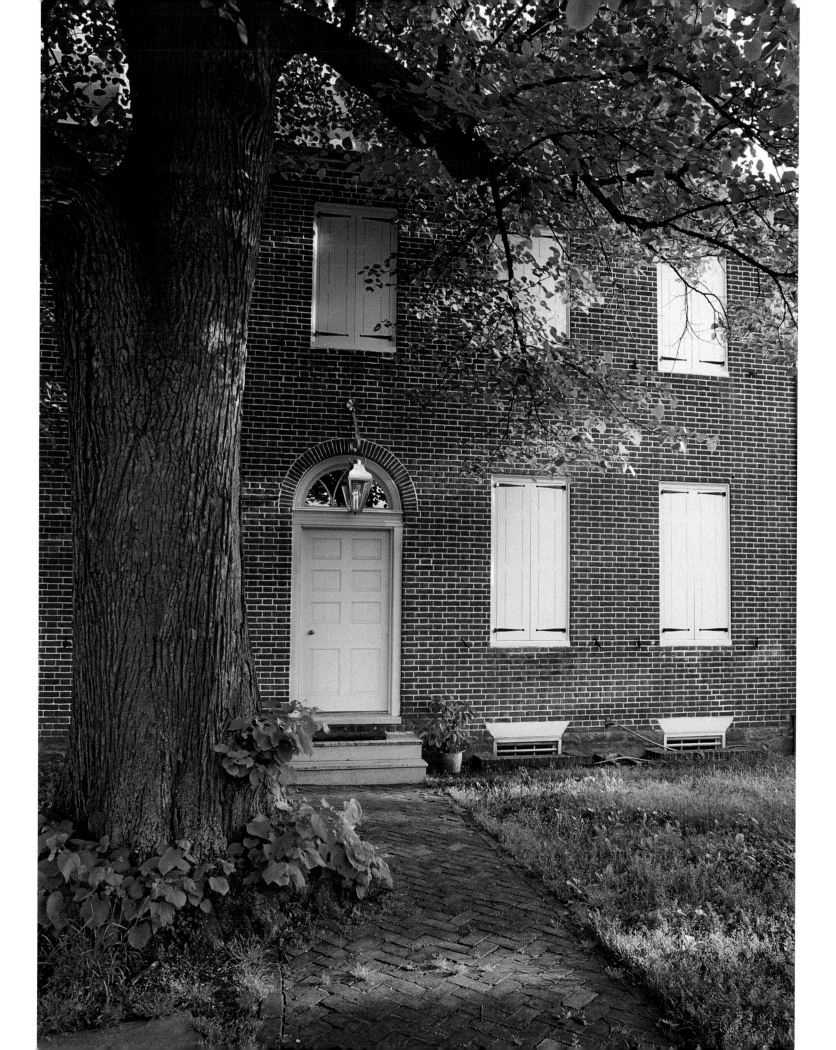

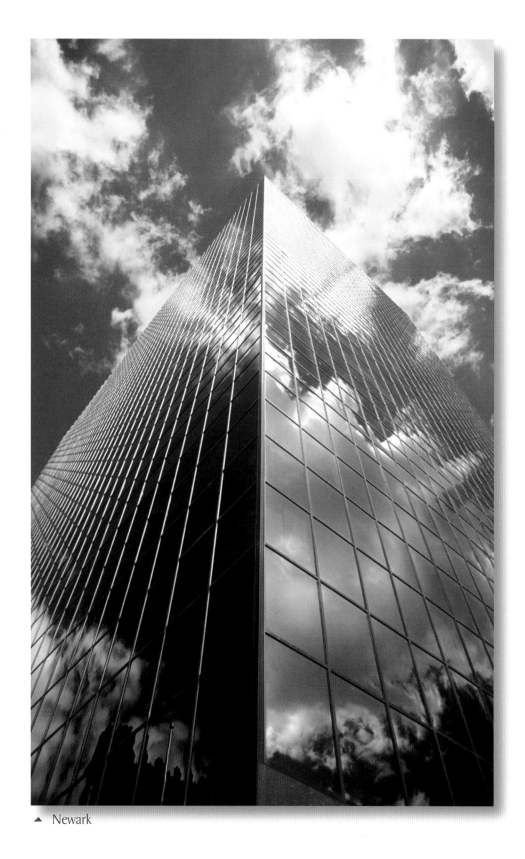

▲ Newark

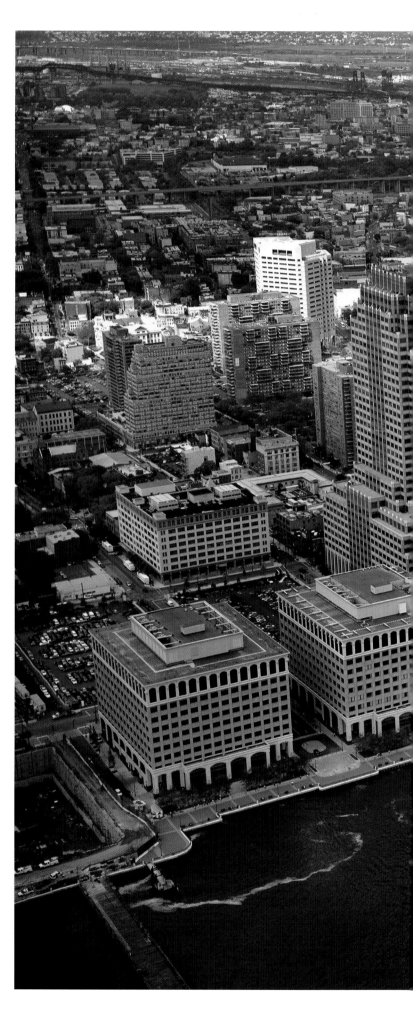

Jersey City ▸

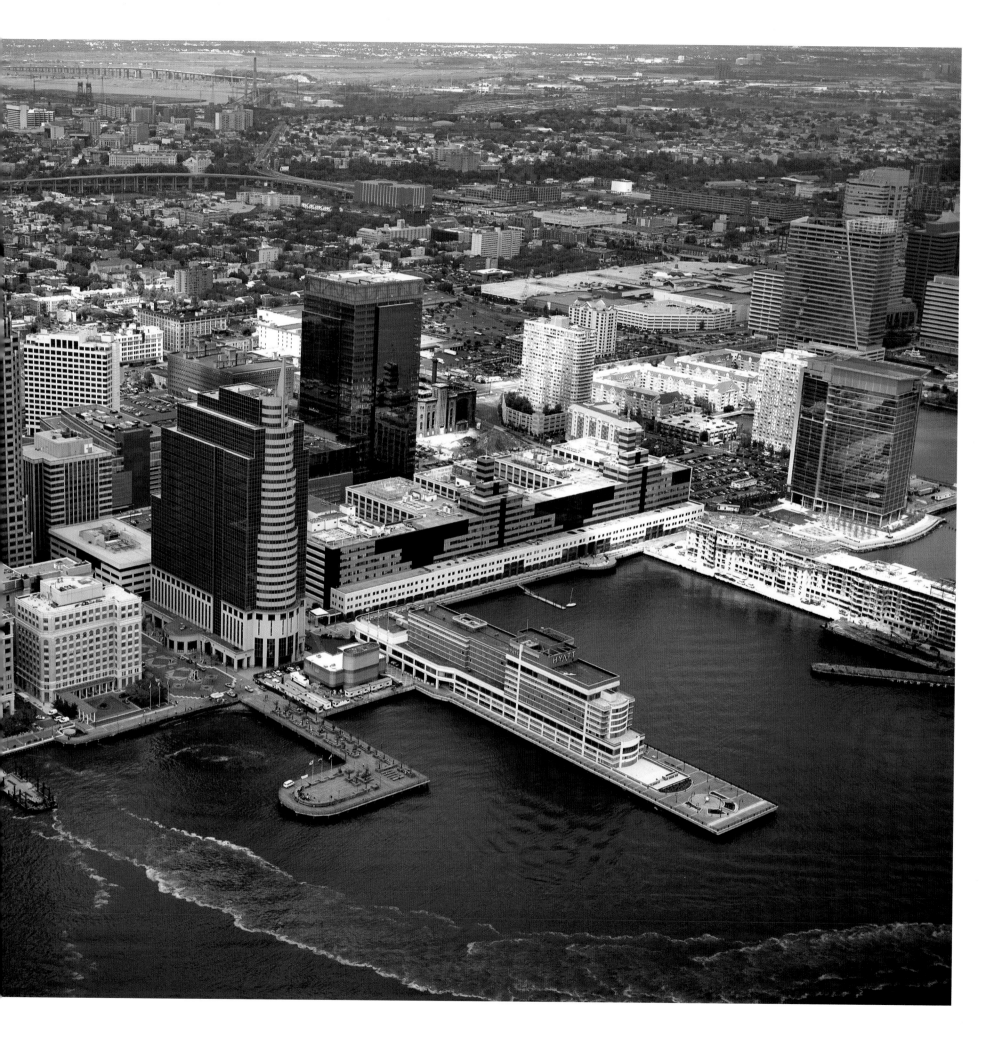

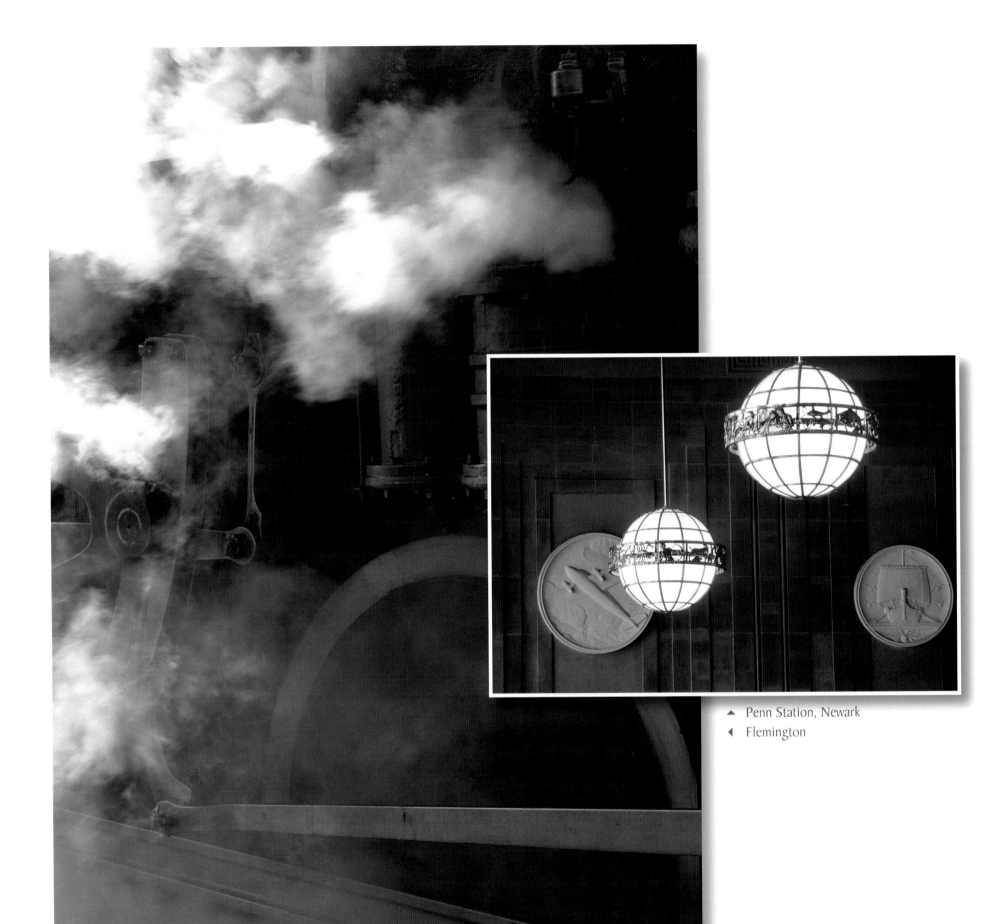

▲ Penn Station, Newark
◀ Flemington

164 Ridgewood ▶

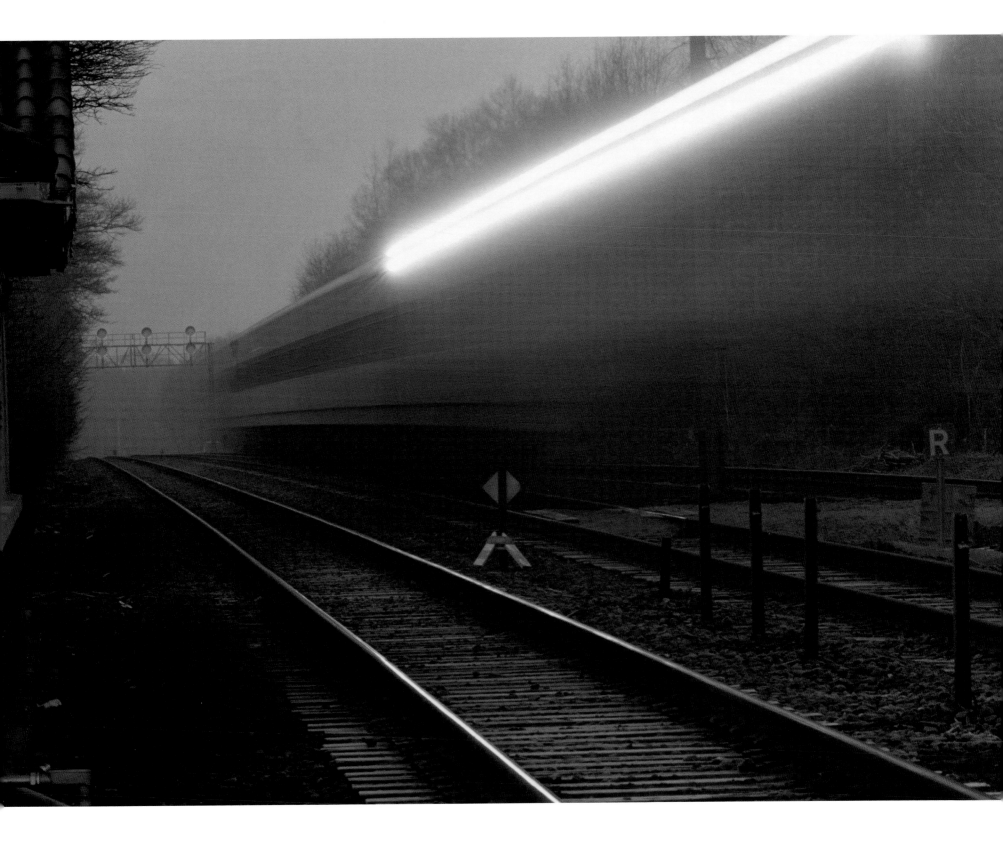

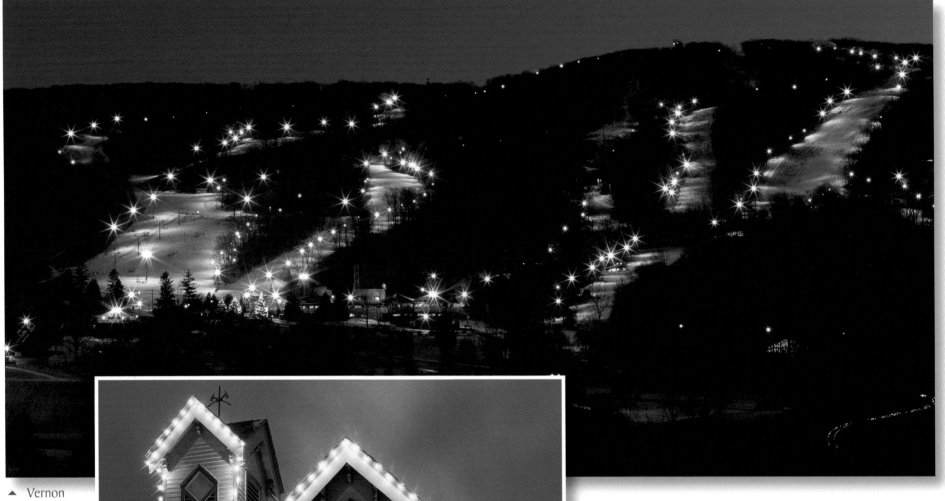

▲ Vernon

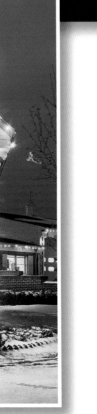

▲ Cape May

▲ Tuckerton Seaport, Tuckerton

The Town Green, Morristown ▶

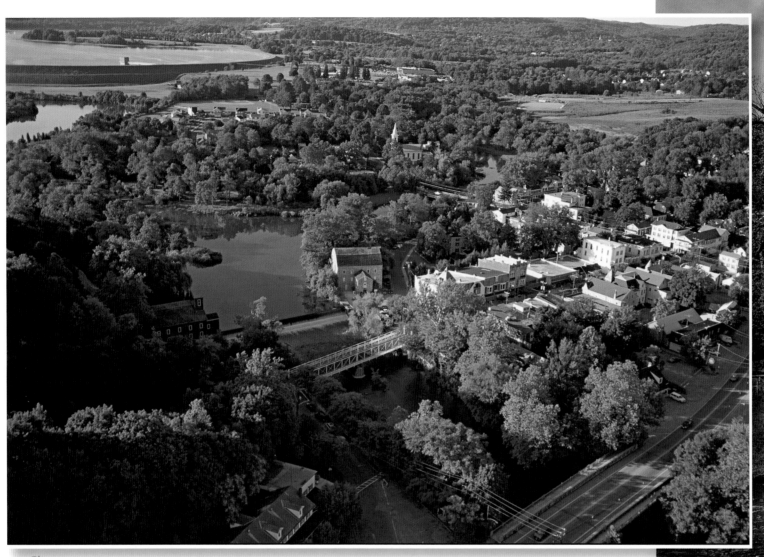

▲ Clinton

Clinton is a quaint river town with two historic mills alongside a small dam on the South Branch Raritan River.

The Red Mill Museum (right) is possibly the most photographed site in New Jersey. On the opposite side of the river a 19th century stone mill is home to Hunterdon Museum of Art, the cooperating organization which helped publish my book **HUNTERDON COUNTY, A Millennial Portrait.**

The people of Hunterdon love their county and they supported this book with extraordinary enthusiasm. My first book signing for this title seemed like a "Harry Potter" event with a line of people extending down Main Street from Clinton Book Shop as they awaited my arrival. I felt like a celebrity!

HUNTERDON COUNTY
A Millennial Portrait
(1999)

Red Mill Museum, Clinton ▶

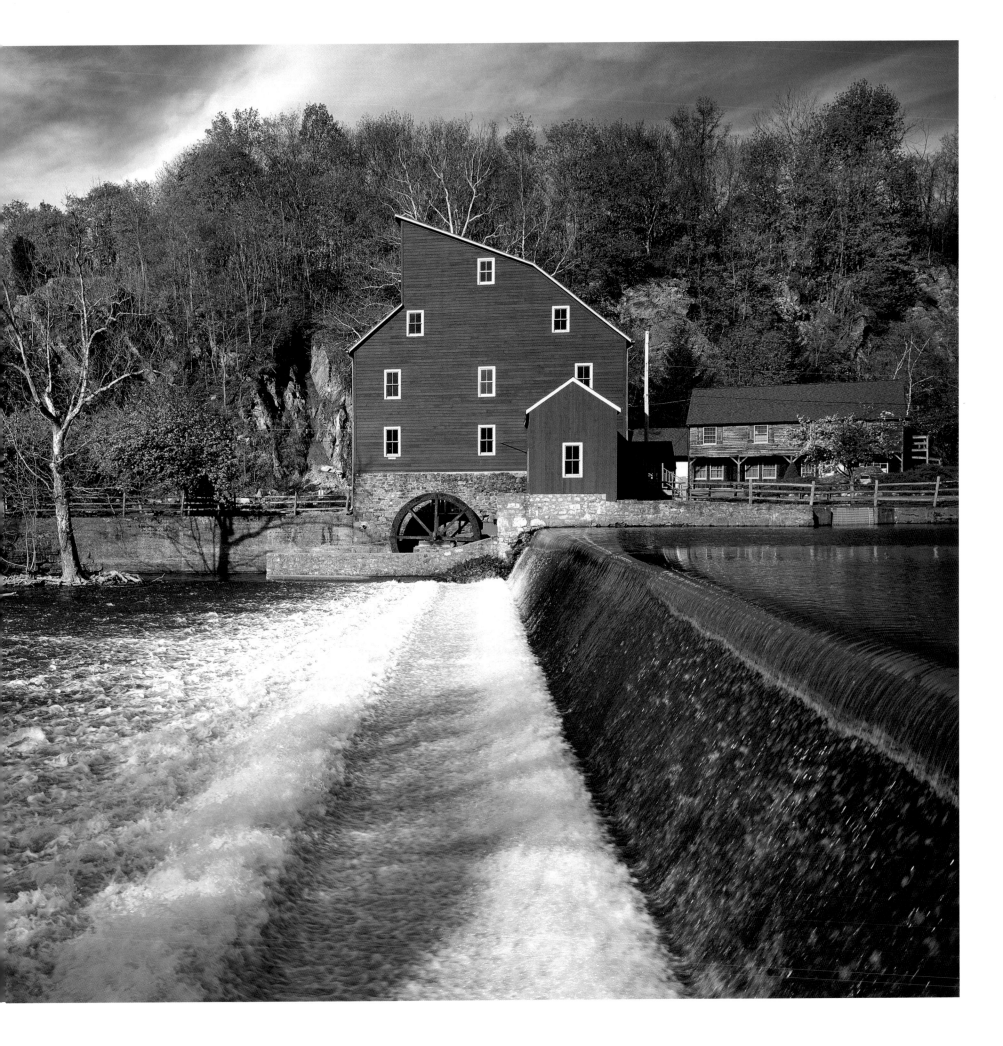

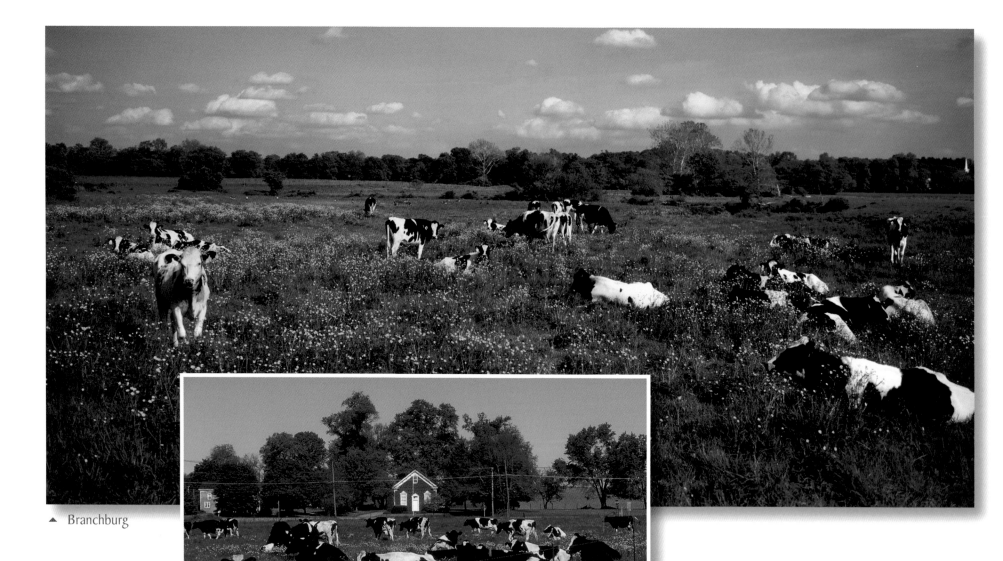

▲ Branchburg

▲ South Branch School (Little Red Schoolhouse), Branchburg

My family and I moved to one of the last remaining farming areas of Somerset County in 1985 and cherished the scenes of holstein cows that dotted the nearby fields. A fond memory is the daily "cow crossing" at River-Lea Farm in Branchburg. Rush hour commuters—some patient, some not—were treated to the twice-daily parade of cows that made their way to and from their barn and the meadows along the Raritan. This daily ritual has now ended, but I am pleased to add that cattle (and ponies) still roam those fields and that Stanley and Mary Kanach's magnifcent River-Lea farm will remain pristine under Farmland Preservation.

▲ Newborn calf, Branchburg

Cow crossing, River-Lea Farm, Branchburg ▶

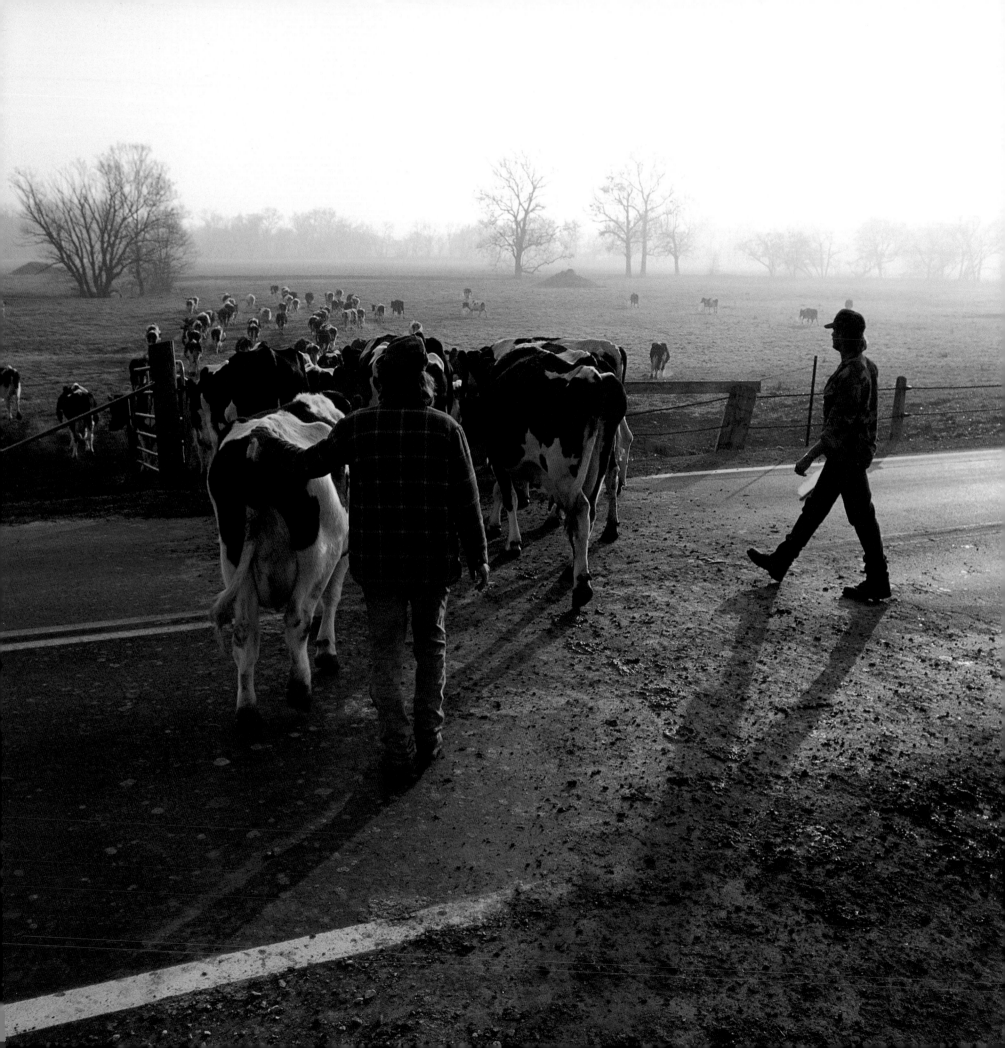

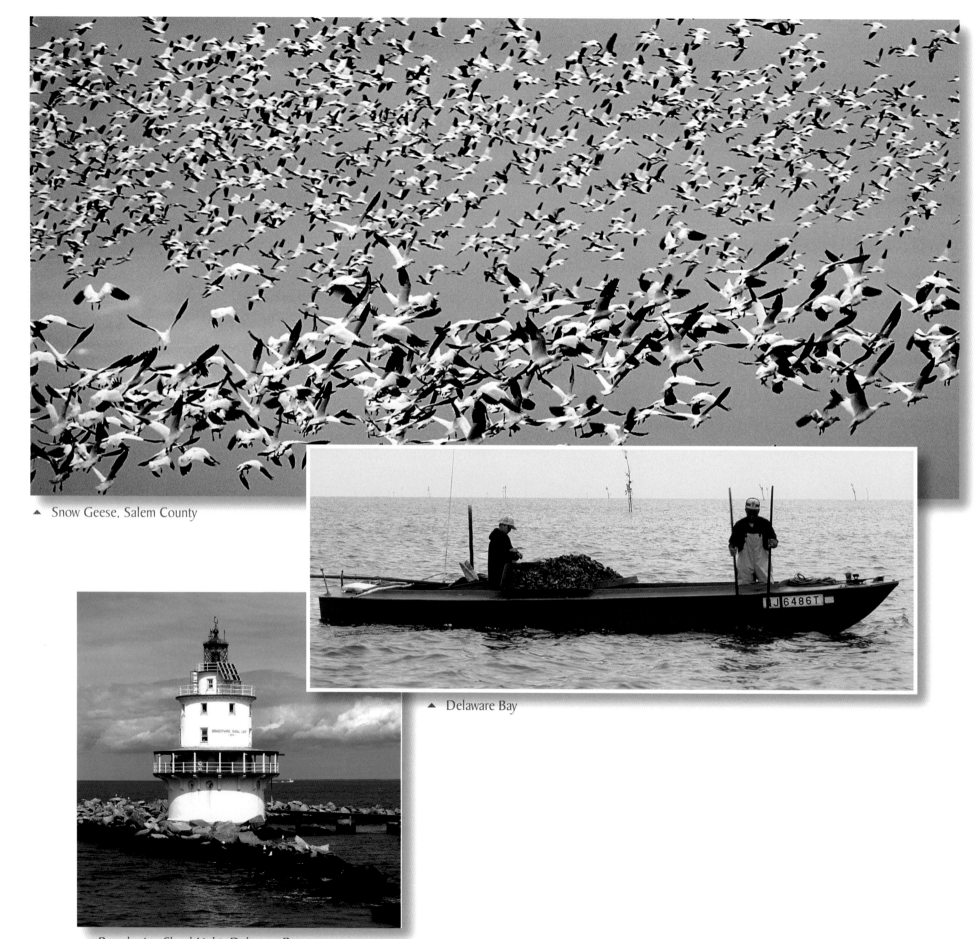

▲ Snow Geese, Salem County

▲ Delaware Bay

▲ Brandywine Shoal Light, Delaware Bay

East Point Light, Heislerville ▶

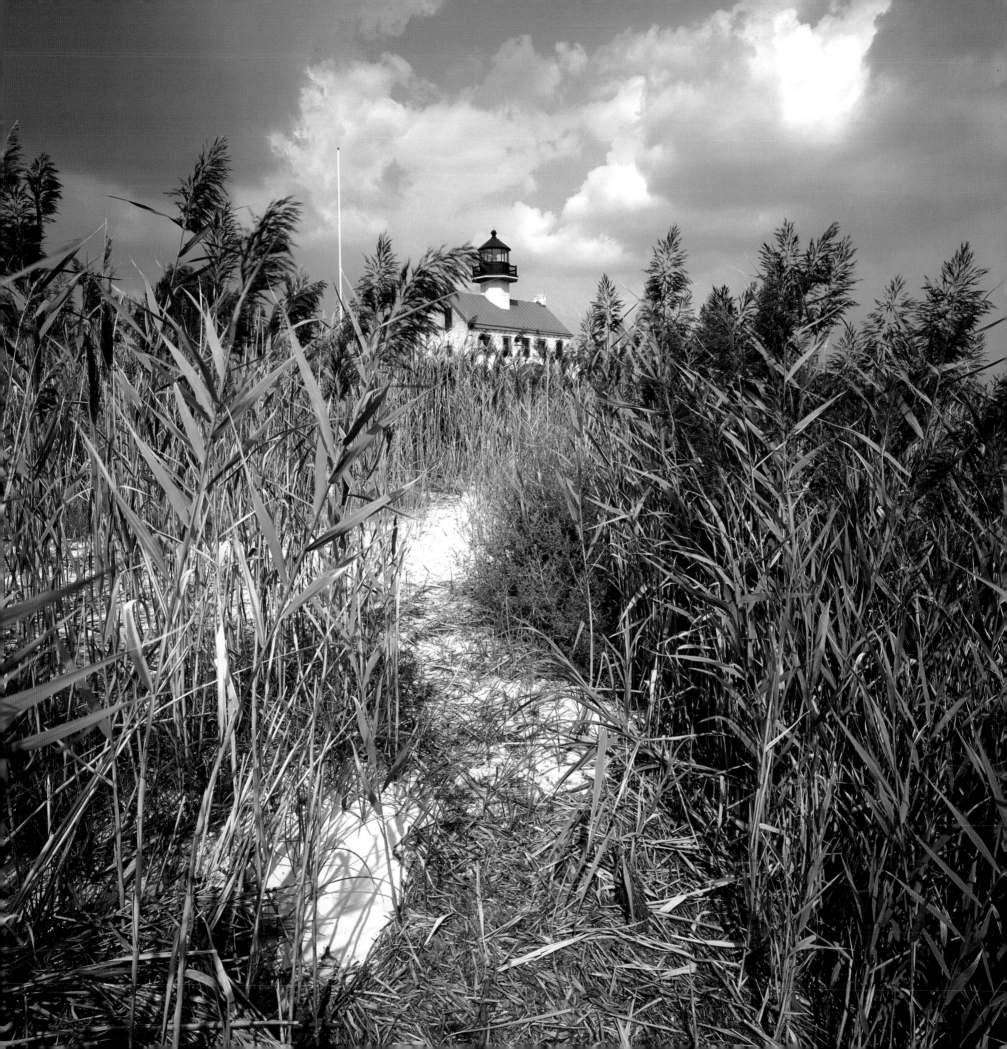

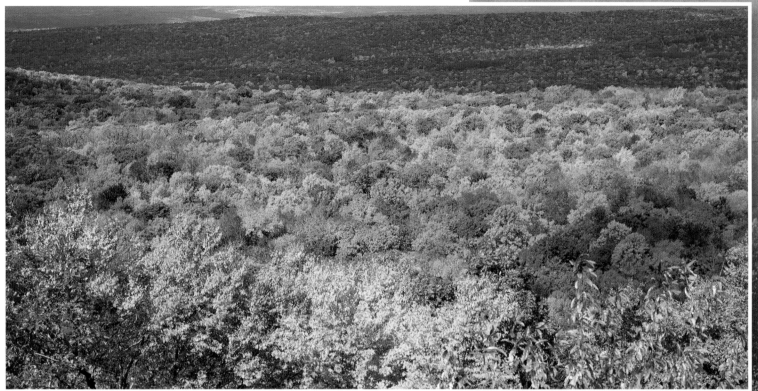

▲ Stokes State Forest

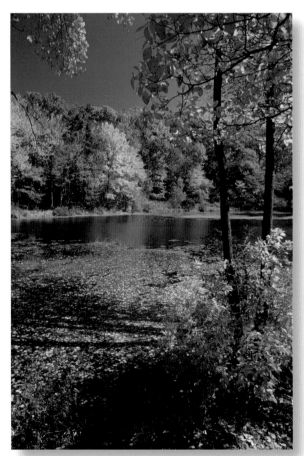

▲ South Mountain Reservation

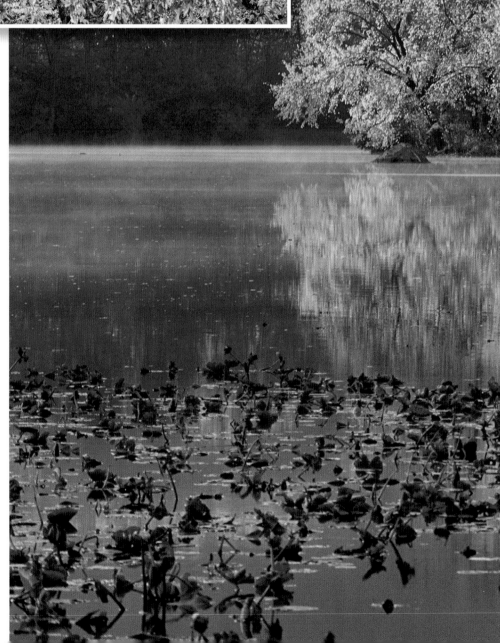

Musconetcong River, Saxton Falls ▶

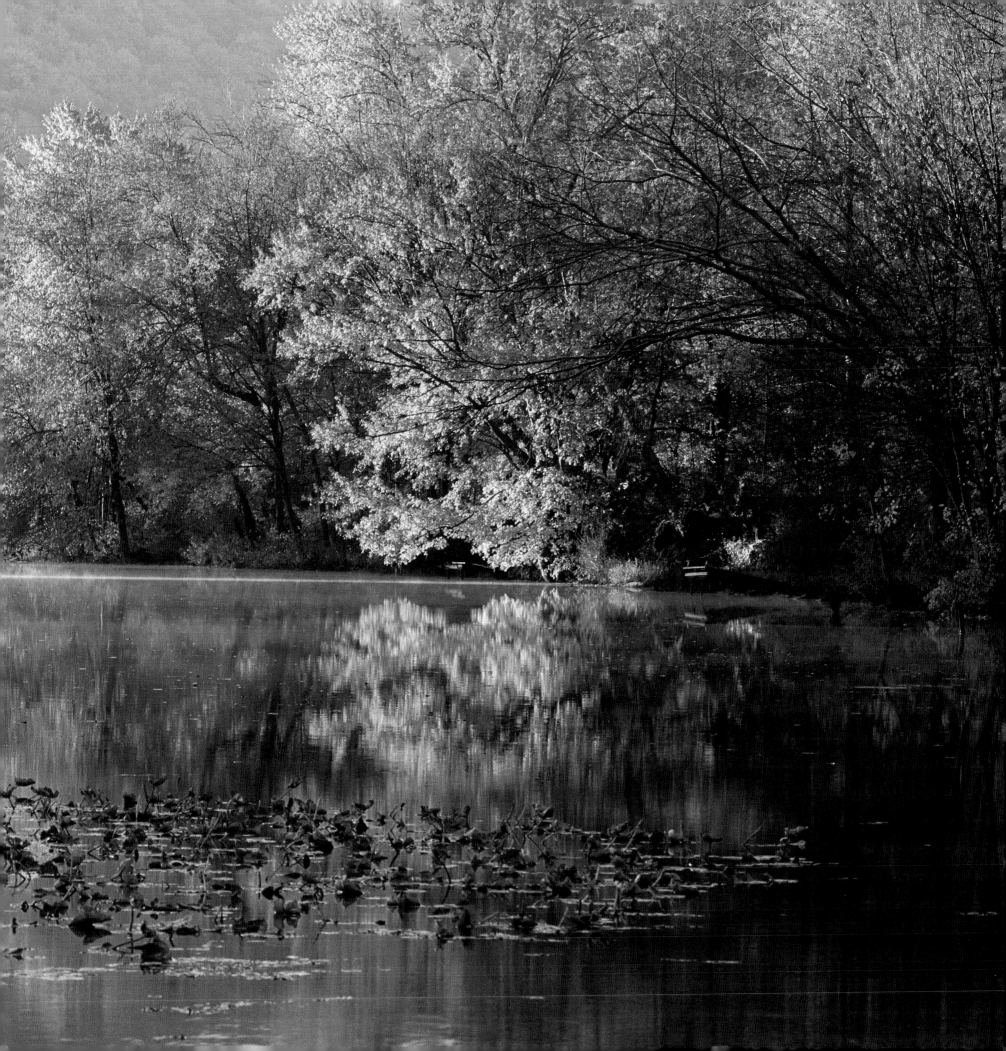

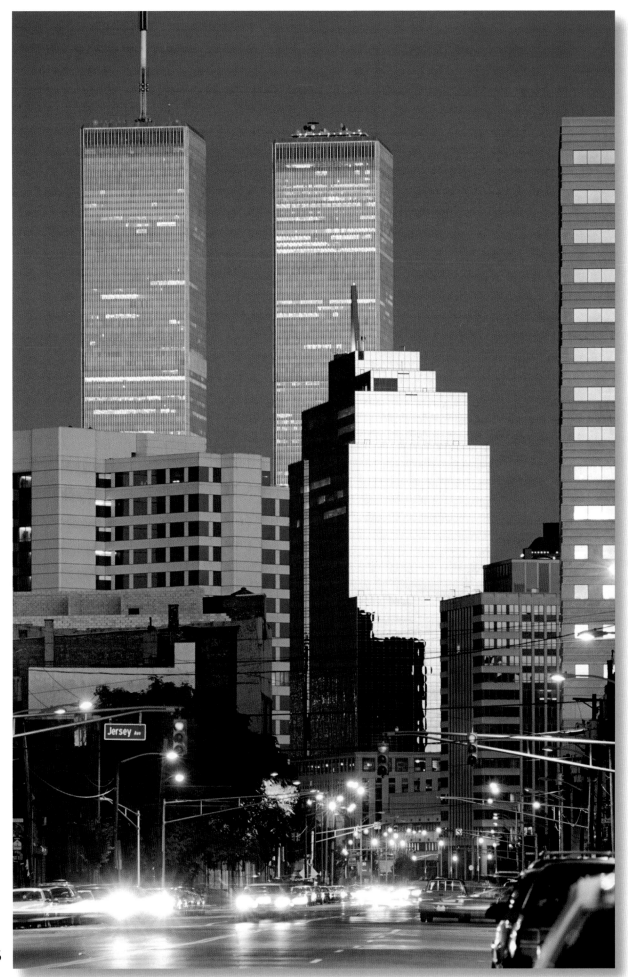

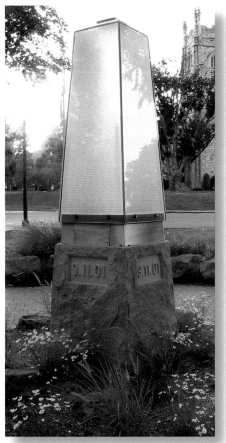

▲ 9-11 Memorial, Westfield
◀ Jersey City

Although the World Trade Center had stood across the Hudson River in New York, its dominant presence was very much a part of New Jersey. We shall never forget the almost 700 New Jerseyans who lost their lives that tragic day— September 11, 2001. Today, 9-11 Memorials are being erected in cities and towns across the state paying tribute to the victims' ultimate sacrifice.

View of World Trade Center, Jersey City ▶

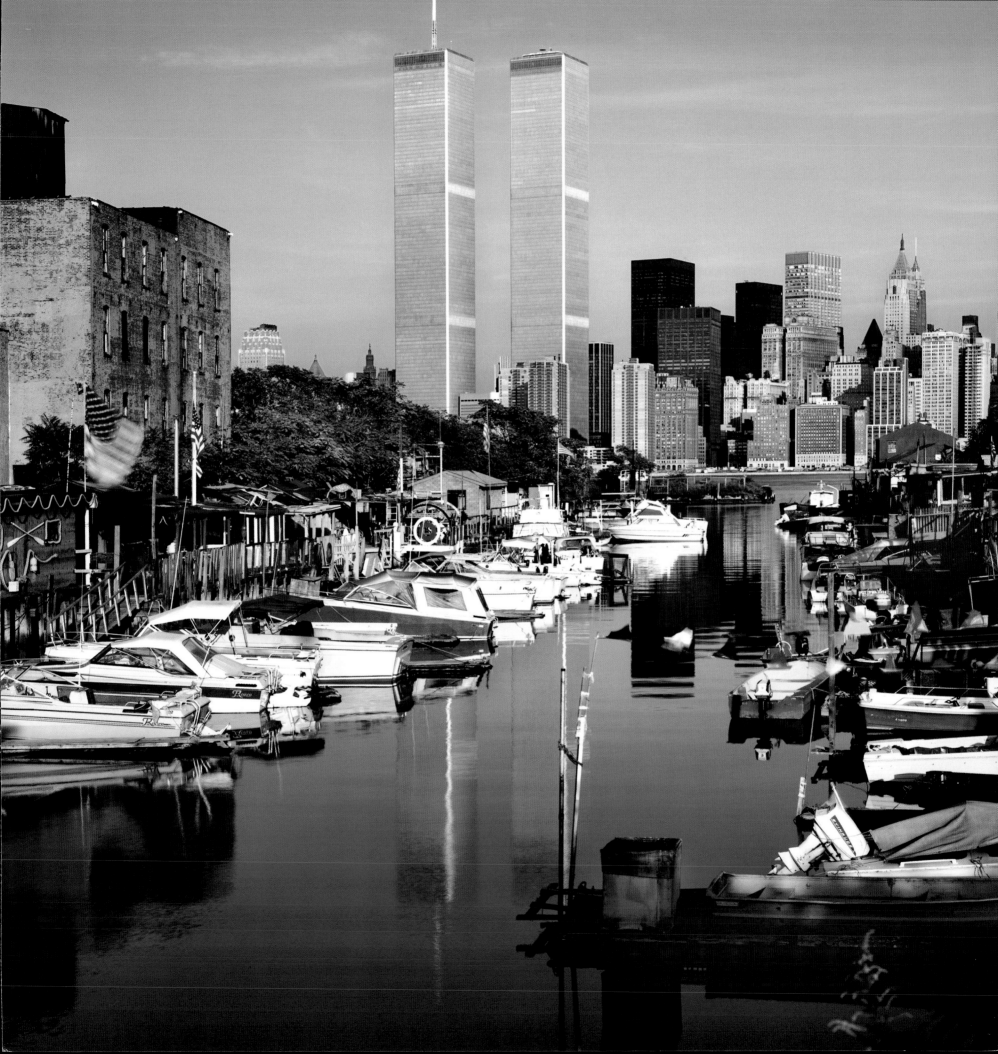

ABOUT THE PHOTOGRAPHER

My childhood dreams were to become an architect, archeologist, oceanographer or environmentalist—lofty aspirations for the son of a coal miner. I finally majored in Biology at Penn State with a goal of becoming a doctor. In my senior year, when medical school rejection letters made it clear it was time for "Plan B," I took solace in an art elective and soon realized my true calling was within me all along. Throughout my school years I enjoyed drawing and taking photos using my Uncle Joe's vintage Voigtländer camera. After graduating from college in the spring of 1975, my gift money helped me purchase a used Nikon F.

My first job was teaching environmental biology in the Pocono Mountains of Pennsylvania. After that contract ended, I moved to New York and was employed at the North Shore Science Museum on Long Island, teaching chemistry and biology workshops. I exhibited some nature photos at a faculty art show. A visitor suggested that I contact his friend, Selma Brackman, owner of FPG, one of the premier stock photography agencies in the world. I met with Mrs. Brackman and showed her my portfolio. She asked if I wanted a job—not as a photographer but rather as a photo researcher. I accepted the offer; her parting words to me that day were, "*I'm going to make you a mensch.*"

This launched my almost 4-year apprenticeship in the stock photography business. I wasn't familiar with the Yiddish term "*mensch*" but quickly learned that it involved fast-track plans for me. From researcher to account executive, I was soon promoted to International Sales Manager, which included some international travel as well as reciprocally hosting and entertaining the foreign clients who came to New York. Lunches at **Lutèce**, dinners at **Windows on the World**, dancing and drinks at the **Rainbow Room**, negotiating contracts from my corner office on Park Avenue South—all pretty heady stuff for a 24-year-old of humble beginnings!

In August 1977, I married the love of my life, Susan Keller. We honeymooned in Martha's Vineyard where I took many photos. One of the images, a landscape shot of Gay Head cliffs, made its way into FPG's library and soon was sold for the cover of a romance novel. This *first* photo sale yielded $250.

Although the grass was *very green* for me working at FPG, there was something extremely intoxicating about selling my first stock photo. My Nikon F eventually got pushed aside and I added medium and large format cameras to my arsenal for regular weekend stock photo trips. I began adding more transparencies to FPG's files which resulted in even more stock photo sales.

By 1980 I couldn't take the 9-to-5 routine any longer as the fire of becoming a photographer burned even hotter. I resigned from my position, informing Mrs. Brackman that I simply had to follow my passion for photography. Leaving my job was both exhilarating and frightening, but I was free!

I heard that a New England publisher was looking for a photographer for a book about New Jersey. With the naiveté of youth, I decided that this project would be mine! I called the publisher but discovered that I was too late. I begged for a chance to meet with him anyway, which he granted. He was impressed by the large format transparencies I showed him, but added that he had offered the book to another photographer and was awaiting his decision.

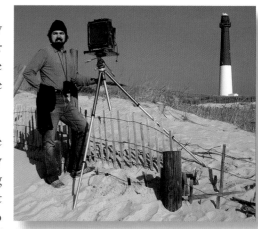

Returning to New York, I persistently called the publisher about the status of the project. The other photographer declined his offer, so he requested that I shoot some photos of New Jersey as a one month "test." Two weeks later, the publisher surprised me with an urgent call requesting that I send him the film *immediately!* Within a few days, another call from him informed me that the book project was indeed mine! I was given a token advance for expenses and contracted to shoot 300 rolls of Kodachrome. The publisher's only instruction to me was, "*Make New Jersey look like New England.*"

Susan was very pregnant as I continued my almost daily sojourns into New Jersey searching for those New England-like

scenes. Consumer pager service was new technology in the late 1970s so I rented a "beeper" to be on call for the delivery. During the mid-July heat wave of 1980, I was getting ready for a typical 4 AM departure to South Jersey. Susan was also awake and complained of some indigestion—probably from eating too many of those Jersey blueberries that I brought home a few days earlier. I left the house and as I approached the familiar Turnpike toll booth, I heard the beeper summon me home. Twenty-one hours later our son, Joseph, was born and our lives became richer.

My shooting was completed in early winter. Time flew by quickly and many things had changed in less than a year—a new baby and a new career! Susan and I went from two great salaries to no income at all. We lived on our savings and I eventually had to take part-time jobs in real estate and insurance to pay the bills.

On a spring day in 1981, a box of books had arrived at our door without much fanfare. Susan and I thrilled at seeing **NEW JERSEY,** *A Scenic Discovery* for the first time. What followed was a life changing 25-year commitment to a state that had its fill of insults and "*What Exit?*" jokes.

Susan, Joe and I eventually moved to New Jersey in the summer of 1985 and made our home in Somerset County. That same year we started Aesthetic Press as a way to publish other New Jersey products. Our home-based publishing business continues today as the same small operation it has been for 20 years, only now claiming even more space from our garage and basement.

Besides loving each other, we were fortunate to discover that we can even *work* together! Susan markets the books, calendars and greeting cards to bookstores and gift shops. Behind every successful artist is a supportive partner. Words cannot express enough my appreciation for the invaluable contributions Susan has made in allowing me to pursue my photographic career.

Our son inherited our passion for the arts. Joe's interest in music was apparent at age two when he set up pots and pans as a makeshift drumset. After achieving top placement in the New Jersey All-State Jazz ensemble, he graduated from the University of North Texas with a degree in Jazz Studies Percussion Performance. Joe spent a few years seeing the world as a cruise ship musician and is now living in Hudson County. He works as a freelance drummer on Broadway and performs at various other venues in New York and New Jersey.

In the spring of 1994 there was a new member in the family— "Beans" our beloved English Springer Spaniel, who was my photo companion for 10 years until his premature passing in 2004. The quintessential *New Jersey* dog, Beans hiked with me along the trails of the Delaware Water Gap, frolicked in the waves at Sandy Hook and Island Beach State Park, walked the streets of most every city and town in New Jersey, and jumped into every clean river, stream and lake from High Point to West Cape May.

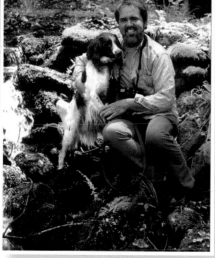

A combination of serendipity and perseverance has brought me to this silver anniversary of photographing New Jersey. As I look back on my personal and professional life these past 25 years, I am *thankful* for the blessings that have come my way.

But this job is never finished, and I will continue to seek, photograph and publish the beautiful side of New Jersey.

Walter Choroszewski

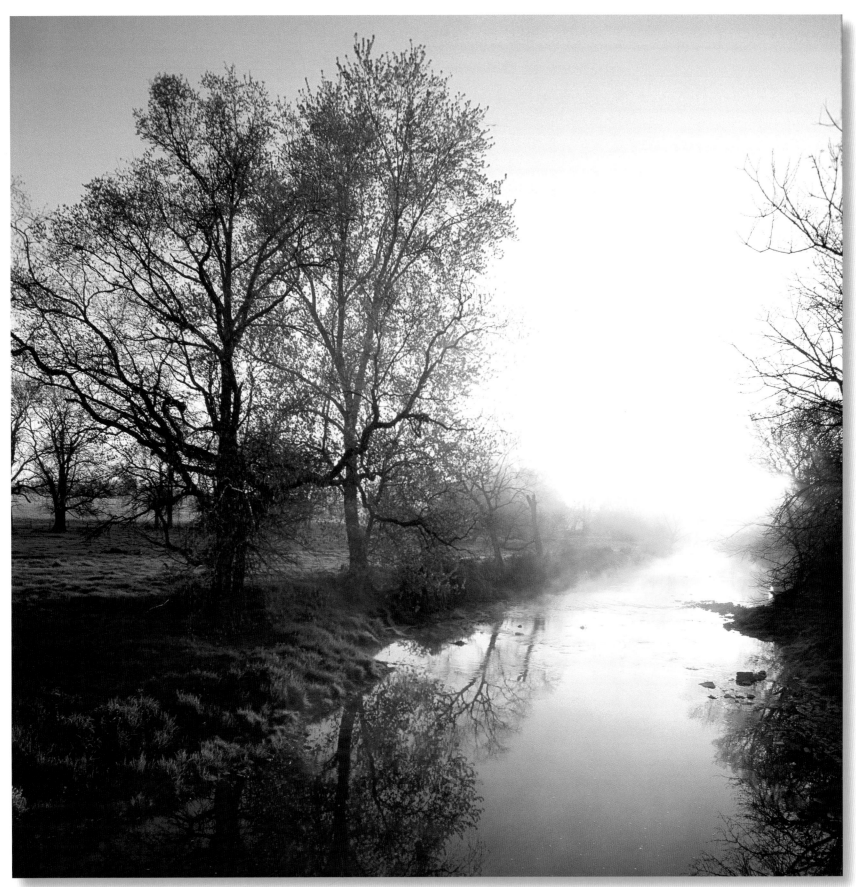

▲ Neshanic River, East Amwell